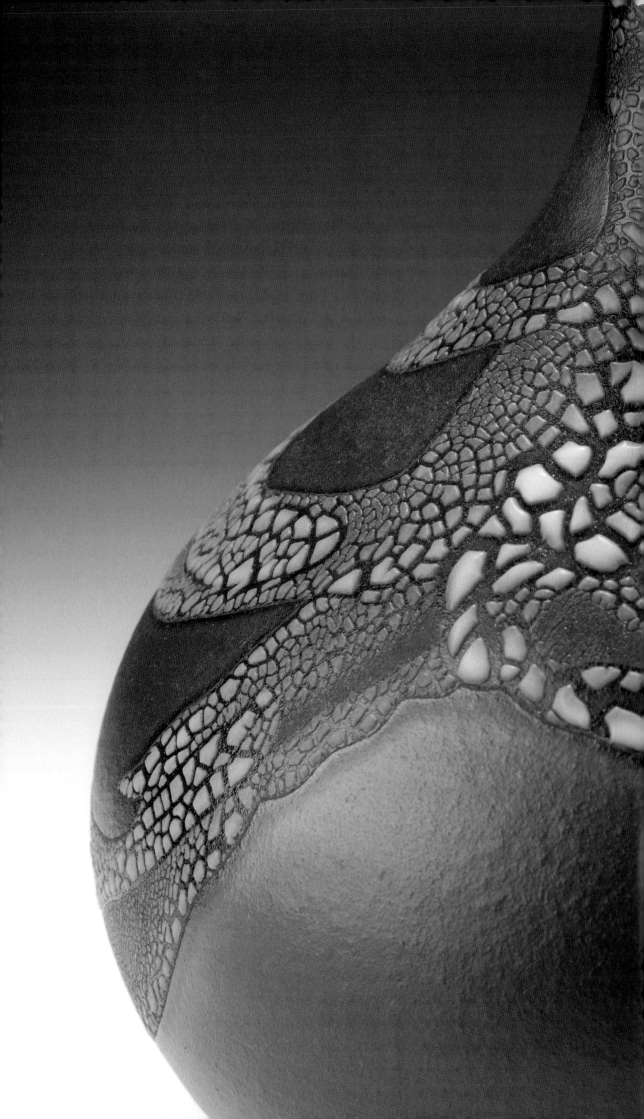

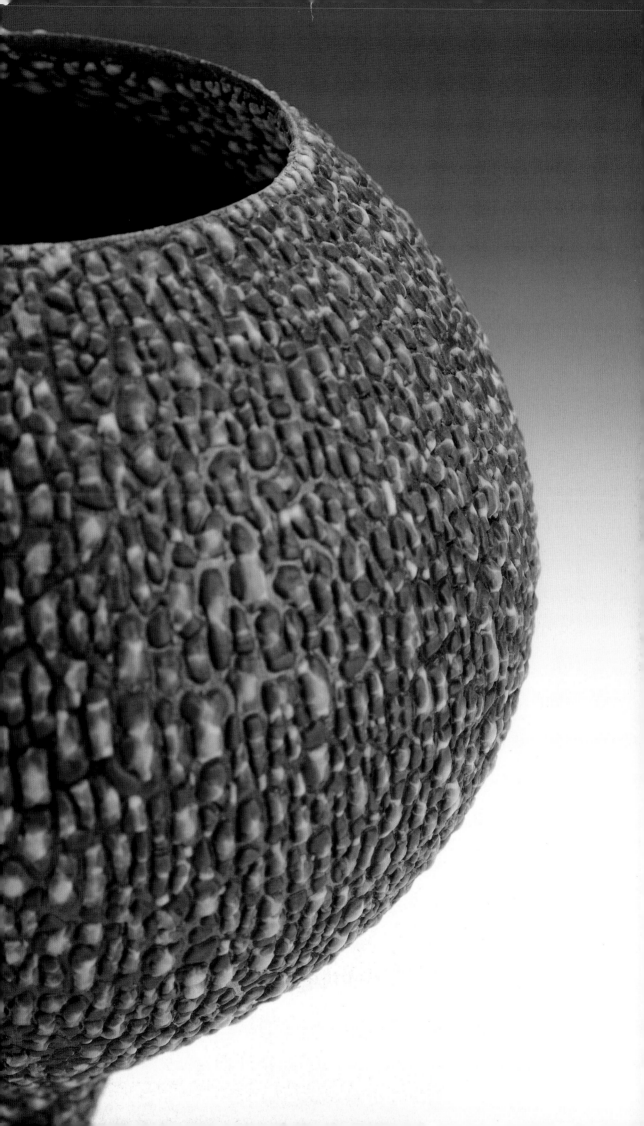

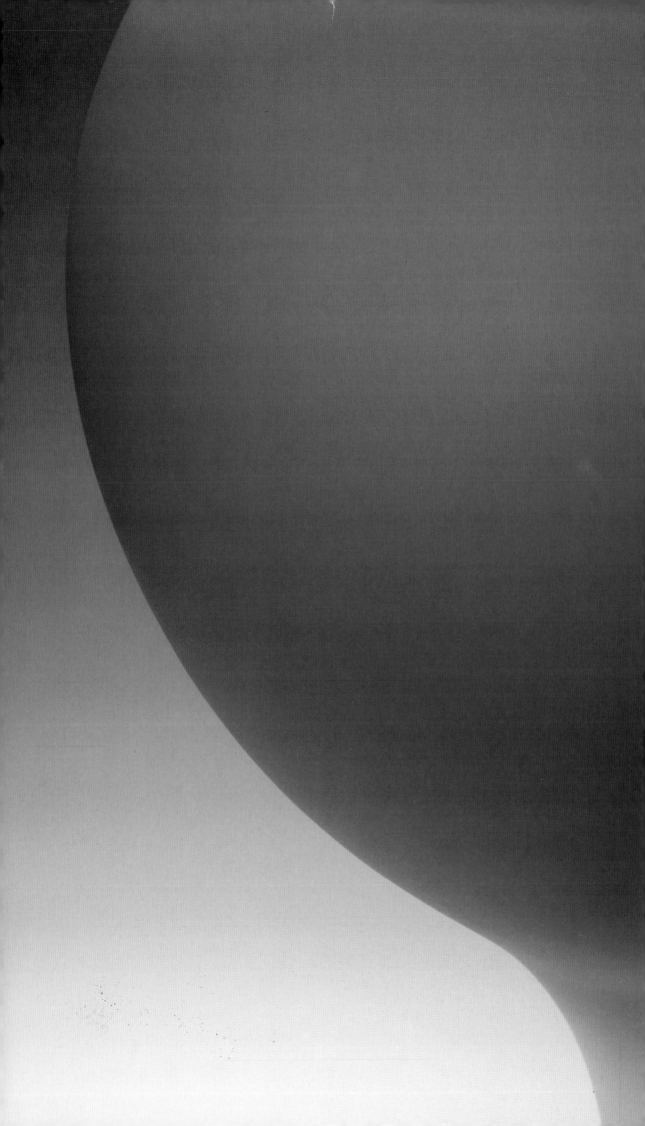

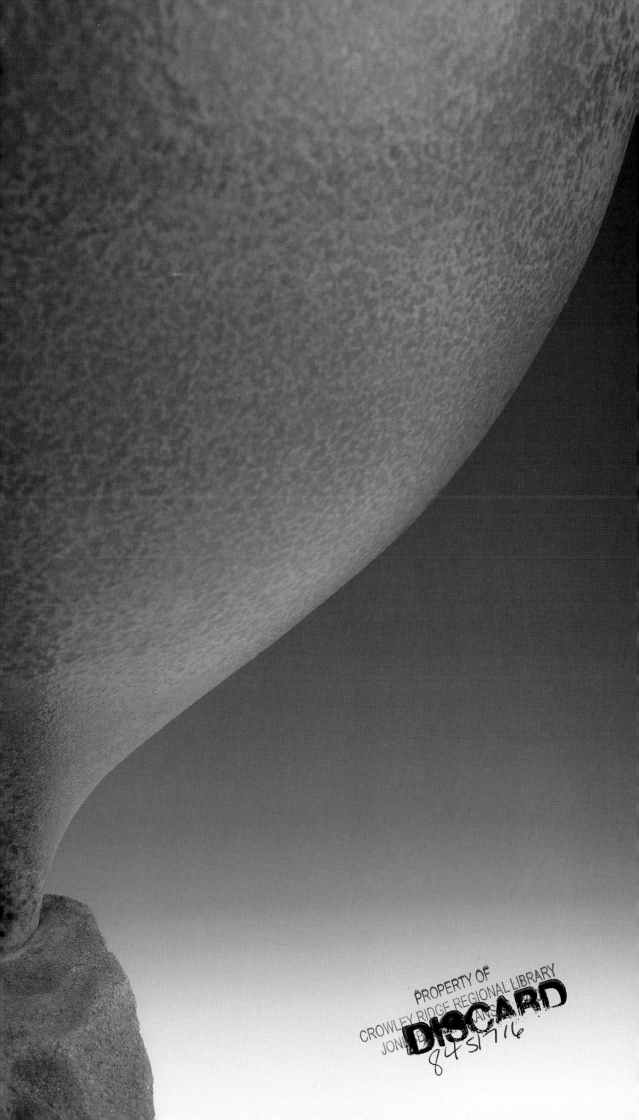

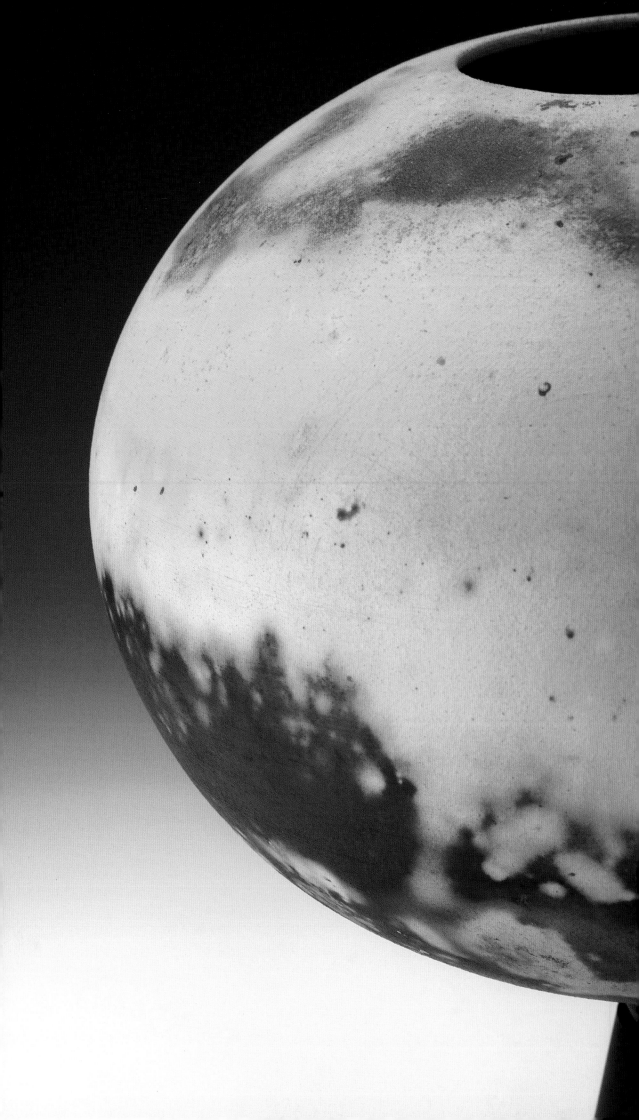

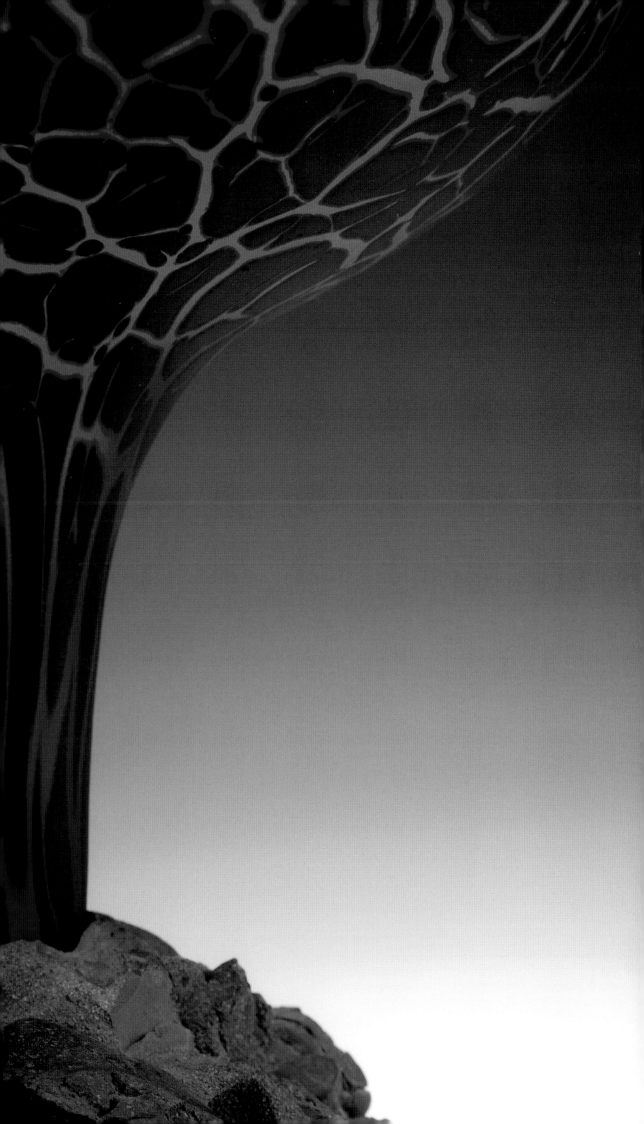

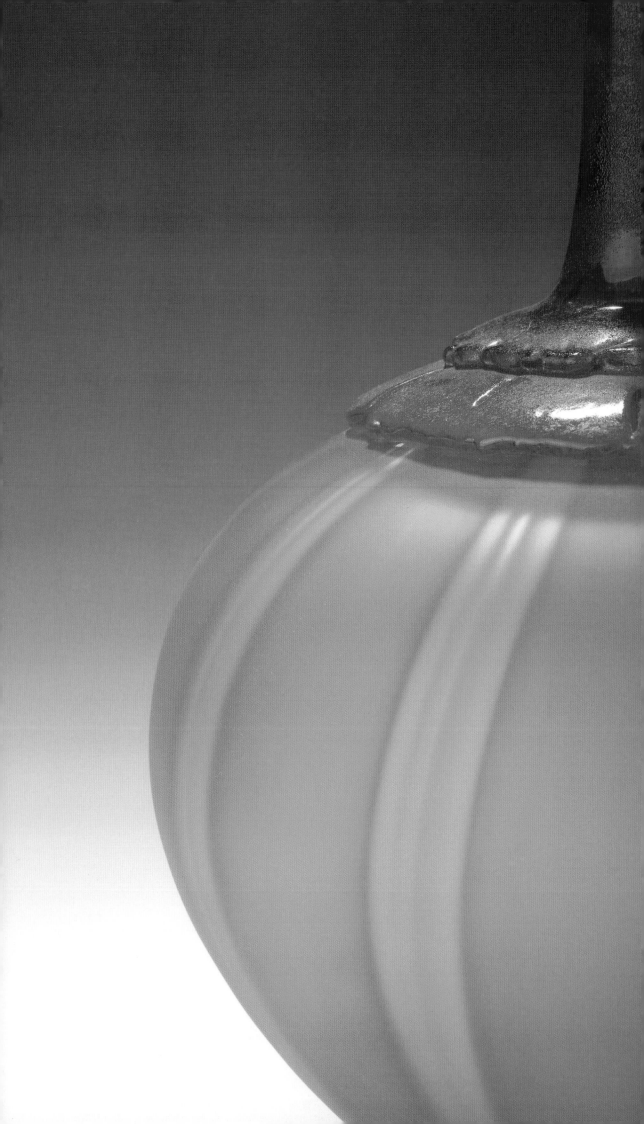

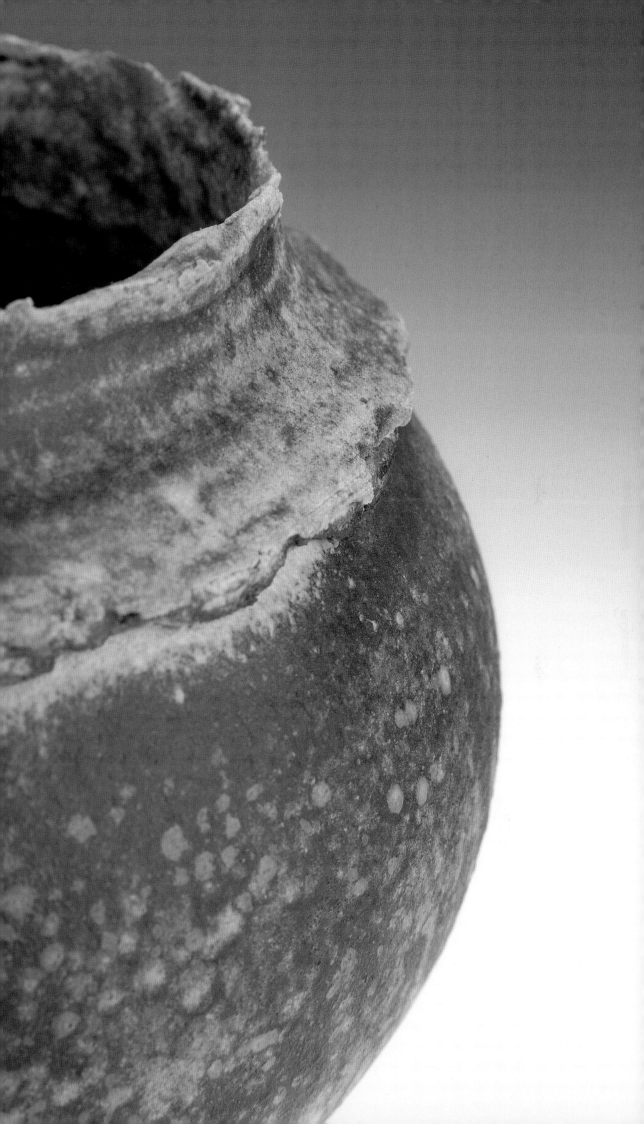

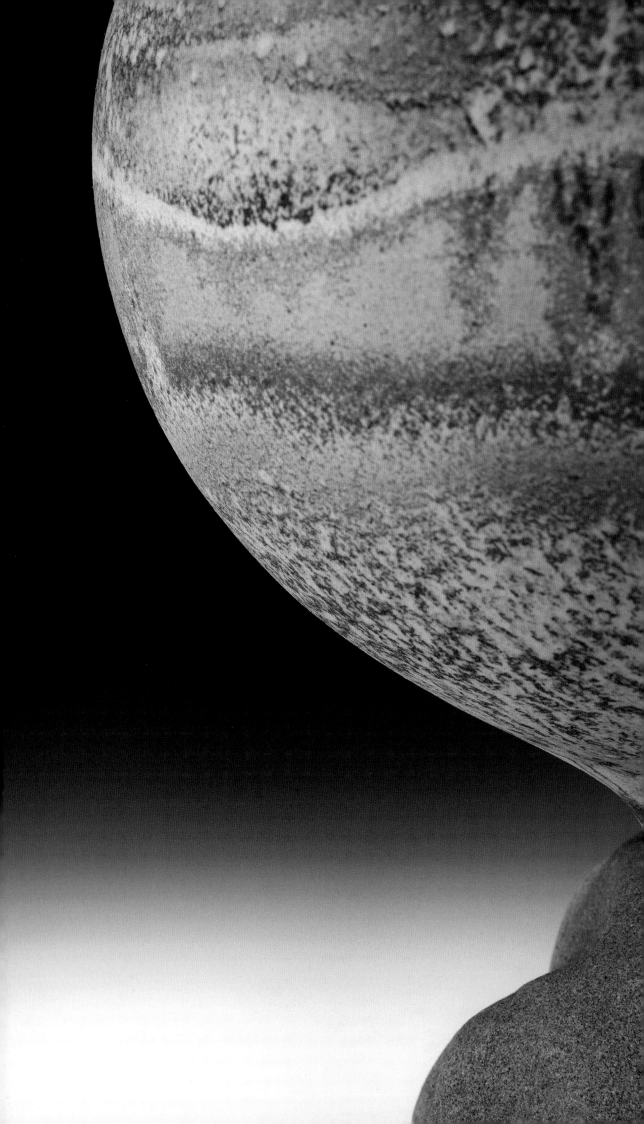

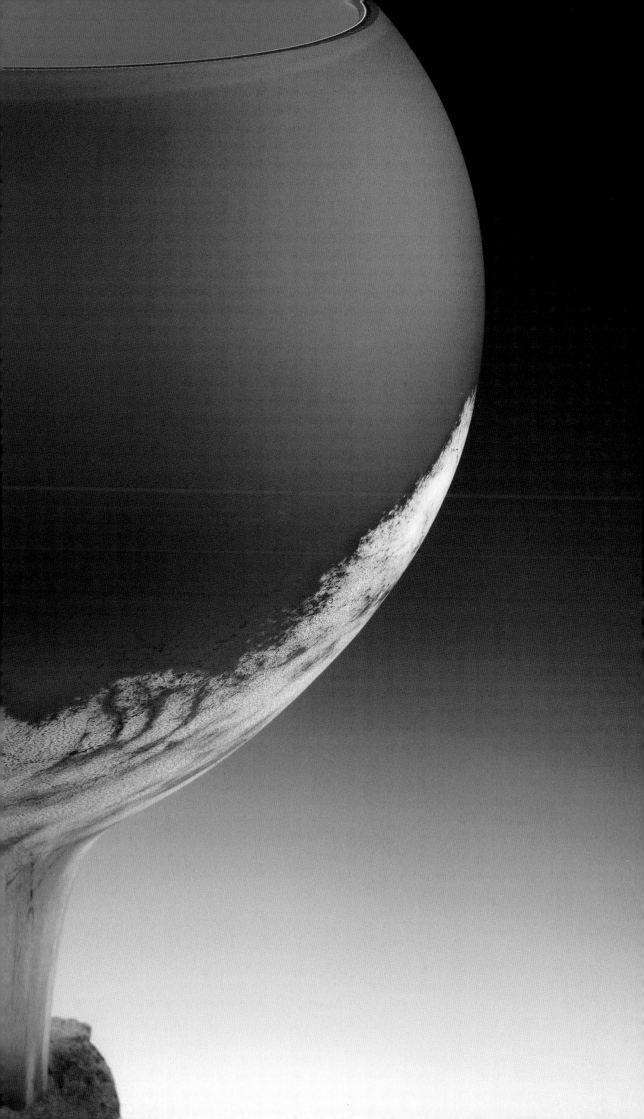

MARY FOX

MY LIFE AS A POTTER

STORIES AND TECHNIQUES

HARBOUR PUBLISHING

To Heather Vaughan, whose love
and unwavering support helped me
to grow into the person I am today.

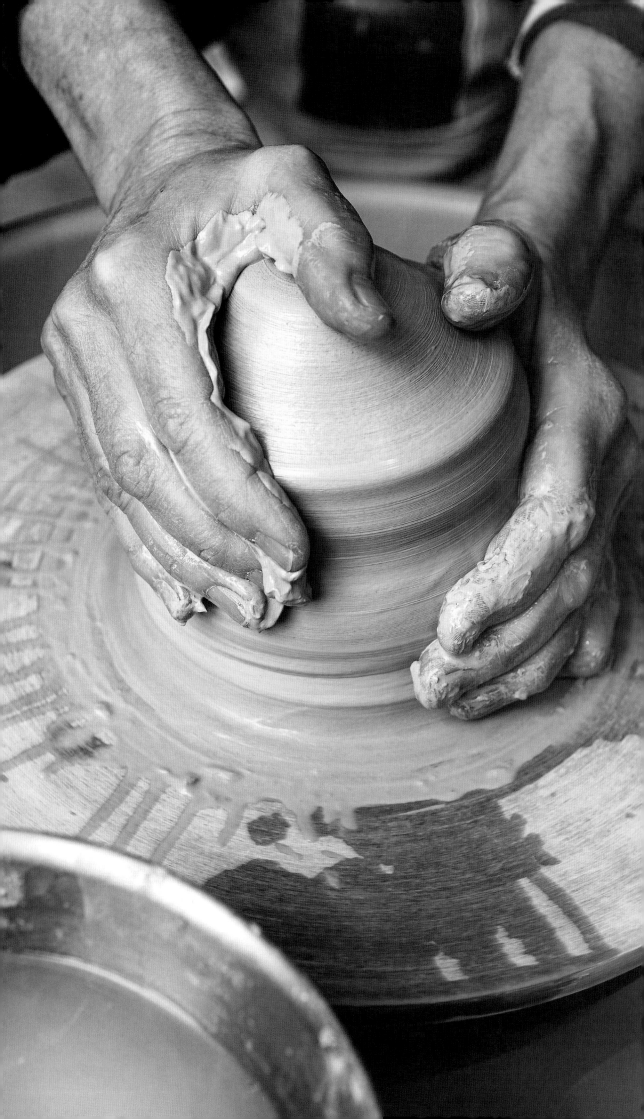

CONTENTS

FOREWORD

Carol E. Mayer | **XVIII**

PART I | BECOMING A POTTER

1 Love at first touch | **1**

2 Finding my creative style when life takes a sharp turn | **17**

3 Beginning again, together and alone | **33**

4 Collaboration fires new creativity | **51**

5 Hand-built sculpture | **65**

6 Living and working with the seasons | **75**

7 Envisioning the future: The legacy project | **89**

PART II | TECHNICAL NOTES

8 Things I wish I had known | **95**

9 Sell those pots! | **111**

10 Chalice forms and bases | **117**

11 Creating chalices: Thrown and cast | **127**

12 Throwing vases in sections | **137**

13 Lithium compound glazes | **145**

14 Crawl glazes | **153**

15 Cone 6 tableware glazes | **165**

16 My functional ware designs evolve | **169**

17 The challenging series of glass chalices | **179**

18 Working with the Blaauw gas kiln | **195**

ACKNOWLEDGEMENTS | **208**

APPENDIX | **210**

SELECTED REFERENCES | **212**

PHOTOGRAPHY CREDITS | **213**

ABOUT MARY FOX | **214**

It seems there was never a choice for Mary Fox. She knew she wanted to be a potter and admits she stubbornly and obsessively set out to become exactly that. In this book she tells the story of her journey through a personal lens that is both revealing and inspiring.

The first phrase that caught my eye was "my life's work has been devoted to simplicity of form." I have many ceramics in my home and am picky about what I choose to live with. So when I am given a new work I tend to don a fixed grin and hope for the best. Some years ago, my husband, Ken, brought home a gift: "I've found you a pot—I think you'll like it." I opened the box and lifted out my first work by Mary Fox. Phew, I liked it. First, the form: I confess to being a form junky; I understand and admire the skill it takes to create a form that evokes perpetual pleasure. I am always intrigued by the relationship, sometimes quite tense, between the form and the surface. It is in this realm of tension that Mary creates harmony. As I held my new blue vessel, I turned it and touched it and knew we would become friends. It now resides in a place where I can see and admire its form every day. It is not really surprising, therefore, that I was pleased to be given the opportunity to write this foreword.

Like other potters before her, Mary received little encouragement from her family, who did not view potting as a viable profession. "You will be poor," they predicted. She didn't hear this; there simply was no choice in the matter. She was born to be a potter, and nothing could stop her. She held on to her determination and never looked back, even when life took her away from her work. It requires much courage to put into print that which is so private, but Mary chose to share about her personal life with her partner, Heather, and her commitment to take care of Heather after they both developed myalgic encephalomyelitis, an auto-immune disease. Mary was less affected than Heather, but the disease was invasive enough to force Mary to take a prolonged five-year hiatus from working. They moved from Vancouver to new premises in Ladysmith, where Mary cared for Heather until her journey ended on July 7, 2007. Throughout these difficult times Heather continued to support Mary's progress, critiquing her work and suggesting new possibilities when Mary felt lost.

"I confess to being a form junky; I understand and admire the skill it takes to create a form that evokes perpetual pleasure. I am always intrigued by the relationship, sometimes quite tense, between the form and the surface. It is in this realm of tension that Mary creates harmony."

Mary's progression as a potter and the development of her artistic philosophy are well described. Her constant quest for beauty in all its forms has shaped her life and enabled her to inspire others. She finds it in the quiet of her studio, the growth of her garden, small dinner parties, the sumptuousness of a pot before it dries, the anticipation of unloading a kiln and the euphoria when all goes well. She admits to being a bit of a recluse, spending much time alone, exploring the possibilities that clay affords. Yet she also credits her circle of friends as a source of inspiration, including Jamie Evrard, one of her favourite artists; Walter Dexter, who encouraged her when they were both seriously ill; Lisa Samphire and Jay Macdonell, who brought her new adventures and collaborations working with glass; and Robin Hopper, who modelled living, working and selling within one place, while also developing a world-renowned garden.

Like Robin, Mary needed to live, work and sell within one building, although her garden would be less ambitious. All this was confirmed for her during a six-week residency at the Banff Centre for Arts and Creativity, where she concentrated on developing her work without needing to worry about accommodation, money or meals. It was also during this time that her work became all about form, its movement and energy pushing up and out from within.

As well as developing her own practice, Mary thought about creating possibilities for others to do the same. Building on earlier conversations with Heather, who had asked her what would have made things easier for her as a developing potter, Mary knew the answer was a low-cost, equipped studio where potters could sell what they were creating. Thus she developed and launched the Mary Fox Legacy Project Society, and established an endowment fund through the Vancouver Foundation and the Craft Council of British Columbia. The Project will enable young ceramic artists to spend significant time in residence at Mary Fox Pottery, where they will have space and security to develop skills and sell their works—and discover whether they are destined for a career as a studio potter. A section in this book outlines these very laudable plans and encourages readers to contribute to the Legacy Project and help secure the residency program well into the future.

There is a dearth of autobiographies by potters that cover the scope reached in this book. Some do provide useful technical information, but the pickings are slim. Mary was not formally trained as a potter beyond high school and expresses some anxiety when faced with the vocabulary used by those who benefited from post-secondary education. She wonders whether the public truly understands what is being said and is impatient with what she views as inaccessible jargon. In the technical section of the book, she shares the things she wished she had known when she started, offering practical advice in her own everyday language. She takes readers step-by-step through her process, her failures, her discoveries, her "aha" moments, even the operating of a kiln, never expressing disappointment when things don't work out as she hoped. "It's okay to make mistakes," she says.

I'm fairly sure Mary was unaware she was following the example set by Cipriano Piccolpasso (1524–1579), a young nobleman of Castel Durante, Italy, whom I "met" while researching ceramic history. He authored *The Three Books of the Potter's Art*, a three-part treatise composed around 1557. He wrote it because, he says, "It is better that many should know a good thing than that a few should keep it hidden." It is a practical manual that takes the reader through the process of creating the famous Italian tin-glazed wares. This is the earliest record that documents the process: the collection and preparation of clay; the construction of pottery wheels and kilns; the composition of glazes, pigments and lustres; and the variation in firing techniques. It is clear throughout Piccolpasso's writing that he, like Mary, enjoyed and marvelled at the transformations that belong especially to ceramics: from soft and inarticulate clay to durable and expressive forms; from rough sand and ash to smooth glass; from fleeting images to lasting line and colour. "By enjoying the process," Mary says, "you are crafting your life."

As I witness the dwindling number of senior potters in British Columbia, many not leaving written records, I applaud Mary Fox for taking the early initiative to share her personal journey, her still-developing artistic vision and her technical knowledge, as well as her foresight in creating the Legacy Project that will so benefit future ceramic artists. We are fortunate that she always knew she wanted to be a potter, and that she acted on her stubborn streak. Without these, we would not be reading this book today.

— CAROL E. MAYER, Ph.D, FCMA

Beauty is everywhere in the act of creation, and it is humbling to be embraced by it. It fills me with surges of joy and delight.

—MARY FOX

LOVE AT
FIRST TOUCH

CHAPTER 1

"But I can't take ceramics," I told the school counsellor. "I'm not artistic!"

"Well, that's the only elective that has any space left, Mary," she said.

It was 1973. I was thirteen and starting grade eight at Central Junior High in Victoria, BC, and my life was about to change dramatically. I didn't know it then, but clay was going to touch every aspect of my life and help me grow into the person I am today. Up to that point, things had not been going very well for me. My mother was struggling, and with five kids it was a very challenging situation. My father was doing his best to hold things together for us all, but he could not prevent our family life from becoming increasingly chaotic. I remember feeling at this time that life was almost unbearable. My life outside the home was tightly controlled, and I was seldom allowed after-school activities. I was usually permitted to go to the public library, however, so that became my refuge. I was a shy introvert who read voraciously, and the library was the perfect place for me, with its feeling of calm and safety.

Then I walked into the art room at Central Junior and everything started to change. It is hard to express how large an impact clay had on me at that time. It was literally love at first touch. I had never been good at drawing, but with clay that didn't matter, as my hands could make what I couldn't draw. For the first time in my life I felt there was something I might be good at, and I loved it. My confidence started to grow. No longer did I dread going to school. I actually wanted to. I wasn't the slowest in the class any-more. I was the one the other kids looked to for help with their projects. The feelings of failure that had dogged my school years began to slip away.

I disappeared into the art room every minute that I could. At lunch hours you would find me there, quietly working away on the wheel, and if the teacher stayed late after school, so did I. When I wasn't in the art room, I was at the library poring through the books on ceramics, studying the pictures. At home my bedroom turned into a small studio crammed with my creations. An old table became a workbench where I made little sculptures and pots with clay I had dug up at the beach. Clay was becoming my salvation.

People often ask me if I was surrounded by art when I was growing up, but nothing could be further from the truth. Our home on Linden Avenue contained no art to speak of, only religious pictures. My family was Catholic, and my mom insisted that we go to church often, sometimes daily, but I found church boring beyond belief and would escape into my inner world to pass the time. The only part of the service that I paid any attention to was the offering. I would watch intently as the priest held up the large silver chalice and reverently drank from it. When he was done, he would lovingly clean and polish it as part of his ritual.

After church we would walk home along Fort Street, where many of Victoria's antique stores and my favourite shop, Ego Interiors, were located. When we got to that block, I would dart across the street to gaze at the window display. It was a bit of a mystery to me then why I was so drawn to this store, since most of the furnishings and decor they carried were simple in form and not highly decorated. Of the potters who sold work there, my favourites were Jan and Helga Grove. They produced simple forms that were glazed in beautiful solid colours. Looking back now, I can understand the attraction, as my life's work has been devoted to simplicity of form.

In my bedroom "studio" creating a coil-built form from beach clay, age fifteen.

As I got older and more self-assured, I would venture inside Ego Interiors and other stores that carried pottery. By the time I was in grade ten, I was throwing regularly, and my desire to "feel up" the work of other potters was insatiable. Fortunately for me, there were quite a few stores in Victoria that carried local potters' work, and I frequented them, studying the work and looking for ideas. I was already filled with dreams of becoming a full-time potter.

At school I had two new art teachers, Waine Ryzak and Mary Tremaine, who gave me more freedom in the art room than other teachers had. To my delight, Waine stayed after school every night until six, so I did too. One night my mother got suspicious about what I was up to and sent my brother to the school to see if I was really there. When my brother went home to report that indeed I was working away in the art room, she seemed to accept my new routine, and my coming home at six o'clock became the new norm.

When Christmas break rolled around, I approached Waine to see if she might be coming into the school during the break. She said no, but asked if I had been hoping to come in and use the wheel. Of course I was! Well, she said, as long as I didn't tell anyone, why didn't I take the wheel home over the holidays? Oh happy day!

I asked my dad if we could make a space in the basement where I could throw, and shortly afterwards my first little studio was set up. Dad drove me and a friend up to the school, and we toted that heavy Shimpo wheel down three flights of stairs. Then off home I went with my prize! I borrowed the wheel during all the other school breaks and even over the summer.

GROWING INTO A PROFESSIONAL

By the end of grade ten, I had been throwing obsessively for over a year, and my small basement studio now had a homemade kick wheel that I had built with help from my dad and my brother Tim, using plans supplied by my art teacher, Mary Tremaine. I was supposed to move from Central Junior High to Victoria High for grade eleven, but when I found out they didn't have a clay department, I asked to be sent to Oak Bay High, which had two good art teachers and a large clay room. I made myself right at home in that room, and it wasn't long before the other students were looking to me for throwing tips. I was having fun, making new friends and enjoying the attention my clay work was bringing me.

EGO INTERIORS

In 1962, a young married couple named Shushan and Joseph Egoyan fled political turmoil in their home country of Egypt and arrived in Vancouver, hoping to build a new life. Both had been trained as artists and had operated a gallery and design store in Cairo. At that time, Don Adams ran a well-known furniture store in Vancouver. When Joseph Egoyan walked in to introduce himself, Adams was impressed enough to invite him to manage his interior design store in Victoria. With some trepidation but limited options as immigrants in a new country, Shushan and Joseph and their young son,

Atom, soon to be joined by a younger sister, Eve, moved to Victoria to operate the store that came to be known as Ego Interiors.

At its storefront shop on Fort Street, Ego Interiors combined uniquely designed furniture with imported and local artworks to bring a modern, international perspective to interior design in Victoria. The store had a gallery space upstairs, and Ego Interiors became a hub of artistic activity and the meeting place of a group of artists known as the Point

Group, which later became the Limners. Although most of the artists were painters or sculptors, members eventually included prominent Victoria ceramists Jan and Helga Grove and Walter Dexter.

It was here that Mary Fox, still in high school and unknown to this older generation of artists, discovered a sense of form and design that resonated with her own sensibilities. It would feed her imagination and help her develop her distinctive style.

— PAT FEINDEL

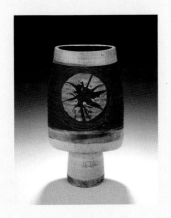

Walter Dexter, *Raku Vase*, 1993. 41 cm T × 23 cm W.

This photo of me working at the wheel after school was taken by Doug Berg for the Central Junior High annual, and it ended up as the title photo for the fine arts section. All year the kids working on the annual teased me about the caption they had written for my "mug shot." They wouldn't say the line but insisted it was perfect, and it was: *Mary's gone to pot*.

One day I was in my usual position, hunched over a wheel in the clay room, when I heard my art teacher say to a woman who had walked into the room, "Go talk to her. She could teach your classes for you." The classes she was referring to were held in a little pottery store on Shelbourne Street in Victoria. The owner had a bunch of wheels crammed into a small attic room, and she wanted someone to teach her adult students. Although I was a bit unnerved at the prospect of teaching, I was very keen to make some money, as this clay habit of mine was getting costly. Up to that point, my only money source had been babysitting, which I really did not enjoy, but teaching would be an excellent gig for me since it was in the evenings and the pay was good. I jumped at the opportunity.

I'll never forget that first night. I was on edge as the room filled with middle-aged women—at least I remember them as middle-aged, but I was all of sixteen and everyone seemed much older to me. I was wondering how to start things off when one of the women said, "Who's our teacher?"

I stepped forward and boldly announced, "I am."

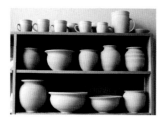
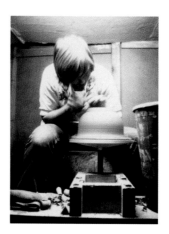

Some of the pots I made over the summer, waiting to be fired in the kiln room at Central Junior.

Working away on the homemade kick wheel in my tiny basement studio while my brother Chris and my sister Angelika watch, 1976. The painting on the studio door was by Miles Lowry.

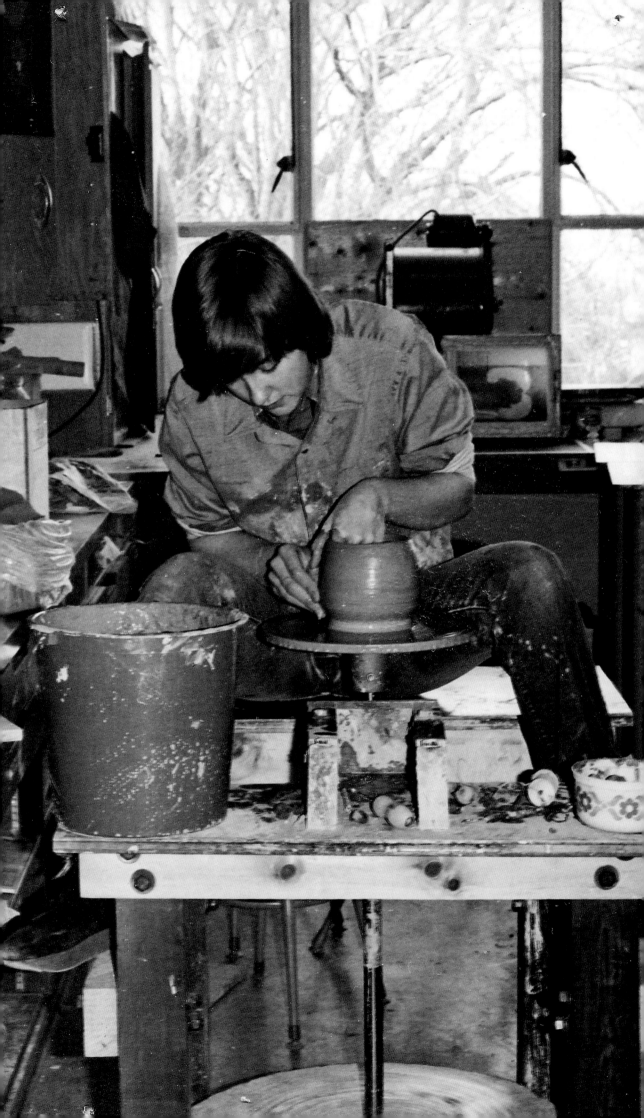

"I saw in Mary the beginnings of a very talented, focused artist. She succeeded immediately in her efforts to manipulate clay, and you would often find her after school in the art room, creating forms on the potter's wheel.

Mary's energy was electric. I remember her running down the hall, her long hair swaying from side to side, inevitably late for class after spending too long in the art room.

I can truly say that Mary stood out as an excellent, vibrant and promising art student."

— WAINE RYZAK, art teacher

There was a moment of silence, and then the woman laughed and said, "Really?"

Clearly they had doubts that someone so young could be their teacher. I quickly wedged up a piece of clay, went over to the kick wheel and in a matter of minutes threw a large pot. Then they were mine! As they watched me handle the clay with confidence and skill, the age difference just slipped away. After that, it was a full-on night as I went from wheel to wheel giving pointers and helping them out. By the end of the evening they all agreed I was a good teacher, and they were eager to come back. I think they were a bit tickled by the idea of being taught by a mere kid.

Those ten weeks flew by, and by the end we were all having a great deal of fun with each other. On our last night together one of the women suggested we go out for a beer after class to celebrate. Then they looked at me. I said I didn't think I would get served. "Awww, don't worry about it! We'll get you in," they chimed. I was hesitant but also chuffed that these women wanted me to go out with them, so I put my nerves aside and said okay.

Off we went to the Crown and I Pub in the Imperial Inn. I still remember us all sitting around that big round table, me nervous as hell but putting on a good show. The waiter came to our table and promptly asked us for IDs. My companions were flattered by this since they were all over thirty and likely hadn't been asked for ID in some time. I, on the other hand, was feeling a bit green. The waiter started with the woman sitting next to me and went around the table the other way, finally ending at me. This gave me some time to come up with something to say, but the best I could do was, "I didn't bring my wallet." My students came to the rescue, chiming in with, "She's our teacher, and we're here celebrating our last class." The waiter looked hard at me and said, "Well, okay, I guess if she's your teacher." I breathed a big sigh of relief and downed the first beer quickly for some liquid courage!

I taught a few more classes at that shop and then taught at Whales Ceramics (later Whales Gallery) in Victoria for a few years. However, I came to enjoy teaching less and less, as all I really wanted to do was make pots myself, so when I was around nineteen, I stopped teaching and didn't take it up again until I was in my fifties. Now I enjoy teaching beginners and giving workshops on the creative process, though I rarely have the time to do it.

Grade eleven at Oak Bay High was great for me. I loved having two new art teachers and was once again in the art room every possible minute. While at Central I only had access to firing in the low earthenware temperatures. At Oak Bay they fired everything to cone 6, and I was keen to learn about firing in this range. The art teacher, Sharron Bailey, allowed me to experiment as much as I wanted, and I explored with glazes and learned more about firing the kilns.

However, when I returned to Oak Bay the following year for grade twelve, it was a different scene. Both art teachers had left, and the home economics teacher was now teaching art. I was not happy! Although she would ask me for instructions on how to fire the kiln, she wasn't keen on me being in the art room all the time. All of a sudden I felt that school had nothing to offer me, and I didn't want to be there anymore.

Then one lunch hour in January one of my friends told me they were hiring at Oakland Fisheries for the herring season. The job wouldn't be for long since herring season was only around three weeks, but they paid ten dollars an hour, which was very good at the time. I immediately rode my bike down to the fisheries and applied for the job. I reasoned that I could always go back to school later if I wanted, but I couldn't get another job that would pay this well and get me closer to buying a used kiln. By now all I could think about was getting away from the family home and starting my life as a potter. I had the wheel we had built, a stash of glaze supplies I had bought from a potter going out of business and a gram scale. All I needed was a kiln.

At dinner that night I announced my decision to my family. My dad was somewhat horrified but realized he wasn't going to be able to talk me out of it. I remember his words of warning: "Mary, artists don't make much money. You will be poor." I replied, "That may well be, but I think they are happy." Inside I was thinking, *and you are not.* For as long as I could remember, my dad had known exactly how many years and days he needed to work until retirement, and that was not how I wanted my life to go.

So off to the fisheries I went. It was the stinkiest job I ever had, but when they hired for the salmon season, I got right back in line for a job. By now my parents had separated and I had moved out on my own, and the need to make more money was pressing. I worked two herring seasons and two summers on the line cleaning salmon. Along with teaching night classes, this earned me enough to pay my rent and buy more clay. I didn't have a studio space in those days but managed to create a small workspace no matter where I lived.

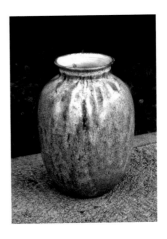

This was one of my earliest glaze experiments. I glazed the vase with a layer of white glaze, then on the outside I added a woodash glaze made with ashes from our fireplace. *Woodash Vase,* 1976. 23 cm T × 8 cm W.

Around 1977 Robin Hopper moved to Metchosin, outside Victoria, and established his pottery. There was a lot of buzz around town about this famous potter, and naturally I wanted to meet him and see his work. I didn't drive yet, so I asked my dad if he would take me. Though Robin hadn't been there long, he had already set up a working studio with a small area for displaying his finished work. I was in awe, but my shyness overtook me and I didn't ask him much, though that visit made a big impression on me. I remember that when I got in the car to leave, I said to my dad, "He has it right. You need to be able to live, work and sell all from one spot. That's what I want." The seed was planted. It was doable, this being a potter. Here was living proof, someone who was leading the kind of life I envisioned for myself and earning a living at it.

My dad at his work. In the background at right is one of my mugs decorated with brushwork.

Not long after that, I moved into a house with friends and got my driver's licence. I was still very shy, though slowly growing in confidence, and on weekends I ventured out to the local swap meets, where I would display my pots on a small table in the hope of making big sales. I kept the boot of my car open to show more pots were available, but, alas, sales were underwhelming. I realized that if I wanted to make real money, I would have to persuade some local shops to buy my work. The question was: which shop should I approach first?

I am a bit taken aback by the moxie I mustered up as a youngster, but for some reason, when it came to my potting, I could make myself do almost anything. I didn't let my fears stop me. So the first place I approached was the shop in the Art Gallery of Greater Victoria. I took in about a dozen small pots to see if they would buy some. I was led to a lovely back room overlooking the neighbourhood and invited to show my creations to the women working there. Very kindly they looked them over and picked out a few for the shop. I was thrilled! Not only was I, Mary Fox, now "showing" in the art gallery shop, but they even paid me on the spot. Wow, this was good! I had money for clay, and I was filled with the hopes of an aspiring young potter. If they bought these, surely they would buy more. My hat size was getting bigger by the second. Off home I went to get to work.

I let some time go by and then phoned to make an appointment to bring in my latest pieces. Once again the shop staff were very kind to me, looked over all the pots, commented on the attributes of a few and chose several to buy. However, as I was walking out I happened to look up and saw, on a high shelf, some of the work I had brought in on my first visit. I was crushed as I realized that they hadn't sold all the pieces, and here I was pushing more on them. I decided that I had better let more time go by before paying another visit.

It was clear I was going to need more buyers if I was to survive at this, so I started checking out the local shops regularly. Previously when I had gone into stores or galleries, it had been to see how other artists' pots were thrown. Now I had a different agenda: I wanted to find out which pots sold well. I soon learned that anything with brushwork sold faster than plainly glazed pieces.

Brushwork seemed to be the answer, but this was a bit of a problem for me, as a brush felt like a foreign object in my hand and decorating in that way didn't come naturally to me. I preferred glazing my pots with solid colours, but those pieces weren't selling very well. What to do when you don't know how to decorate? I studied other work that sold well and copied what those potters were doing, with a few minor changes. Soon the cheques started coming in, though I never felt like the work was truly my own. Although this bothered me, it was not enough to make me change what I was doing, as I was finally able to pay the bills. (It was not until the mid-nineties that I changed back to using the solid glaze colours that I am known for today.)

The income allowed me to rent a duplex on Niagara Street in James Bay with a street-level basement where I set up my first walk-in pottery studio. Soon people were venturing in to buy my pots, and by 1981 I also had ten stores that were buying my work regularly. I was making a living. Life was good. All I needed now was someone to share it with.

A LIFE PARTNER

By my late teens I had begun to suspect that I might be more attracted to women than I was to men. I was in turmoil about my sexuality and wanted to meet some gay people but was scared to mention this to my friends. One night I fortified myself with a few drinks and went off to the local gay bar, Queen's Head. I was by myself when a woman sitting at a nearby table with a friend caught my eye. I walked over and asked her to dance, and after a few dances moved myself over to her table. We talked and talked. I learned that her name was Heather Vaughan, but then to my chagrin found out that the other woman at the table was her girlfriend.

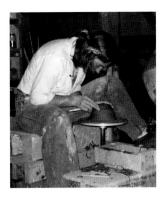

An early basement studio at a rental house I shared with friends, 1979.

From that night on, any time I went out to a bar or a women's dance, I kept an eye out for Heather. (As it turns out, she was keeping an eye out for me, too.) Time went by and I dated other women but never fell for any of them. I had fallen for Heather that first night, but unfortunately for me, I wasn't the only one who knew she was a catch, and I never seemed to see her when she was single. She always had a girlfriend. I had to content myself with the odd lunch date, but even so, I never gave up letting her know that I wanted to go out with her.

In the spring of 1981 I bought a 1980 Honda 750 Custom motorcycle and decided to go on a long road trip. I had learned to ride the year before and wanted to go exploring in the United States, but since no one I knew had the time or a bike that was big enough for such a trip, I had to go by myself. I found someone to sublet my place in James Bay, and I let the stores that stocked my pots know that I would be away for three months and convinced them to take all their summer stock a bit early. Preparing all those pots so far in advance meant I had to work much longer days leading up to my departure, and that was the beginning of my first overwork injury. As I headed off on my trip, I realized

that something wasn't right with my arm. It was the beginning of a "tennis elbow" problem that would plague me for years to come.

Before leaving, I invited Heather out for lunch. I was getting a little frustrated that she didn't seem to be taking my intentions seriously, so I asked her if she broke up with her current girlfriend while I was away, would she *please* wait for me to get back before starting to see someone else? Then off I went on what would end up being a twenty thousand–kilometre trip around the States. When I came home, the first person I called was Heather. And sure enough, in my absence she had broken up with her girlfriend—but to my great annoyance, instead of waiting for my return, she had taken up with her first girlfriend again. I was beyond put out!

I felt that I had been patient and honourable all these years, never interfering in her relationships, but this was just too much. As far as I was concerned, her first girlfriend had had her chance, and now it was time for me. The gloves were off! Heather was taken aback by my reaction. She later told me she had never really thought I was that serious. But I was serious all right, and after a few

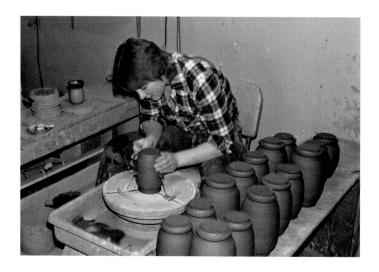

Making a batch of canisters in the basement studio on Niagara Street, 1981.

Tableware in the living room of our Niagara Street home, 1982.

Heather and me out to dinner to celebrate a successful craft fair, December 1982.

months she decided to end things with her ex, and we embarked on what would turn out to be a twenty-five-year relationship.

Other than my clay, Heather was the best thing that happened to me. When we got together, she was attending the University of Victoria with plans to become a social worker. She moved into the James Bay house with me, and though she kept her apartment until we had been together for a year, she never spent the night there again. Until then, although I had dated, I'd never had a serious relationship, and I had to learn what it was like to live with someone. But Heather was able to help me start the long process of dealing with the family trauma in my background, which, of course, was still having an impact on my life. And when she graduated the following spring with her Bachelor of Social Work degree, I was willing to do whatever was necessary to help her get started in her chosen field.

During the 1980s the provincial government, like many other governments, imposed a program of severe economic restraint that cut back many social services, so social work jobs were scarce. When a job came up in Chilliwack, we thought it was a long shot for Heather—they were looking for someone with a master's

GROVE POTTERY

Among the ceramic works that most inspired Mary Fox as a young potter were those of Jan and Helga Grove. They had trained in Germany, apprenticing with Jan's parents, Gerd and Lu Grove, who ran a pottery studio in Lübeck. Helga had also pursued art and textile studies under the Bauhaus master Georg Muche. Jan and Helga married in 1952, and after working and teaching in Turkey, in 1966 they moved to Victoria. Soon after, they established Grove Studio just outside the city and created pottery there for the next forty years. Soon recognized as two of Canada's most

accomplished potters and clay sculptors, the Groves specialized in making unique pieces rather than a production line of identically shaped objects. They were known for finely crafted modernist pottery distinguished by classic forms, subdued matte glazes, geometric designs and sgraffito decorations.

In 2012 the Groves' work was included in a retrospective group exhibit at the Art Gallery of Greater Victoria called *Back to the Land: Ceramics from Vancouver Island and the Gulf Islands 1970–1985*, curated by Diane Carr, who operated The Potter's Wheel gallery in Victoria during the 1970s. Mary Fox was also included in this exhibit as the youngest contributor among thirty-one established ceramic artists from BC. In 2017 the Art Gallery of Greater Victoria held a retrospective exhibit of Jan and Helga Grove's works called *Life with Clay*.

– PAT FEINDEL

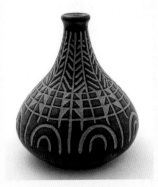

Helga Grove, *Vase*, 1965.
10.5 cm T × 13 cm W.

degree—but we decided she should apply anyway. To our surprise she got the job and off we went to Chilliwack, where we stayed for the next three years.

Those were tough years for me. While Heather immersed herself in a new job and a new workplace culture, I missed my friends and felt isolated. We didn't know anyone in Chilliwack, and it was a very conservative town where I didn't feel I fit in at all. I was used to my walk-in studio where people came in and out all day; now I went down to a dark basement studio and spent day after day by myself. I started to get depressed.

On top of that, I was dealing with overwork injuries in my arms and wrists from the tons of clay I had been throwing. On a visit to Victoria I told my friend Phyllis Serota that I might have to stop potting, as my arm and wrist problems weren't getting better. Phyllis, a painter, had experienced some overwork injuries as well but had found a good physiotherapist. She thought her guy could help me too, and set about getting me an appointment. This turned out to be a very good thing. I saw Phyllis's physio a few times, and when it came time for me to go back to Chilliwack, he set me up to see someone he knew in Abbotsford. Slowly my injuries began to heal, and I became much more mindful of how I used my body. Being self-taught, I had never been exposed to advice about how to prevent work injuries or practise good body mechanics.

I still found my daily time alone and the lack of friends hard, but I decided that perhaps I should start to use this time to explore some new creative directions with decorative works.

Heather and me in Chilliwack. The door behind me led to my latest basement studio.

MY FIRST PLASTER MOULDS

Shortly before we moved from Victoria, I decided that I wanted to try my hand at making a mould of a woman's torso. Knowing it would be more than a one-person job, I teamed up with my friend Miles Lowry. We had studied art together at Central Junior High and had learned about making plaster face moulds in Waine Ryzak's class. (Miles continues to live and work in Victoria as a painter, sculptor and creator of other multimedia works.) Miles and I called up Waine to get some tips; as always, she was game to help us figure it out, and we came up with a plan.

That first torso mould–making experience took place in my James Bay studio. I think it's fair to say it was traumatic for all involved! I would even call it a comedy of errors. When you are making a torso mould like this, you have to be careful to prevent the plaster from going around and under the curve of the model's ribs, or you risk trapping the person in the hardened mould. Our plan was to have our model, Frances Westerman, lie on the floor and to build a clay dam around her torso. We put blankets on the floor, laid our model down and started building the dam. This took a bit longer than we anticipated. By the time we got to the next step of rubbing Vaseline on Frances so the plaster wouldn't stick to her body, she was freezing. It was January, and the bed of blankets she was lying on was nowhere near enough

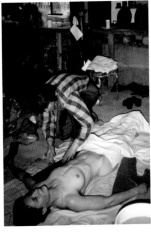

1

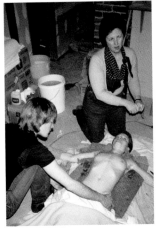

2

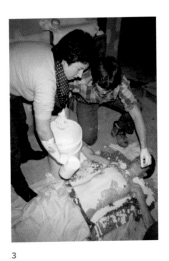

3

4

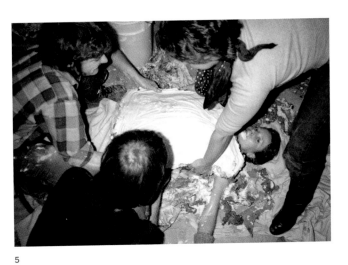

5

1 | It all starts out quite calmly as I build the dam around Frances.

2 | Miles and Waine put the finishing touches on the dam.

3 | Waine and I begin the pour...

4 | Finally done, we step back and breathe a sigh of relief.

5 | The moment when we realize the mould isn't lifting off Frances.

Miles and me setting up the show *Vault of Dreams* at Out of Hand Gallery, 1986.

protection from the chill of the concrete underneath. As if that wasn't bad enough, a dam of cold, wet clay now surrounded her body, and she was starting to shiver. We needed her to be still when the plaster was applied, since shaking would cause cracks in the mould. We got heaters going, put mitts on her hands and Heather tried to calm her while Miles and I mixed the plaster.

When mixing plaster, you have only a small window of time to pour it, but you also have to wait for it to get just to the point where it is about to thicken before starting the pour. Once the plaster is poured, there are only a few minutes until it sets—which is a very good thing when your model is freezing. But there were so many more things we hadn't taken into consideration for our venture, one of them being the weight of the liquid plaster. When we poured it onto Frances, it burst through our flimsy clay dam in a nano-second. Plaster flowed everywhere as we frantically tried to pile it up on her and shore up our dam at the same time. Throughout this disaster Heather spoke soothingly to Frances, reminding her to keep her breathing shallow so as not to crack the mould.

Finally the plaster set. We began slowly removing what was left of our dam and got ready to lift the mould off. However, as we tried to lift it, it became apparent that the plaster had run into parts of Frances's body where it wasn't supposed to, and she was well and truly attached to the mould. Her underarm hair was totally embedded in the plaster, but that wasn't the worst of it. Plaster had also run down into her pubic hair, fusing it to the mould. Not only did we have a very cold Frances on the floor, there wasn't any way we could lift the mould off her until we cut her hair loose from the hardened plaster. It was not an easy job and took what seemed like forever, but eventually we got her free. Heather then rushed our model upstairs and into a hot bath, where she continued the delicate process of cutting the lumps of plaster out of Frances's nether regions. Amazingly, this torso mould became the starting point for my very first show. Miles came to stay with us in Chilliwack, and we began to collaborate on the torsos and a series of new pieces I had created, some of them combining the wheel-thrown forms with handbuilt additions. I was starting to feel happier again as I experimented with these new forms, and Miles was having fun coming up with ways to decorate them. Our show, *Vault of Dreams*, opened at Out of Hand Gallery in Victoria in 1986.

Despite these positive developments, Heather and I knew our time in Chilliwack was coming to a close. Neither of us was very happy there, and though it had been good for Heather to experience working as a social worker, she had begun to question it as a career path. I wanted to move back to the Island, but Heather knew that once I got back there she'd never get me to leave again. She suggested we live in Vancouver for a while, and off to the big city we went.

I have continued to return to
the torso form since those first
moulds in the 1980s.
Torso, 2010.
Lithium compound, oxidation,
64 cm T × 46 cm W.

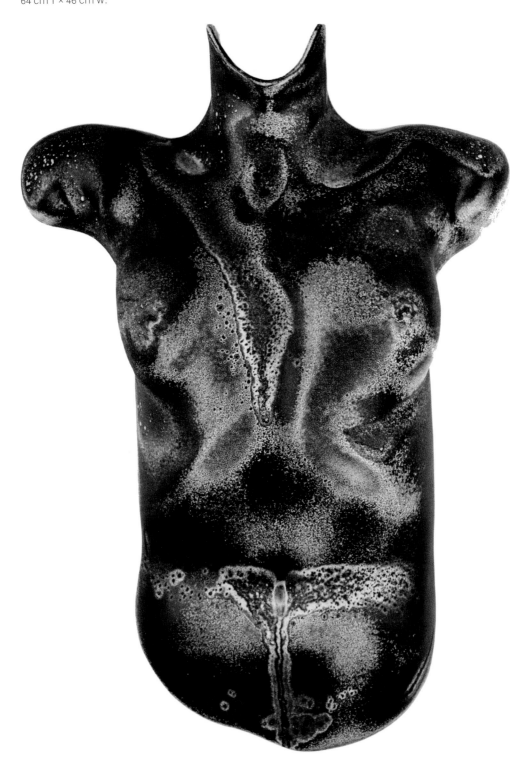

FINDING MY CREATIVE LIFESTYLE WHEN LIFE TAKES A SHARP TURN

CHAPTER 2

"There are pivotal moments in our lives when we have the opportunity to take a big step forward in our personal and artistic growth."

Heather and I moved to Vancouver on May 1, 1986, the day before Expo 86 opened. It was the beginning of a new chapter in our lives and we were excited by it. Heather planned to take some time off from social work to explore other possible careers, and I was happy to get out of Chilliwack. We never envisioned staying permanently in Vancouver because we wanted to move back to Vancouver Island eventually, but the city was a fun place to be at this point in our lives.

Creating the work for *Vault of Dreams* had opened my mind to the possibility of expanding my work beyond production pottery. At this point I still didn't consider myself an "artist," but I was excited by the thought of making one-off pieces. The work Miles and I had shown at Out of Hand Gallery had been well received and I was full of creative dreams.

But there was still the never-ending problem of paying the rent. How could I develop what I had come to refer to as my "decorative work" and still have the time to produce my tableware? The two kinds of work were very different, and I knew I couldn't create both at the same time. However, I work very well with self-made rules, so I made a new rule for myself to divide the month up. Tableware was paying the bills, so I devoted three weeks of the month to that, and the remaining week was my time to explore new creative possibilities.

THE TIME TO CREATE, BUT NOW WHAT?

Down to my basement studio I would go, and then I would sit. What to do? Is it lunchtime yet? The days went by and not much was being created other than an increasing feeling of dread. At the end of the day I went upstairs with a grey cloud over my head and a strong desire to drink lots of beer. Heather supported my latest artistic endeavour, but so far her words of encouragement

hadn't changed the outcome of my days in the studio. One night as I bleated about my plight, she started to ask questions, trying to find a way to help me out of my dark rut. She felt the work was in me but I didn't know how to get started. After much probing, she said, "I want you to go through all your *Ceramics Monthly* magazines and mark the images that you find inspiring, then leave them in a pile for me."

Heather was a night owl; I am not. I didn't know what she had in mind, but I spent that evening going through the magazines and then crawled off to bed. When I got up in the morning, she said, "I've made an inspiration wall for you in your studio. When you are working and you don't know what to do, look at the images on the wall and hopefully they will inspire you. If you still don't know what to do, copy one of the pieces and see where that takes you." I ran down to my studio, and there behind my wheel was a large piece of white cardboard with the images I had picked out pasted on it. I was very touched by this. Once again she was helping me find my way. Although she was always very encouraging of me and my work, I look back on this as one of the most thoughtful things she did for me.

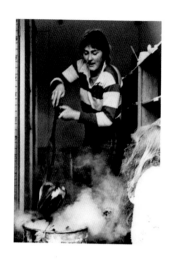

Demonstrating raku at the James Bay Community Centre, 1982.

OPPOSITE
Happily creating with my inspiration wall behind me, 1996.

And it worked! Even though it made me uncomfortable, at first I did as she suggested and copied the pots that I liked. But it was only a matter of weeks before I became unjammed and started coming up with creative ideas of my own.

As soon as I had some decent pieces fired, I was off to Granville Island to see if the galleries there would exhibit my new decorative work. Circle Craft, Gallery of BC Ceramics and Crafthouse were the first galleries to do so, and I realized that I could devote more time to decorative wares. My functional work was starting to take a back seat; a new love was taking over.

——

TECHNICAL EXPLORATIONS

Like many potters, I was drawn to raku firing. I had been introduced to it in grade ten by Waine Ryzak and loved its immediacy and the glaze effects that I could achieve. The other advantage of raku was that my lack of glaze knowledge didn't matter too much. I tried the raku glazes that were popular at the time, but I didn't want the colourful oil-slick glazes that most potters were using. To me they were eye-catching at first but lacked depth and substance.

I soon left them behind and started working with silver nitrate to make a gold crackle glaze, which I liked because I could play around with the amount of reduction and get some lovely marble-like effects. Still, it was a bit of a polished look, and increasingly I wanted my work to have an ancient up-from-the-Adriatic-to-you feeling, so I started to experiment with odd chemical mixtures. I would take one hundred grams (3.5 oz) of one mineral, add 5 per cent of copper carbonate and fire it to see what would happen. I look back on this as the period when my fear of experimenting began to evaporate and my interest in developing glazes and

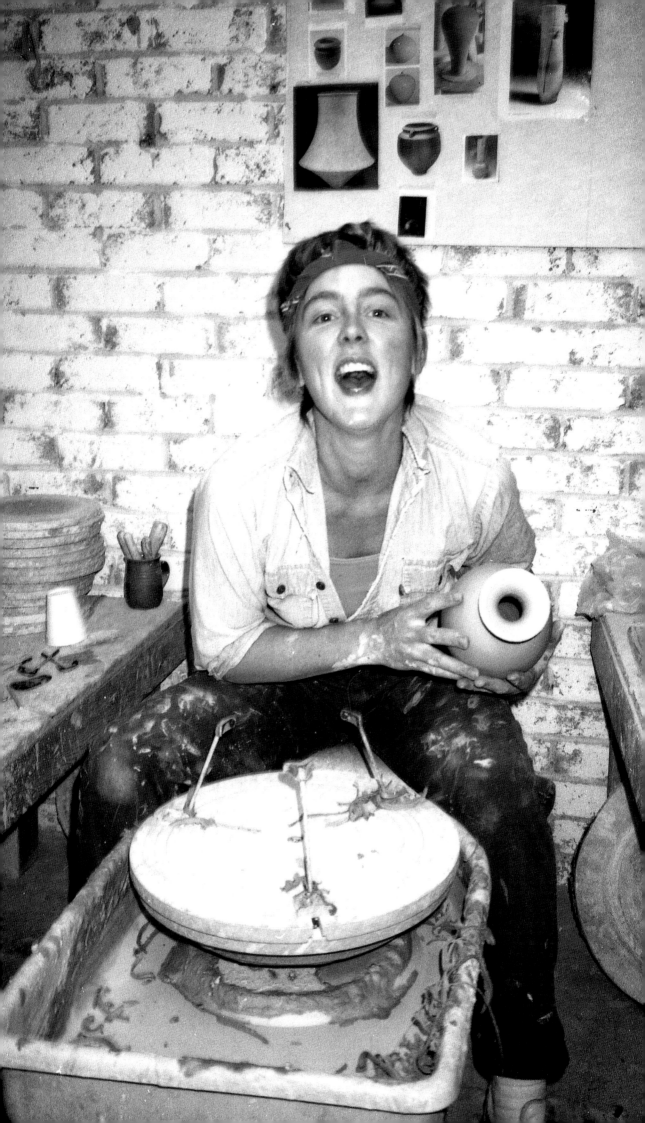

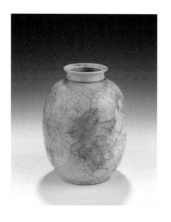

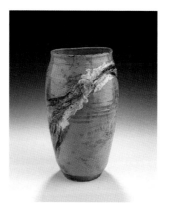

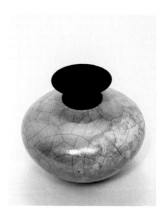

Vase, 1981.
Raku, 19 cm T.

Vessel, 1983.
Raku, 29 cm T.

Vase, 1987.
Gold crackle glaze, raku.

surface effects started to win out, allowing me to blossom. It was also when I began my lifelong affair with the mineral lithium carbonate. At first I wasn't getting great results with lithium glazes, but I saw clues in the pieces I had done that were telling me something promising was happening. Heather was a bit taken aback by the number of my pieces that were going into the garbage cans and questioned why I kept on with this new glaze combo of mine. All I could do was point to the small areas on some of the pots where I saw an effect with potential and say, "I know what you're saying, but I really do think I'm onto something here!" This was an exciting time for me, and I felt I was growing creatively by leaps and bounds.

My functional work, on the other hand, was stagnating, and I was losing interest in my original dream of being a production potter. I asked myself why the passion I felt for decorative work was not spilling over to my tableware. Today the answer is obvious to me. Since I didn't need to worry about the functionality of the glazes on the decorative works, I could unleash my creativity, whereas with tableware I needed to be concerned with how the glazes would hold up over time. Would they craze? Were they stable? Why did some show knife marks? To gain more understanding of the glazes, I read technical books over and over again, but for some reason it wasn't gelling for me. On top of that, I was still doing brushwork on everything, and I didn't like what I was producing. Although I felt no pride in the functional pots I churned out, I continued making them simply to pay the bills. In my heart I knew something was wrong, but I didn't know what to do about it.

———

CREATIVE TRAINING AND NEW POSSIBILITIES

There are pivotal moments in our lives when we have the opportunity to take a big step forward in our personal and artistic growth.

Bottle Vase, 1987.
Lithium compound, raku.
27 cm T.

This piece is one of the earliest examples of what would become my favourite way to finish the edges on my forms. The edge was torn while throwing, and beach sand was rubbed into the clay in the leather hard stage.
Vessel, 1988.
Lithium compound, raku,
18 cm T × 15 cm W.

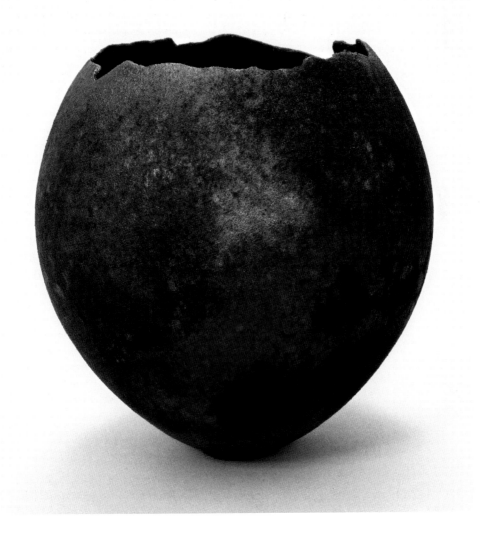

The Banff Centre was one of those times for me. I had always wondered how my life might have been different if I had taken the art school road instead of teaching myself. I envied the potters who had studied because they seemed more like real artists. I had never studied art history. In fact, I never really studied anything about art except when I was young and just starting out, and even then all I did was go to the library and pore over the pictures in art books. It was rare for me to read about any of the work, with the exception of a few ceramic artists, notably Hans Coper and Lucie Rie, whose work inspired and influenced me.

However, for years I had been hearing about the fine arts school at Banff. I knew many people who had gone there and returned with glowing reports of their experiences, but I was scared by the thought of going. I didn't think I measured up to the students who went to such places; besides, I had rent to pay and no savings. Although I was attracted to the idea of going, I talked myself out of it.

Heather recognized the fear that was taking root in me and kept bringing up the subject. In fact, she wouldn't let it drop! She suggested that I apply for the Banff summer program, which ran for six or twelve weeks, an easier length of time to handle than a full year. With her encouragement, in 1987 I applied for the summer program but was not accepted. This, of course, confirmed my belief that I wasn't cut out for art school. They had turned me down, I thought, because I was a craftsperson, not an artist. Art school was for artists, and I was a potter. With a mixture of disappointment and relief, I put it out of my mind. Heather saw it differently, however, and worked on me to apply again the following year. She argued that it was the way I had filled out the application that was the problem, not my work. Slowly she convinced me to try again, and with her help I submitted an application in 1988.

I got turned down again! This time I was mad. I had put a lot of thought into my application and felt they were biased against someone with no formal training. "Oh well, who needs art school anyway," I told myself. "I'm doing okay forging my own path. Enough of Banff!" Then not long before the summer program was to start, I got a call. Someone had cancelled, and they had a spot to fill. Did I want to come for twelve weeks? Whoa, curveball! I certainly hadn't anticipated this possibility. I hadn't planned for a summer away and I still had no savings. Heather suggested I ask them for help, which was not something I was used to doing or liked the prospect of. But the more I thought about the program, the more I wanted to go, so I compromised. I asked the school about the possibility of attending for just six weeks and applied for a scholarship. They granted the scholarship, and my dad offered to help by paying the rent for me while I was away.

All of a sudden there was nothing to keep me from going. So off I went in my Ford F-150 loaded up with clay, feeling both nervous and excited. On the long drive to Banff, I gave a lot of thought

Beaming away in my participant ID photo. I was so happy to finally be there!

to what I would work on in those precious six weeks, and I came up with a rule for myself: I was not to do anything I had done before. This time was to be about exploring new forms and ways of creating that I hadn't previously attempted.

What an opportunity Banff was for me! For the first time in my life I could focus solely on my work without the distractions of daily life. My meals were supplied, I had a room to crash in and I could work in the studio for as long as I wanted every day. I wasn't about to waste a moment of this opportunity, so I got down to work straightaway. I had long been interested in trying to create pottery vessels that evoked the classical period. Amphora, krater and chalice forms were at the top of my list. The first challenge was to come up with workable designs. I wanted them to rise from their bases with an upward flow, so I decided to make the bases and forms separately and then attach them.

I found doing the pieces in two sections quite a challenge. How could I get the stem just the right size to suit the form I was attaching it to? My answer was to make three bases for each piece. When the work was leather hard, I would see which base worked the best. I soon figured out the scale that was needed and I was off and running. I was happy with my first attempts, especially the amphora and krater forms, but I was less satisfied with the chalices. They were beautiful, but I thought they were too derivative of forms from the past. (This is rather funny when I think of it now, since it's not as if the amphora or krater pieces weren't derivative.) I was envisioning the chalice form rising from a small base with a feeling of movement and energy pushing up and out from within.

The artist whose work kept popping into my mind was my early inspiration, Hans Coper. I didn't want to copy his work, but it did influence my image of what I wanted to achieve. As luck would have it, our visiting guest artist that week was Victor Margie from Harrow College in England. I approached him after his lecture and asked if he could come to my studio to see my work and have a talk. He was perfect! He spent almost two hours with me. We chatted about the life of an artist, the challenge of finding your own style and my latest issue: how to proceed with the chalice form. He understood my dilemma and gave me advice that was very similar to Heather's: Don't worry too much about the work being derivative. Follow your heart and see where it guides you. And so I did.

SAGGAR FIRED WORK

Unearthed antiquities—this was the look I wanted for the work I had been creating at Banff. To me these pieces should be like archaeological treasures. I wanted them to be surrounded by an air of mystery. Were they metal, stone, clay? What was their story? As I looked at the forms, I realized that glazing them might take the aura of mystery away. That is when the idea of saggar firing came to mind.

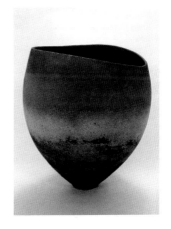

My first *Altered Vessel* created at Banff, saggar fired. I still marvel at the incredible flow this piece has. I remember taking it out of the saggar and gasping as I realized that I was finally starting to get the ancient look I was aiming for. I also remember the day I sold it, which is rare given how many pots I've sold over the years. I didn't want to part with it and wish I had kept it for my collection.

OPPOSITE
Tribute, 1988. Saggar fired,
51 cm T. Created at Banff and
exhibited in 2012 in *Back to
the Land* at the Art Gallery of
Greater Victoria.

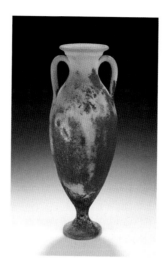

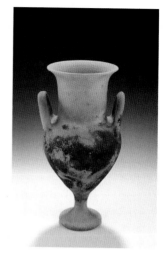

BELOW
My first chalices created at
Banff after chatting with
Victor Margie, saggar fired.

Amphora, 1988.
Saggar fired, 40 cm T.

Krater, 1988.
Saggar fired, 27 cm T.

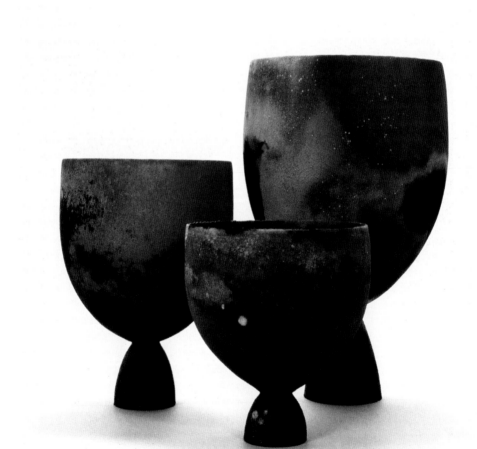

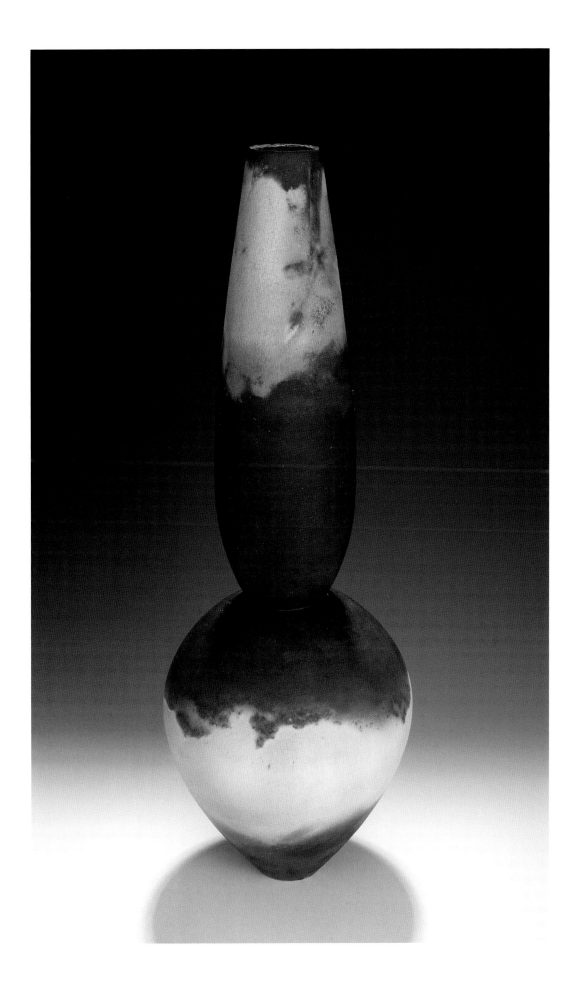

Me feeling very happy with a
saggar firing at the Banff Centre.

A saggar is a container for pots that is traditionally used in wood fired kilns to protect the pots from flying ash. But I wanted to use saggars for the opposite purpose. I dusted the vessel I had made with copper carbonate and placed it in a saggar I made out of a groggy clay body. Then I piled combustible materials into the saggar—sawdust, kitchen waste, pretty much anything I could get my hands on that would burn. I also soaked coffee grounds in salt and sprinkled them throughout. Then I sealed the saggar and slowly fired it to cone 08 in a reduction atmosphere.

Banff was my first experience firing in a gas kiln, and I really didn't know what I was doing. However, the results from my first firings were pretty good, so I forged on with my experiments. This was fun! I felt like a whole new playground was opening up to me, and I was keen to explore further. I fired everything I created at Banff this way. When my six weeks were up, I surveyed all that I had created and realized I had the makings of a show. I was on the verge of developing my own style, and the feedback I was receiving on this new body of work was very positive and encouraging.

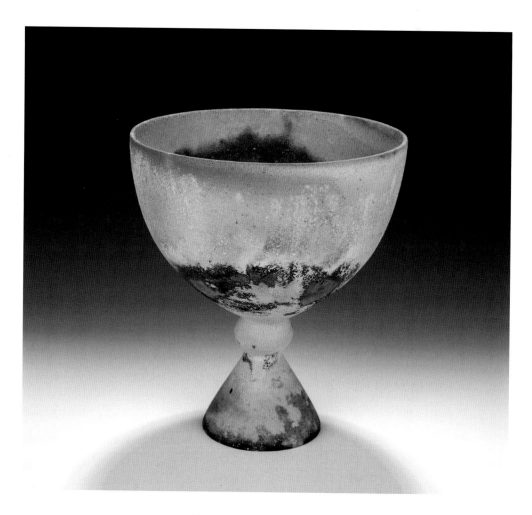

Chalice, 1988.
Saggar fired, 22 cm T × 19 cm W.

On my return home I bought a used gas kiln so I could carry on with saggar work, while at the same time continuing explorations with my lithium compound glaze. It was a busy time for me, and I was blossoming into my work like never before. I had three shows that year. My favourite was a body of work exhibited at Crafthouse Gallery on Granville Island, where I introduced my first successful lithium work.

Then, to my delight, I was asked by the shop at the Art Gallery of Greater Victoria to be part of a group show booked for the fall of 1989. This was huge for me. The first place that had supported me was now going to show me! I felt I had arrived. My artwork was being taken seriously and the invitations to exhibit were coming in. I was over the moon! I don't like to be behind the time gun, so when I am working toward a show, I get right to it and usually have the work created well in advance. In this case, it was a good thing I did, as my life suddenly veered off course in a way I never could have predicted.

—
A CURVEBALL

It was July 1989 and Heather and I were off to the Vancouver Folk Festival for the weekend with our friends Wendy and Fraser. Heather wasn't feeling very well, so I carried our stuff and, along with Wendy, started the "blanket run" to the main stage to secure our spot on the field. As I was running, my legs started to give out on me. Wendy was ahead of me, and when I caught up to her at the main stage, my lungs were burning, I could barely breathe and my legs felt like jelly. I collapsed on the blanket and looked up at Wendy, asking if her lungs burned after the run. She looked a bit puzzled and said no. When Heather arrived, I told her what had happened and how I was feeling, and she said she wasn't feeling well either. Although I had always had a strong and healthy body, Heather wasn't as hardy and often came down with whatever bug was making the rounds.

We stuck out the first day at the festival, but when we awoke the following morning, we were both far too ill to go anywhere. We thought we had the worst flu ever. Heather couldn't walk. I could, though just barely. For the next six weeks we were completely flat on our backs and housebound. Because I couldn't walk more than a couple of metres, I had to ask friends to do our grocery shopping.

Eventually our symptoms improved a little, and we thought we were on the mend. Heather, who had a temporary job at BC Tel at that time, was very anxious about how long she had been away and wanted to try going back to work. This made me nervous, since I really didn't think she was up to it, but she was determined and headed off in the car. About twenty minutes later I got a frantic phone call. She had made it only a few blocks and needed to be picked up. She said she had forgotten how to drive. I was shocked. What did she mean, she had forgotten how to drive? How could this be? She was beside herself and said she had just barely managed to pull over. She never left the house unattended again.

Heather and me ready to head out to an event at the Vancouver Art Gallery called Art after Dark. The invitation said to "dress to excess," so we had a bit of fun with it. More than a couple of people did a double take when they saw me dressed like this! For years I referred to the event as my night of going out in drag.

Our doctor was taken aback by what was happening to us and sent us off to St. Paul's Hospital for what would be the first of many tests. The internist overseeing our case was puzzled that we had become sick at the same time and thought that perhaps something in the house was causing the problem. Our water was tested and found to be fine. Then we were advised to move out of the house for at least two weeks to rule out an environmental problem. My dad was going to Hawaii with his partner, Joy, for a few weeks, so with help we moved to his house on Vancouver Island. Unfortunately the move did not make any difference. After more than six months of tests, we were diagnosed with myalgic encephalomyelitis (ME), an autoimmune disease.

I was very ill and barely able to walk. Work was completely out of the question. Even nipping out to the grocery store became a thing of the past. Normally Miss Independent, I needed help with even the simplest of tasks. Each morning Heather and I dragged ourselves from bed to the living room, where we spent the day lying on the floor on a foamy watching TV; then we dragged

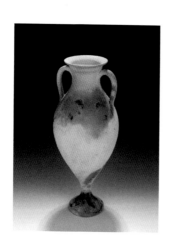

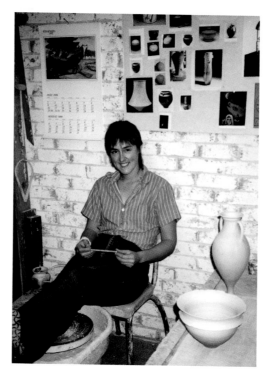

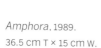
Amphora, 1989.
36.5 cm T × 15 cm W.

This picture always leaves me feeling sad because it was taken days before I got ill. The amphora sitting beside me on the bench was saggar fired (photo at left) and is now in my collection.

ourselves back to bed at night. One day bled into the next, each one the same. My body was like a lead weight. I could barely think and I was becoming depressed. How could this be happening? Why was there nothing to help us feel better? What if I never worked again? Who was I without my work? Did I even want to live if this was what life was going to look like?

I needed to hold on to some hope: our doctor told us that some people with ME start to improve around the two-year mark and if that happened, it was a good sign. We would likely never be the same again, but we might improve from where we were. I reminded myself of this daily, praying that this would be the case. But my strong body was disappearing; the muscular arms I was so proud of, built up through my years of potting, were now flabby. I couldn't listen to music anymore because it was so deeply connected to my work. My studio had always been filled with music. In fact, I never worked without it. Now it was a painful reminder of the life that was slipping away from me.

But as bad as things were for me, they were much worse for Heather. ME varies in severity. I could manage being on my legs for short periods of time, but Heather could barely stand; if I

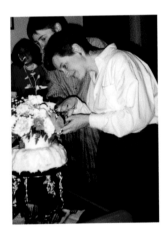

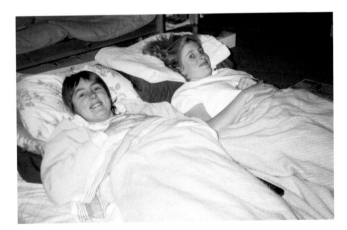

Cutting wedding cake after our commitment ceremony, 1987.

After we got ill, Heather and I spent much of our time lying on the living room floor, so my sister Angelika decided to join me there during a visit, 1991.

couldn't help her to the bathroom, she had to crawl there. On top of that, she had developed photophobia (sensitivity to light). She wore sunglasses all the time and needed blankets over all the windows to keep the light out. She also had become sensitive to scents and began to complain of increasing pain in her body. Things were not good.

ADJUSTING TO LIFE WITH A DISABILITY

Our friends were shocked by what was happening to us, and our friend Louise Allen organized a meeting to develop a plan for our care. Friends were assigned a day of the week on which they would turn up and do whatever errands were needed. I don't know what we would have done without them. I found it hard to ask for and accept more help but realized it was needed since things weren't improving. If anything, they were getting worse.

After about a year of this routine, Louise suggested applying for home support. I was horrified! I was only thirty years old. It was bad enough having to ask friends and family for so much help, but home support? No way! I didn't want strangers coming into our home! Then my dad and his partner suggested that I might improve if I weren't caring for Heather so much and asked if I had considered putting her into a care facility. That shocked me. I understood where they were coming from, but Heather was my wife. We had held a commitment ceremony two years before becoming ill, and I wasn't about to let her be taken from our home. I swallowed what was left of my pride and agreed to have home support.

Another year went by with no improvement, and we both applied for Canada Disability Pensions, which we received. The next hurdle was our housing situation. We were renting in Vancouver and could no longer afford to stay where we were. I had a heart-to-heart with Heather and told her the only option I could see for us was to scrape together as much money as we could to buy a small house on Vancouver Island. She was panic-stricken by this, since it meant leaving our support circle behind, but after she realized this was what we needed to do, we called a meeting.

Heather's parents and my dad and his partner, Joy, came over from Vancouver Island to join our support circle for this meeting. We decided to sell everything we could, cash in all savings and put the money toward a house. Dad, Joy and Heather's parents would be our house hunters. I had been looking at house prices on the Island and knew it would be a challenge to find a home in our price range, but I drew a circle on the map from Cobble Hill to Nanaimo and put a star by the little town of Ladysmith. Interestingly, though I had grown up on the Island and Heather and I had travelled up and down it many times, neither of us had ever ventured into Ladysmith. I only put a star beside it because house prices were a little bit lower there.

And so the search began. After a few weeks our parents suggested that it might be impossible to find a cheap enough house and that

we should consider a condominium. I was dismayed by this and told them I didn't think I could carry on if I didn't have a home with at least the possibility of a future studio. I had accepted that I was disabled and unable to work, but I needed to hang on to the hope of an eventual return to my craft. When they realized how important this was for my survival, they doubled down on the search.

A few weeks later I got a call from my dad. They had found a small two-bedroom home on a half-lot in Ladysmith with an unfinished garage that could become a studio. Did I want to put a down payment on it? I didn't hesitate. With just a verbal description of the house over the phone, I said yes right away. I didn't know it at the time, but my dad had not wanted to take a chance on losing the house and had already made an offer and put a deposit on it.

Then came the challenge of the big move. Again our friends came to the rescue and packed up our home. It was very upsetting for them to go into my studio and find it just the way I had left it on that final working day before we became ill. Two years had gone by and I had not set foot in it. They said it felt as if I had died, and in a way a part of me had. My life would never be the same again.

Our little miner's cabin, 1991.

LADYSMITH MINER'S CABINS

The home Heather and I bought on Third Avenue in Ladysmith was one of the town's original miner's cabins. At the end of the nineteenth century, mining magnate James Dunsmuir had built shipping wharves at Oyster Harbour (now Ladysmith Harbour) to load coal from his Extension mine. A small settlement soon grew up adjacent to the wharves, but as the output from the Extension mine grew, Dunsmuir ordered that the miner's houses at his declining Wellington colliery to the north be taken apart, transported to Oyster Harbour and reassembled there as homes for his workers. He offered building lots free to two hundred miners who agreed to erect one of these homes.

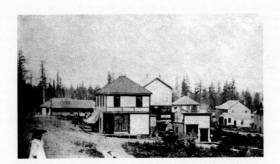

The settlement was renamed Ladysmith in 1900 and incorporated as a city in 1904.

During the rebuild of our house that I began in 2008, we found newspapers announcing the end of the First World War under a layer of flooring.

Ladysmith miner's cabins, date unknown.

BEGINNNING AGAIN,
TOGETHER
AND ALONE

"From this point on I resolved to produce
only work that I felt deeply connected to."

Moving to Ladysmith was one of my biggest leaps of faith. Before
becoming ill, Heather and I had talked about looking for a house
on Vancouver Island or one of the Gulf Islands, someplace rural
where I could build a pottery and Heather might run a bed and
breakfast. I had envisioned our excitement as we looked for our
first home together. Never in my wildest dreams did I think we
would be buying a house sight unseen over the phone.

Somehow word of our move to Ladysmith spread. When we arrived
in the spring of 1991, the people of the little town welcomed us with
open arms, and we soon had several offers of help. We couldn't
be involved in any of the town activities, but it turned out to be
the perfect place for us and quickly came to feel like home.

Although life was very different for us here, we had a sense of
security. We owned our own home, and the mortgage payments
were low. Louise had lined up a meeting with the local health
authority, and we were provided with home support right away.
We were poor, very poor, and often had to ask for financial help,
but we were happy. I know this must sound strange given what
we were dealing with, but Heather and I were a love story. Being
together twenty-four hours a day would be too much for some
people, but we were fine with it.

Three more years went by. Heather's health didn't improve, but
I was slowly getting stronger. I still couldn't walk around the block,
but I could garden for short periods, come back into the house,
rest and go back out to the garden. Slowly the amount of time I
could be on my feet grew, and I began to think that I might be able
to work a bit.

That spring I had a visit from a dear friend, Lorraine Brownrigg, whom I hadn't seen for a long time. She had married in the years since I became ill and now she had come to introduce me to her first child. In the course of our conversation she brought up the question of my working again. I admitted I was thinking about it, though the idea still felt overwhelming. The space for a studio was there, but it was just an empty, completely uninsulated garage—the cold shell of a building attached to the side of the house. When I showed it to Lorraine, she said, "Oh, we can do something with this! I married a fireman and he loves building projects. I think he would be willing to help you turn this space into a studio."

When we sold off everything in Vancouver, I had set aside the money from the sale of my gas kiln to put toward building a studio in case I could work again one day. It was not much, but it was a start. So when Lorraine headed home, I felt a part of me that had been dormant slowly waking up. I was excited.

A few days later I got a call from Lorraine's husband, Steve Sharples, asking if he could drive up from Victoria that weekend to take a look at things. And could he stay with us, and did we watch *Star Trek: Deep Space Nine*? It was such a funny moment that I liked him instantly. And as it happened, we did watch *Deep Space Nine*, so up he came.

After that, Steve came up every weekend that he was free to work on the studio, bringing materials that were scavenged or donated. Then Mark, the husband of my childhood friend Joanna Finch, came down from Cumberland one weekend and built my workbenches. Someone in town donated the windows and front door, and before I knew it, my new studio was ready to go. Once again the kindness of friends was touching me and helping me along.

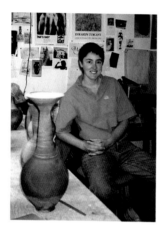

My new Ladysmith studio, the wall peppered with images from my last studio. With some old and new works on my workbench, I begin again, 1994.

Slowly I started to unpack the boxes from my old studio that my friends had packed up three years earlier when we moved to Ladysmith. It was an emotional task. I came across boxes full of bisqued pots that I had made just before getting ill, pots I had completely forgotten about. I put them on my shelves and just stared at them, hardly believing that five years had gone by since I last worked. It was as if these pots were from a different life.

I have always pinned up interesting and inspiring posters, cards, cartoons, invites and messages on my studio walls, and in one of the boxes I found the ones that had been up when I became ill. As I pinned these onto my new studio wall, I felt a warmth coming over me that I hadn't felt in years. I was going to do this! I would start out with very small chunks of time and build up gradually.

Because I am an introvert, having different people come into our home to help with Heather's care was a challenge for me. But her need for hands-on care was increasing, and I knew I was going to need more help if I was going to return to my work. I asked the

MY FIRST LADYSMITH STUDIO

My first Ladysmith studio was the nicest space I had ever worked in, and I loved it! Its Dutch doors opened onto the street, and on a warm day I could swing the top door open for a fresh breeze through the studio and have a view of the goings-on outside.

Kids often peered in to see what I was up to and hang their arms over the fence to pat my dog, Judy. But they weren't the only ones who wanted to hang out there; animals also gravitated to the small courtyard out front where the afternoon sun warmed the bricks. For years a garter snake spent much of his time in a pot of hens and chicks by the front door. Snake, as I called him, would scratch his underbelly on the tips of the succulents and, when he got hot, would burrow down under them. Most days Judy would go up to him for a sniff, and Snake would look back at her, flicking his tongue. They were obviously quite comfortable with each other, and I loved observing their greetings. Sometimes I would find Snake and Judy in the side garden, Judy sleeping right beside a round patch of grass that Snake had gradually worn down into a sleeping nest.

Birds also came to visit, and I wondered if they were drawn to the strains of classical music I played or just to the overall vibe that emanated from the studio. Whatever it was, I delighted in their visits. In the summer a little chickadee used to sit on the fence post, looking in at me. One day to my great surprise she flew right into the studio and perched on the rim of a vase that was on top of the kiln near the front door. She watched me working for quite a while before flying back outside. That was a first!

On one of those beautiful, still summer days, the front door of the studio was open, my music filled the air and I was happily working on my wheel when two cars pulled up and disgorged a gaggle of children, all heading toward the studio door. Ahead of the others was one little girl who came running in at top speed, went straight to the display shelves and grabbed a small bowl.

Holding it high above her head so everyone outside could see, she yelled, "Look Mommy, it's just like the bowl we all fight over!" Oh, how I laughed at both the girl's enthusiasm and the look of horror on her mother's face as she watched her daughter waving the bowl in the air, its future uncertain in those excited little hands.

Many sweet memories were made in that studio over the years.

Enjoying my afternoon tea at the pottery. The sill on the Dutch door was the perfect height for me to enjoy some sun before going back to work.

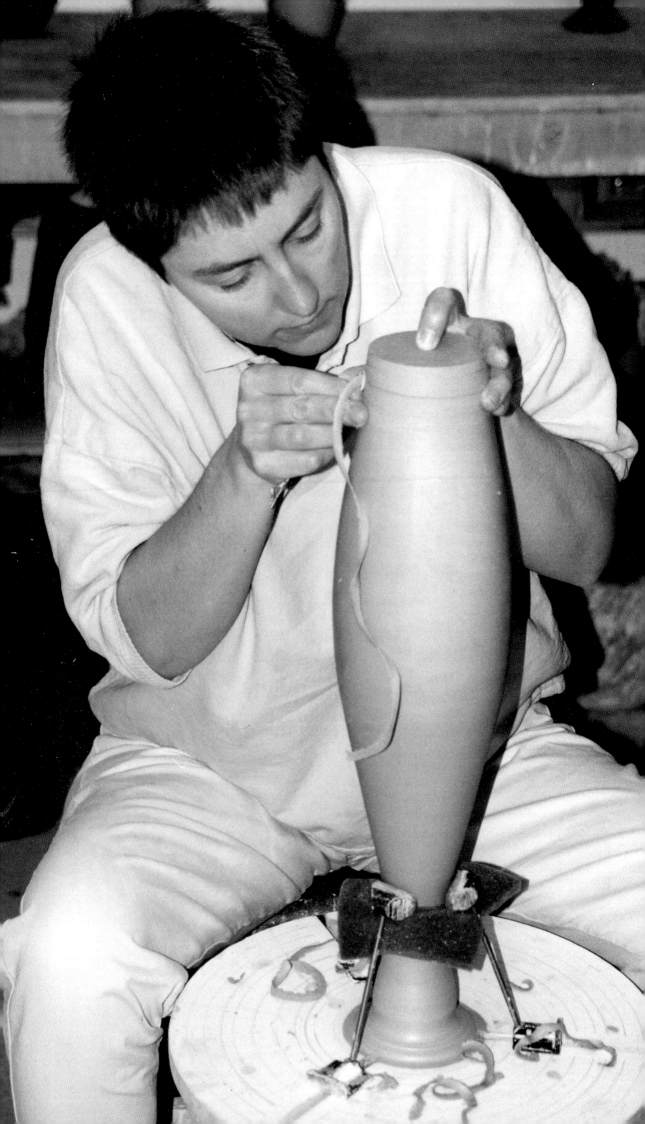

These pots are glazed with
the functional ware glazes
I developed when I resumed
working in 1995.

Jugs, 2012.
Midnight blue glaze, cone 6
oxidation.

Tea Pot, 2012.
Chrome green glaze, cone 6
oxidation.

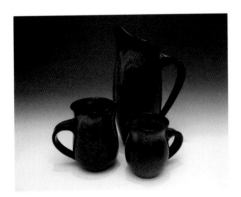
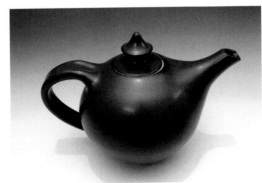

Home Support office to come for another home assessment
visit. They agreed to provide home support Tuesday to Saturday
afternoons from one until five so I could spend time in the studio.
Those four hours, five days a week, became precious to me, as
they were my only break from caregiving.

CREATING AGAIN

Although I had been working at my craft for sixteen years when
I became ill and had to stop, at that point I was still growing into
myself as an artist, unsure about my style and looking outside
myself for inspiration. When I started to work again, it was as if
there had been no break in my creative path. I hadn't been think-
ing about my work for all those years—that would have been too
depressing—and yet, it was as if no time had gone by. Creatively,
I picked up where I had left off, and I still find this amazing. It
was as if I had been walking along a forest path, sat down for a
moment's rest, then got up and continued on my way.

But the experiences of the last five years had changed me. My
approach to my life and work was fundamentally different, though
in a good way. From this point on I resolved to produce only work
that I felt deeply connected to. That meant that my approach to
functional work needed to shift. I had continued doing brush-
work on my functional work until I stopped working in '89. Now
I decided to drop the brushwork and go back to what I had liked
as a young potter—solid colours that accentuated the form of
the piece. I would no longer compromise my work over concerns
about how well it would sell. Being able to return to my craft was
a huge gift, and I wasn't going to squander one moment of it.
Immediately my energy began to change and creating functional
ware became a joy again.

OPPOSITE
Trimming a piece with a torn
edge is a bit of a challenge. Here
I've thrown a small chuck, held
in place by my Giffin Grip, to
hold and protect the delicate
edge of a tall bottle vase. These
days I keep a variety of chucks
on hand that I've thrown for
this purpose.

This was an amazingly creative chapter in my life. Although I was still very limited physically, I let go of searching outside of myself or looking to other people's work for inspiration. Instead, the very act of creating inspired me. There was no end to the creative paths I wanted to explore.

The galleries were happy to hear that I was back on the scene, and I soon started to work on shows. My first show was *Classic Vessels and Adornments* with Marianne Brown in 1996 at Circle Craft Gallery on Granville Island. In this show I introduced my first chalices mounted in black bases, my raised treasure jars with thrown bases and the first of my vases thrown in sections.

No sooner was this show over than I started work on what I still think was one of the best solo shows of my career, *Fine Form*, at the Gallery of BC Ceramics in 1997. This was a special time. I was developing new crawl glazes that I was excited about, and throwing my vases in sections had opened up a new world of creativity for me. Heather was doing a little better, as well, and wanted to create a video of me making my two-section vases to include in the *Fine Form* show. I was nervous about her doing this, as any

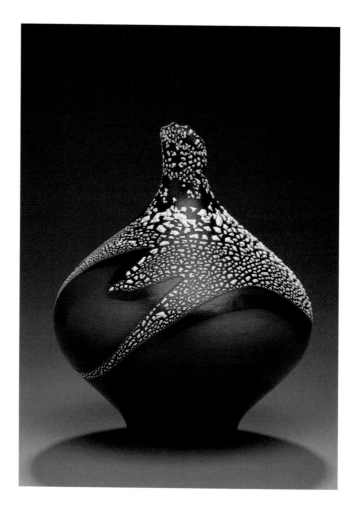

I began developing my crawl glaze work in the mid-1990s and am still learning about all the amazing effects you can attain with them. They remain a favourite way to glaze my work. *Bottle Vase*, 2006. Blue terra sigillata, white crawl glaze, cone 06 oxidation. 21 cm T × 16 W.

exertion on her part made her sicker, but I also loved the idea of her filming how I work. We borrowed a camera, Heather shot the video and it became part of the show. The video is precious to me now, as it's the only one Heather did. Her period of feeling a little stronger was short-lived, and her health continued to decline after that.

STRUGGLING FOR BALANCE AND HOME CARE

The following years were good years for me creatively. I exhibited regularly, both nationally and internationally, and my work was getting into publications. Although I was still very limited physically in what I could do, I was happy. I was able to do everything from Ladysmith. I didn't go to any of the openings, but that was okay. My work was going all over the world, and I was content to stay home and create. However, trying to work while ill and also care for Heather was a constant balancing act. Although I hired people to help out with some of the jobs in the studio, I started to sink under the weight of it all. In 2001 I had a very bad spell and ended up in bed for six months, which was sobering. I was ter-

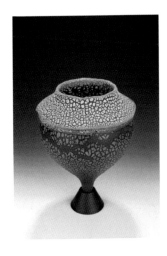

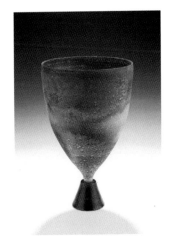

Chalice, circa 2002.
Blue terra sigillata, layered crawl glazes, multifired, cone 06 oxidation, 23 cm T × 18 cm W.

Chalice, 1998.
Lithium compound, raku, 30 cm T × 18.5 cm W.

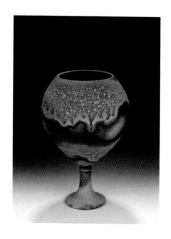

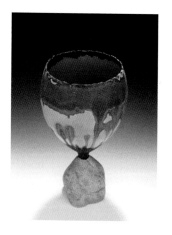

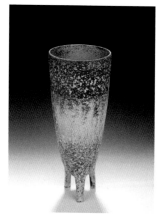

Chalice, 1995.
Lithium compound, raku,
29 cm T × 20 cm W.

Chalice, circa 2005.
Lithium compound, raku,
mounted in rock,
35.5 cm T × 19 cm W.

Tripod Chalice, 2002.
Lithium compound, raku,
34.5 cm T × 13.5 cm W.

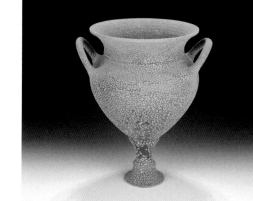

Krater, 1996.
Orange terra sigillata, glazed
with the first crawl glaze
I developed, cone 06 oxidation,
30 cm T × 26 W.

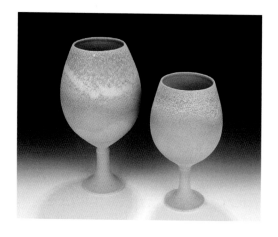

Chalices, 1995.
Lithium compound, first crawl
glaze, multifired, cone 05
oxidation, 34 cm T × 18 cm W,
28 cm T × 15 cm W.

OPPOSITE
Vase, 1997.
Multifired, cone 06 oxidation,
47 cm T × 17 cm W.

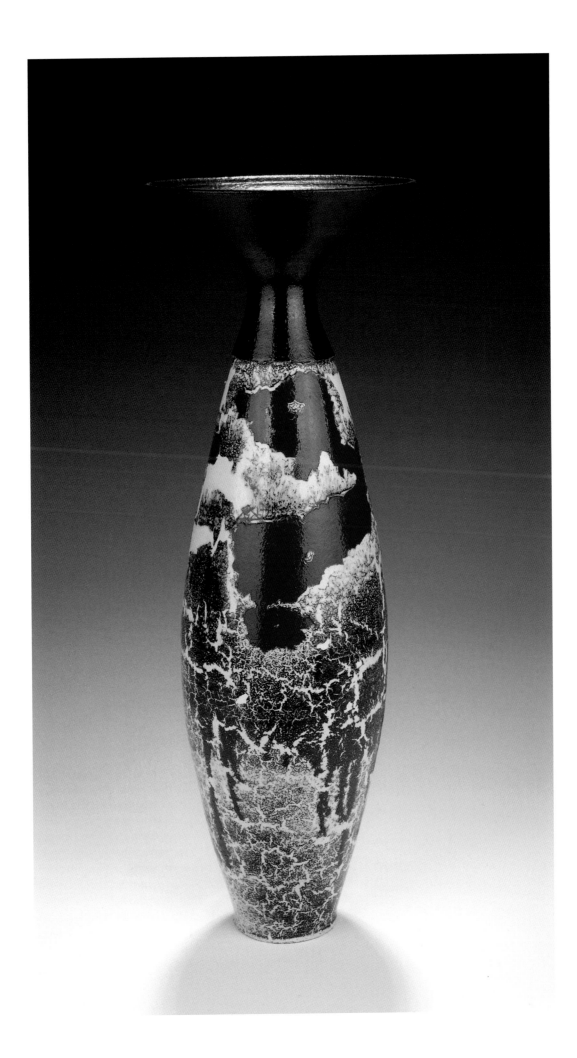

rified that my health would decline again to the point of not being able to work, but I was caught in the vortex of trying to care for Heather while holding on to my creative life.

Heather now needed extensive care. Along with the ME, other autoimmune diseases were jumping on board. She had developed Sjogren's syndrome and Raynaud's disease. She was in constant pain and could have no one around her other than her caregivers. The house was always in darkness since she couldn't tolerate light. Our world, which had already grown quite small, shrank even more. Then I noticed that a bruise on her arm wasn't going away. It had started out as a puffy spot some weeks earlier; though the puffiness was diminishing, there was a strange dent appearing in its place. Off to the doctors we went again.

A biopsy indicated that she had a very rare form of lupus—lupus profundus (panniculitis). This form of lupus necrotizes fat tissue, which is what had happened on Heather's arm. We were devastated. Although the doctors said this condition was rarely life-threatening, I knew in my heart that she was dying. By now getting Heather the appropriate care from the Home Support office had become increasingly difficult. Then I figured out that I stood a better chance of getting it if I stopped focusing on her severe ME and emphasized her lupus instead. It is unfortunate to say, but severe ME was still not viewed as a life-threatening disease, whereas lupus was.

Bursting with excitement after setting up *Beauty of Form Enhanced* at the Gallery of BC Ceramics. What a treat to actually be there.

I continued to work as much as I could. I exhibited only in group shows in the years following *Fine Form*, until I was able to create another solo show, *Beauty of Form Enhanced,* for the Gallery of BC Ceramics in 2005. By that time Heather needed care at night as well as during the day, and I was in dire need of a break. My friend Gail Johnson suggested that I consider going over to Vancouver for the show's opening and offered to drive me. I hadn't left the Island since we moved there in 1991. Fourteen years had gone by! I called my friend Jamie Evrard, who had been part of our first support group, and asked if she was up for a couple of visitors. Jamie was delighted to have us, so I arranged care for Heather, and Gail and I packed up the show and headed for Vancouver. For years afterwards Gail said this trip was like taking Rip Van Winkle out on a weekend pass. Vancouver had changed dramatically since I left, and the years of not going anywhere had affected me greatly. I was like someone who had been in solitary confinement, and in a way I had.

The time away was rejuvenating on many levels. Although everything felt overwhelming, it was wonderful to be out in the world again. My friend Jamie was determined that I start getting some regular respite and suggested that I come over to her place every couple of weeks for a rest and recharge. I loved the idea, but Jamie had no idea how difficult it would be to put that into place from my end. Although Home Support had given us some extra hours so I could go to Vancouver for this opening, I knew they would see it as a one-time exception. If I wanted to do this again, I would have to hire people on my own dime to care for Heather. This was becoming more difficult as Heather's care needs were

increasingly more challenging and stressful, especially for new caregivers. Besides that, there was the additional cost of getting me to Vancouver and back. However, I was desperate for a break from everything, so when Jamie generously offered to fly me over once a month, I decided to accept her help and find a way to make it work.

My life for the next two years became a constant battle with Home Support to get the care Heather needed. I hired people privately for the night shift, but they often quit after a few shifts since the care was so challenging. Eventually I rented a place in town for a caregiver from the Philippines, and she took over most of the evening shifts. Then in May 2007 I finally burned out and put Heather into a care home. Her suffering was so intense by then that she had begged me for months to help her die. I could no longer cope.

I always knew that Heather wouldn't last long if I put her into care, and because of that I had resisted taking this step for as

Heather loved looking at my work and would visit my studio whenever she had the energy. Here she inspects new pieces for my first studio sale in Ladysmith, 1995.

During the brief period when Heather was doing better, she would bring my afternoon tea out to the studio and sometimes linger for a bit. On this day I asked her if she would help me place a slab of clay into a torso mold, and our friend Pat Feindel, who happened to be visiting, took this photo.

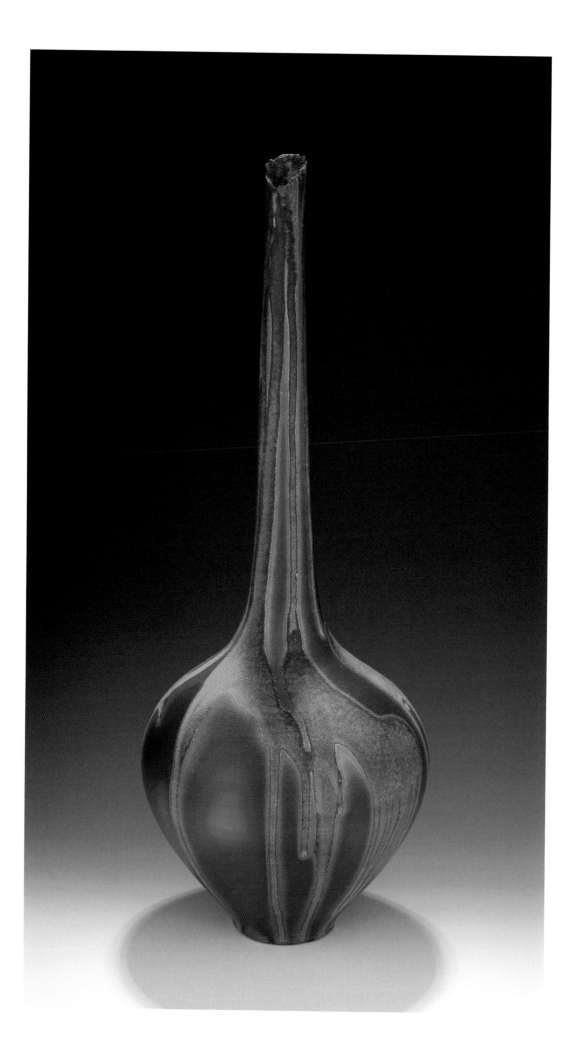

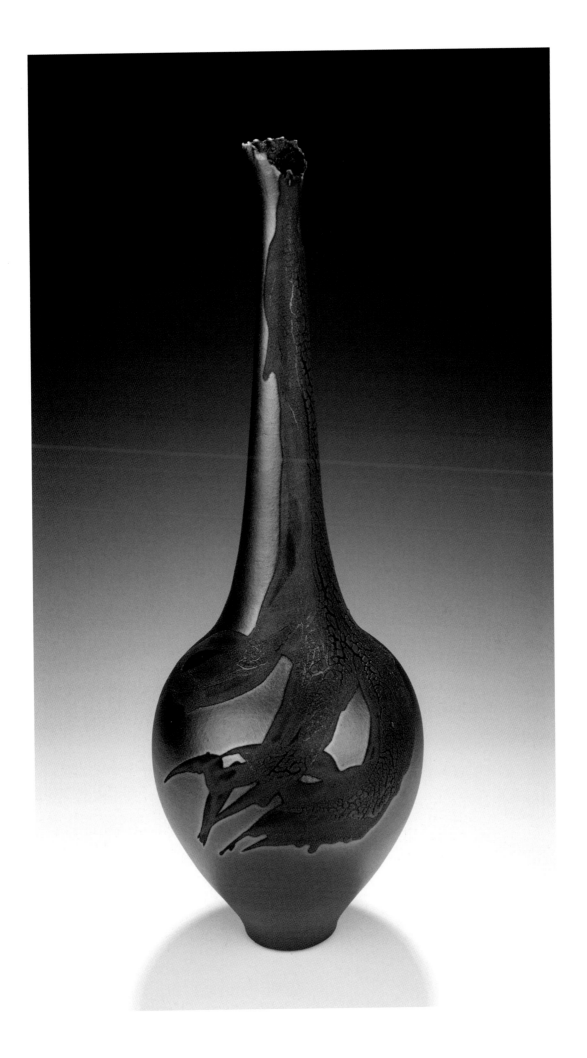

The leather hard sculpture
I took into the care home for
Heather to see.

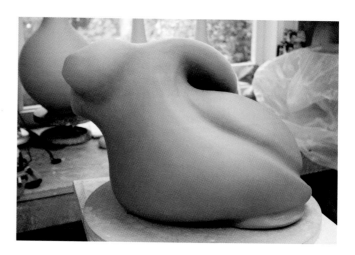

long as I could. Heather died on July 7, 2007, just after her fiftieth
birthday and two months before what would have been our
twenty-fifth anniversary.

RECOVERING FROM LOSS, EMBRACING THE FUTURE

With Heather's passing, my life changed overnight. I was con-
sumed with mixed emotions, bereft but invigorated at the same
time. At last I could let light into the house again, so down came
the blankets covering the windows. I could have people over,
play my music in the house and start to have a more normal life.
I had always loved to give dinner parties, and the first thing I did
in the studio was make a dinner set for the meals I planned to
cook for friends. I had a feeling of freedom that was exhilarating,
and I felt like I was coming back to life. But it was a different life:
my greatest love and supporter was gone, and making pots didn't
feel the same anymore. There was no one to show them to. I
started to venture into the world more, but I soon realized that,
though I was doing far better than I had been, I still wasn't healthy
enough to combine work and much of a social life.

So what would my new life look like?

During the weeks that Heather had been at the care home, my
visits with her had been hard. Most of our time was spent talking
about her care needs, and she wasn't letting up on the topic of
wanting to die either. I wanted her suffering to end, but I came
to realize that I couldn't be the one to bring that about. I had
spent eighteen years looking after her, and I just couldn't have
my last memories of Heather be of me helping her to end her
life. So I would change the subject and talk about our life to-
gether in happier times and share with her what I was doing in
the studio.

During that period I started to sculpt again. Sculpting has always been one of my passions. It is all-consuming for me. It takes me over and everything else fades away, so it was a perfect reprieve from all the stresses of that time. As always, Heather was very interested in what I was up to, but I could see that it was also painful for her to hear about it. Although I was sharing my passion for the new sculptures with her, for the first time in our life together she was unable to see them. At home, after she could no longer go out to the studio to look at the work, I had brought the pieces into the house to show her. If they were freshly thrown, I waited until they were leather hard and, one by one, brought them in to her for a viewing. When pots came out of the kiln, I paraded them in and lined them up in the living room so she could look at them from her electric bed. Then I would go back out to the studio to finish my workday while she spent time with the pots. Later in the evening we would chat about the pieces. This was always a special moment in our day. No matter how hard life was, we always managed to insert a little bit of beauty into it.

I missed that time we shared, so, much to Heather's surprise, during one visit I lugged one of my sculptures into the care home for her to see. I'll never forget that evening. I got her transferred from her bed to an easy chair, then went and found a bed table on wheels to put the sculpture on. She ran her hands over the leather hard piece, exclaiming about its sensuous feel and flowing lines. It was an intimate moment of beauty, a sweet break from the reality of life.

That evening I wanted to get her mind away from all the suffering, so instead of changing the subject when she started talking about her care needs, I suggested we talk about creativity and living the life of an artist for the first part of our visit, and then if she needed, we could talk about whatever else was on her mind. As we chatted, one of the subjects that came up was the difficulty inherent in a young artist's life, and she wondered aloud what would have made life easier for me as a young artist. The main challenge for me had always been finding a place to live where I could also have a studio and a display room for selling my work. We also talked about how limiting my present studio was, especially now that I was starting to sculpt again. Our house was on a half-lot, so there was no room to expand out. That's when the idea came to me of lifting the house to get more space. If I did that, I would be able to add eighty-five square metres, which would provide plenty of room for a studio and gallery. Heather thought this was a fantastic idea. My greatest supporter was leaving me, but before she did, we shared a vision of what my home and studio could become.

Five months later I had my first meeting with the people who would become my rebuilding team, and in August 2008, just over a year after Heather died, my house was raised and the rebuild began. I designed it to be the home/studio/gallery of my dreams. I had never thought of building a house before, and it was more than a little overwhelming, but it was also good to have something to focus on. Along with my house, I was rebuilding my life.

The finished form.
Elemental Connection, 2007.

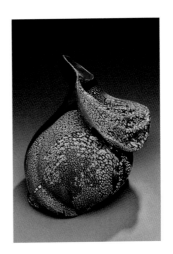

CREATING UNTIL THE END: WALTER DEXTER, 1931–2015

I first met Walter Dexter in the late 1970s but didn't come to know him as a close friend until after his wife, Rona Murray, died in 2003. I was in my studio unloading a kiln full of fresh decorative pieces when I wondered how he was holding up by himself, and I thought, *Why not give him a call?* As we chatted that day I realized that he was in a similar situation to me in some ways. His poor health limited his activities, and he was struggling with depression. By the end of our call I could tell that our chat had cheered him, so I said I would call again soon.

Over the following years I had many chats with Walter. I often called him from the bathtub in the morning, talking till the water was tepid and it was time to get out. He had a hard time dealing with how limited his life had become, and much of what we chatted about was how to continue creating while dealing with a failing body. He would often apologize for going on about his health and being a "downer," and I would reassure him, reminding him that, because of what I was living through with physical limitations as well as being a full-time caregiver, I had a unique understanding of his situation. Who better for him to bleat to?

One way I feel I helped Walter was by reminding him that he could still work, just not the same way he used to. I shared with him how I slowly brought my body back to working after those five years of illness by going into the studio for short periods of time followed by a rest. If possible, I went back out later in the day for another short work session. "Twenty minutes a day," I told Walter. "It will add up." And add up it did. Many of Walter's torso vases were created this way, coil by coil, with slow intent.

In early 2007 Walter told me that he had been asked to do a retrospective exhibit at Jonathon Bancroft-Snell Gallery in London, Ontario. I could tell he wanted to do this but was worried he would be too unwell to make the trip to the opening in September.

I suggested that he agree to the exhibit and, if he was up to it when the time came, I would be his travel companion. I had no idea how I would pull this off, as Heather's health was rapidly declining and I knew she did not have long to live, but I also knew that Walter wouldn't say yes to the exhibition without my reassurance and support. In the months leading up to it, he managed to create some new works for the show, and his mood was better for it. He was doing what he loved. Heather died in July, and my life had changed dramatically. That trip with Walter was timely; we were two old friends supporting one another in different ways. He was not well, far from it, but we had a great time.

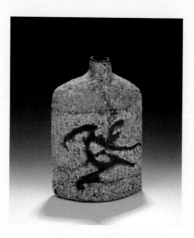

This torso vase is very special to me. It was among the last pieces Walter created. 2013, 31 cm T.

My favourite memory from that trip was entering the room where his exhibit was set up before the opening began. He was visibly moved by it and a bit overcome. Then he started to fret about how he would make it through the opening. "You'll make it, Walter," I said. "There will be a chair for you to sit in, and just before the show opens I am going to give you a glass of red wine. Throughout the evening, my hand will pop up by your side with a small snack or a drink of water for you. Then at the end of the evening, we will celebrate with a nice glass of single malt Scotch." He giggled at this and promised to eat the snacks and drink the water. He made it through the evening surrounded by his fans and friends. It was a night to remember.

Five years later, in October 2012, the *Back to the Land* exhibition opened at the Art Gallery of Greater Victoria, featuring some of Walter's work as well as some of my own. He didn't feel up to going to the opening reception but thought he could manage the artists' meet-and-greet the following day if I took him. I arrived at his place at the appointed time to see if he was still okay to go to the gallery. As soon as he saw me, he told me he had finally fired the kiln and was waiting for someone to help him unload it. Would I mind doing that when we got back from the meet-and-greet? I could tell that he was dying to see the finished work—the torso vases he had slowly created over the last few months— so I suggested we have a quick look right away. He took out the first two pots but then felt

weak, so I unloaded the rest of the kiln for him. I had never helped Walter unload a firing before, and it was a treat to see his joy in it. I didn't have a very good camera with me, but I suggested we take a few photos and am very glad I did. Then off to the gallery we went.

Walter's health continued to decline, but his creative mind worked right up until the end. He was in the hospital for what would be the last time during one of our last phone chats. "Mary," he said, "I must get someone to take a picture of the drapes in here for me. The way the light falls on them is beautiful and it's given me an idea for a piece." That was my friend, creative to the very last moment.

 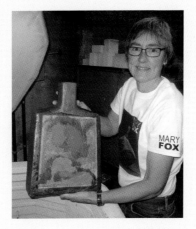

Walter and me unloading his kiln before going to the artists' meet-and-greet at the Art Gallery of Greater Victoria.

COLLLABORATION
FIRES NEW
CREATIVITY

"It took over two years to rebuild the house and studio, but its completion in 2010 marked a turning point in my life and career."

It took over two years to rebuild the house and studio, but its completion in 2010 marked a turning point in my life and career. Now that I had created the studio and gallery of my dreams, I focused my attention on the next challenge: if I wanted a steady stream of customers from all over the world, I needed to start promoting my work globally. I created a website and Facebook page, which was quite the learning curve for someone who still doesn't have a cellphone! I didn't know much about social media, and it took me a while to get the hang of it, but once I did, I found that I quite enjoyed how it brought the world closer. It was perfect for someone like me who needs time alone but also wants to feel in touch with the people who are interested in my work.

The next hurdle was photography. I needed a steady supply of images of my work to post online, and I didn't want to be constantly lugging pots off to a photographer's studio. Then Teddy McCrea started popping into my studio. As well as running a bed and breakfast, Teddy had an interest in photography. He had just bought a new camera and needed to learn more about it, so he asked if he could take photos of my work. How lucky was I? This was perfect since he lived close by and didn't mind taking my pots to his house to photograph. We did this for a while, and then Teddy offered to teach me how to take the photos myself. I was grateful but also scared of trying to learn yet another skill. Since becoming ill with ME, I have found it a challenge to learn new things, but he reassured me that I could do this. "You don't need to learn a lot," he said, "just enough to photograph the work. And since it's visual, you should do okay." Teddy shopped for all the equipment I needed and set up a photography room in what had been my guest room. Once again, the kindness of a friend helped me find a solution to my problem. It wasn't long before I was able to take my own photos, many of which, I am happy to say, you can see in this book.

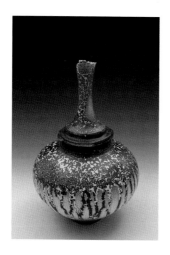

One of the trickiest glass de-
signs we tried on our first day
was modelled on this collared
bottle vase. We had to make
the neck part in two sections
and then join them to the base
of the form.
Collared Bottle Vase, 2011.
Relic series, clay,
35 cm T × 23 cm W.

OPPOSITE
Glass Bottle Vase, 2016.
47 cm T × 24 cm W.

OVERLEAF LEFT
Glass Chalice, 2017.
Mounted in rock,
50 cm T × 20 cm W.

OVERLEAF RIGHT
Glass Chalice, 2017.
Flower series, mounted in rock,
39 cm T × 33 cm W.

A NEW ADVENTURE: COLLABORATIONS IN GLASS

One never knows what the future holds. I certainly had not
imagined that mine would involve taking up glass-blowing, but
then opportunity knocked. One day glass artists Lisa Samphire
and Jay Macdonell came up from Victoria to visit my gallery.
Both were working at the Art Gallery of Greater Victoria at
the time, and they had been asked to pick out a gift for David
Flaherty, who was retiring from his position as trustee for the
Pacific Opera Victoria Foundation. As they looked at my work,
Jay commented on how well suited it would be for interpretation
in glass. I was immediately drawn to the idea but had no idea
how that would be possible. After much discussion, Lisa and
Jay suggested that the best way for me to explore how this
could work would be to have a glass play date with them. I was
to come up with forms I wanted to create, draw them on paper,
decide on colour possibilities and then book the hot shop.
They worked an eight-hour day, they told me, and expected that
I would do the same. Whoa! This was a big challenge for me.
My energy level is good for about five or six hours at the most,
but I wasn't about to let this opportunity pass me by, so I
said yes.

We had our first glass-blowing day in December 2014, and I was
so inspired by all the creative possibilities it opened up that I
could hardly contain myself. It brought back memories of what
I had learned from the first glass artist I ever met, Waine Ryzak,
my grade ten art teacher and now friend. I recalled how as a
teenager I was in awe of Waine's glass collection. I had never
been in a home full of art before, and what an eclectic collection
she had! Beautiful glass bowls, goblets and sculptural pieces
of all sorts were displayed everywhere. I would carefully make
my way around the house studying it all, amazed by the diversity
of forms. Waine was always very generous to me with her work,
so my collection of odd glass pieces started to grow. She would
go down to Pilchuck for the summer to blow glass and come
back full of stories and more creations for me to study and
covet. Everything about her glass adventures seemed magical
to me. I was fifteen, and my eyes were being opened by an
amazing artist who always had time and words of encourage-
ment for me.

From Waine I also learned about the challenges of glass work.
I would be all agog over a piece and she would say, "Yes, but
there's a check." In other words, it could break at any time or
might hold together for years. Glass has its own set of flaws,
just like ceramics, and so at a young age I began to learn about
acceptance—accepting that whatever I was working on might
end up as a good piece or it might not. Pots cracking or sticking
to kiln shelves, glazes bubbling, forms collapsing in my hands
on the wheel—it's all a part of the process. This was a crucial
lesson for me as a young artist—accepting losses and imperfec-
tions as part of the act of creation.

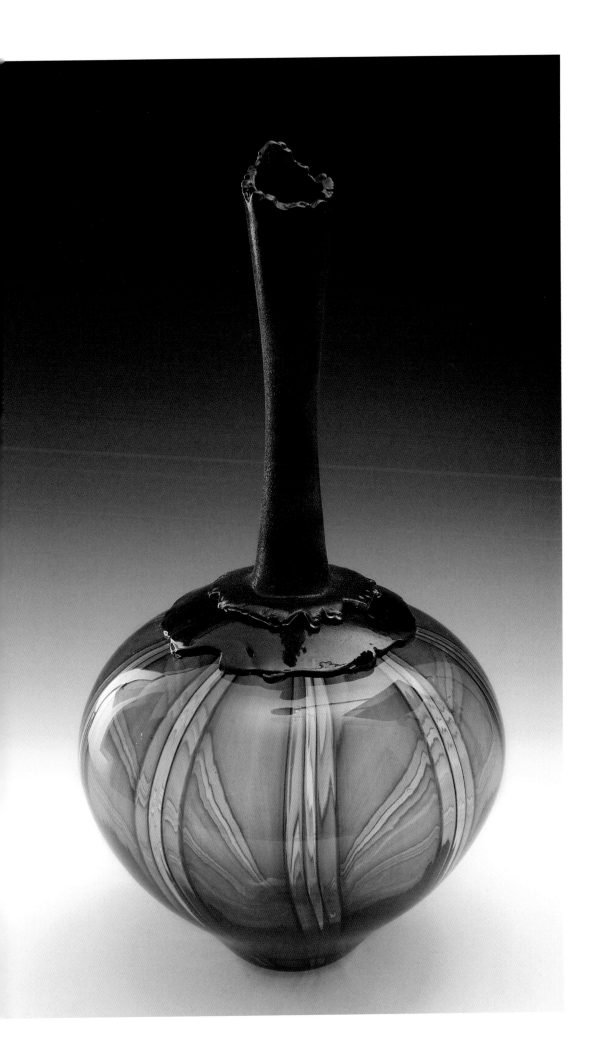

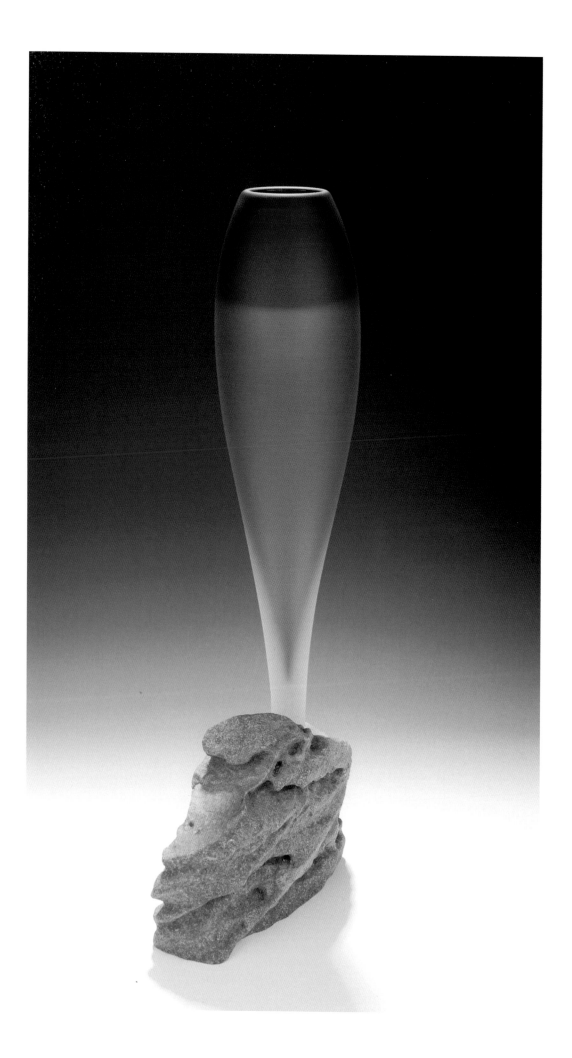

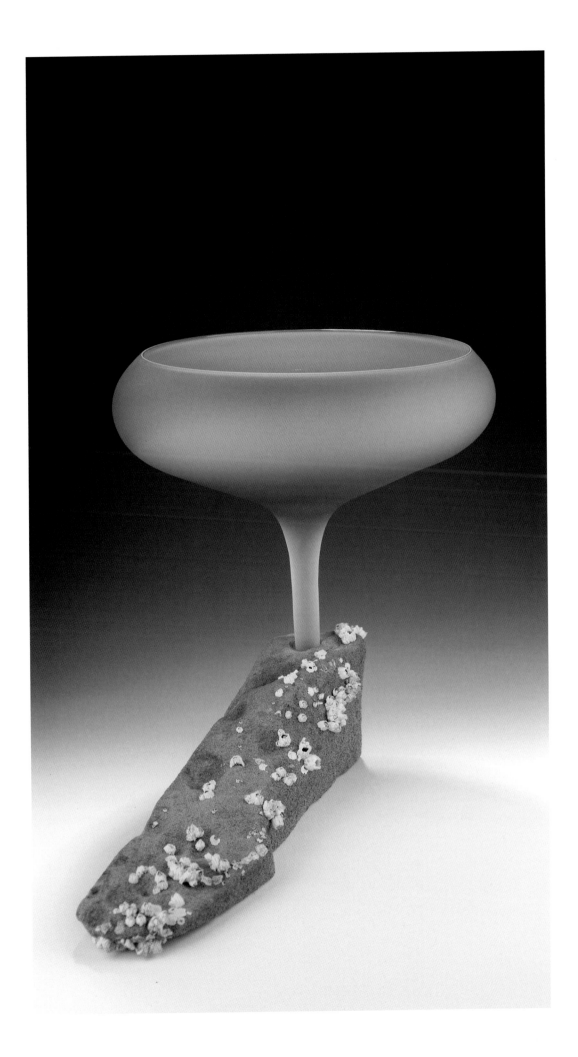

On the ride home from our day of playing with glass, my friend Jacq commented on how the three of us had reacted when a large piece we had been working on for about an hour broke off the blowpipe and shattered on the floor.

"No 'Oh fucks!' or anything," she said. "You guys just looked at it, took a break to commiserate and then tried again."

"Yes," I said, "we're all used to losing pieces. It's part of the process."

When you think about it, that's a really good lesson to learn early about anything in life. So what if you don't succeed at first? Keep on trying and you'll get there. One of my self-made rules is that it's okay to make mistakes while learning, and we are always learning.

Working with Jay and Lisa opened me up creatively in ways I hadn't imagined. Until that point, the idea of working with other artists collaboratively did not have a lot of appeal for me. I am very much a lone wolf when it comes to my work, and I don't like to throw in front of people unless I am teaching. For me, throwing is my church, the time I am closest to the work. I immerse myself completely in the forms I am creating, going deep into the zone. It is how my best work is created. If I am being observed, the work is still good, but it's never as good as it could have been. Once a pot is made, it is made, and I want it to be the best it can be. I am always mindful of how I am feeling when I go to the wheel. If my mood is a bit off, there are always other studio jobs to be done, and I wait until I am in the right space before sitting down to throw.

Reviewing the forms we are going to work on with my glass team before we get started.

Working with Jay and Lisa also raised new questions for me. Although I created the designs, I had to hand over the actual crafting of the pieces to them. Not only that, but I also didn't understand glass. No matter how many times they explained the technical aspects, I couldn't retain it. I can build on knowledge I gained before getting ill, but learning something entirely new is a huge challenge for me. Once again I needed to practise acceptance. I asked myself, "How is this work mine?" They were the hands-on team, and without them this work would never happen. They explained that with glass there is often a designer who works with a team. Still, it was a lot to get my head around. I could understand their point since it was clear the pieces I was designing couldn't be created by one person alone, but I still struggled with it.

At each blow session I learned a little more. I depended on Lisa for guidance with colours and surface effects; for form I relied on Jay. As the body of work we created grew, my designs evolved, gradually drawing on ideas from my clay work but expanding them in new ways. I was playing with colours and patterns in a whole different way. Slowly I came to realize that none of these pieces would have been created by Jay or Lisa. They were from my imagination. This truly was my work, even though I wasn't the actual blower.

COLLABORATING WITH MARY FOX

The collaboration between Mary, Jay Macdonell and me came about after Jay and I saw Mary's pieces during a visit to her studio. Jay and I share the same passion for our material, and our reactions were similar. Our ride home became a lively discussion about the forms we saw and how we might execute them in glass. We initially saw this as a technical challenge, and that's what prompted us to invite Mary into the hot shop[1] with us.

The collaboration process is interesting, something I have always enjoyed, and it's what I like about glass work. It is rarely a solo process; most pieces require a minimum of two people. I have worked with Jay for more than twenty years on many different projects and in many circumstances. We have found a good balance working together.

Our collaboration role with Mary has been as educators and fabricators. She had never been in a hot shop before, so there was a big learning curve for her. There were lots of questions, exchanges of ideas and discussions. It is always exciting to see others experience enthusiasm for your material and process for the first time. It reminds me of my initial excitement about

the material and how far I have come. Mary's role is assistant to Jay and me in the hot shop, as well as chief designer. Jay takes the role of gaffer.[2] I am responsible for organization, colour decoration and realizing Mary's images on the final forms—and, of course, helping Jay with the execution of the pieces.

A few weeks before each blowing session, Mary and I have a discussion to figure out what she wants to make. We talk about colour combos, the effects she wants and the themes. She often sends me images of ideas she wants to pursue, such as waves, nebulas, desert scenes and volcanoes. I figure out how to put the imagery and effects on the work, sometimes sending drawings and ideas to her before we go into the studio. I love this part of the process as I get to use my thirty-four years of knowledge and exploration of glass to try new things on Mary's work. I try to resolve

her vision for the piece. Sometimes we nail it right off the bat, and sometimes it takes a few tries and adjustments.

Making forms that are different from your own designs challenges you to rethink how you work with your material. During our time together, Jay and I have had to figure out ways to make Mary's forms and decoration ideas happen. This is an exciting and rewarding aspect of the collaboration process.

Mary brings her own energy to the studio. Having a third person in the space changes the dynamic and changes how you approach the material and process, but it's a great way for me to expand my own creative process. The collaboration has opened me up to new discoveries in the material, solidified my skills and knowledge as a working artist in glass and gained me a lifelong friend in Mary.

—LISA SAMPHIRE

1. hot shop: A glass-blowing studio. It has a furnace used for melting glass, a "glory hole" for reheating a piece during its creation and an annealer for cooling the finished pieces slowly.

A hot shop will also have a specialized bench designed for working with glass, as well as various hand tools used in the process.

2. gaffer: The person in the hot shop who leads the team and is in charge of the execution of the piece. The gaffer sets the tone in the studio and for the piece at hand.

FROM GLASS-BLOWING TO CLAY MOULDS

In my clay work with chalice forms, I had always wanted to make longer stems, but I was limited on the wheel by the length of my arms. If I made the stem longer, I had to sacrifice height in the body of the form. I couldn't have length in both if I threw the chalice in one piece. However, with glass I was finally able to create chalices with the long stems I had always dreamed of. It made me go back to wondering, of course, how I could achieve the same thing in clay. Then David Dolphin, OC, FRS, FRSC, entered my life. David is a world-renowned, award-winning bio-chemist who took up pottery in his retirement; we met when he turned up at my gallery one day to learn all he could about my glazes. As he peppered me with questions, I realized that he was brilliant in all the ways I am not. Finally, with my brain on over-load, I admitted to him that I had failed both math and chemistry. Although I could share the rabbit trail of how I developed the glazes I am famous for, I couldn't explain why they worked. This he took in stride, quickly changing the topic to his moulds. But by then my brain was in serious meltdown and, although he was interesting, I could take in nothing more, so off he went.

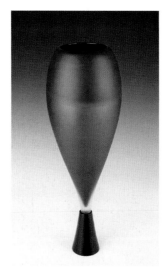

I used the outline of this glass chalice to create the first slip casting moulds.

Very carefully lifting a slip cast chalice out of the mould.

OPPOSITE
Chalice, 2019.
Slip cast, lime green glaze, cone 05 oxidation, mounted in rock, 38 cm T.

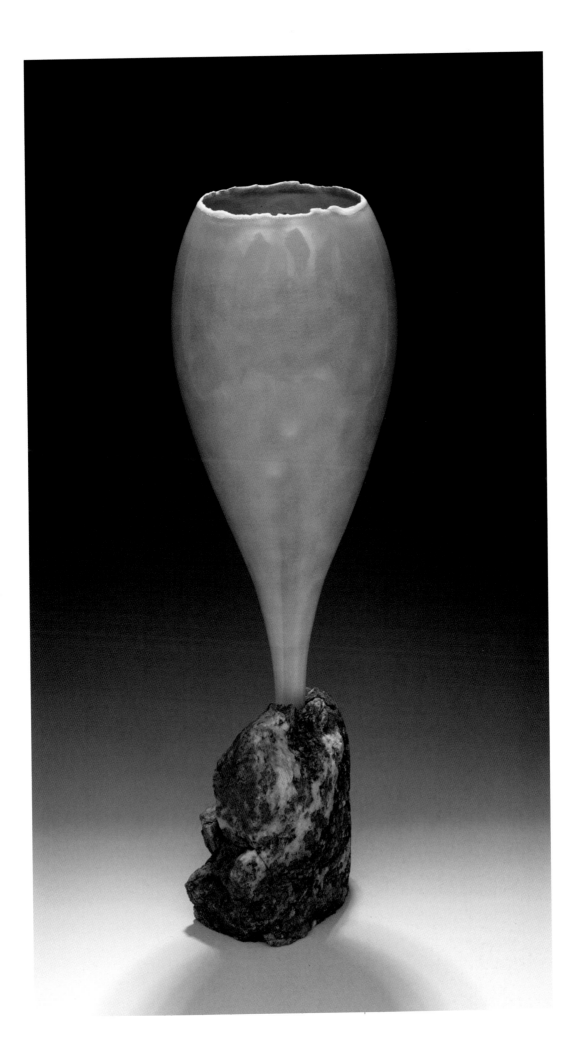

Months went by before I saw David Dolphin again. He turned up at the opening for *Unearthing Beauty* at the Gallery of BC Ceramics in August 2015. He reminded me of our earlier conversation and asked if I would join him and some friends for dinner that evening. At dinner I started to ask him more about his moulds and this "CNC machine" he kept referring to. He explained that I could make clay chalices with long stems like the ones I was creating in glass if I cast them, and he could make the casting moulds with his machine. And then came the magic words: would I like to try? Poor David had no idea what he was letting himself in for. I'm sure he expected to do one or two moulds and that would be the end of it, but he didn't know me. He was about to become part of Team Fox.

We got to work creating moulds from outlines of some of my favourite glass chalices. From those I have now made several slip cast clay chalice forms with long stems. The moulds are made in two pieces and designed to drain through the stem (see Part II for technical details). This works quite nicely and means I don't need equipment to lift the heavy moulds to pour the slip out. Slip casting has turned out to be yet another big learning curve, but I am enjoying it immensely. With this method I can create forms that would be very challenging to do on the wheel.

Working collaboratively with glass artists opened my world up to the idea of working with others to create my forms, which in turn led me to this new slip casting method. One wonders what will be next.

ANOTHER DOOR OPENS: REDUCTION FIRING

I am a member of the Fired Up! group of potters, which holds a show in Metchosin every spring. In 2016 the show's theme was wood firing, and the group gathered at Gordon Hutchens's studio on Denman Island to fire our pots in his anagama kiln and take turns stoking the fire. Wood firing is a three-day affair, so there was plenty of time to hang out and chat while throwing wood into the kiln. I have never been a huge fan of wood fired work and never learned much about it, but as we chatted about different types of firing, I mentioned that I have always been curious about low-fire reduction work. There ensued much discussion about low-fire lustre work, but that wasn't what I meant. What I was really curious about was reduction firing at around cone 07–05. Did anyone know of any potters doing that? No one did. I wondered aloud what raku or my lithium compound glazes would look like if they were fired in a gas kiln and reduced. Everyone agreed it was an interesting question but theorized that it hadn't been explored because traditional gas kilns are designed for firing at high temperatures. At the temperatures I was talking about, a gas kiln was just getting going. Yes, I understood that, I said, but couldn't you stop the firing at the low point and take a look? Everyone agreed that, yes, you could do that, but again they had no idea if anyone had done explorations of this kind.

Then someone piped up. "It could be done in a Blaauw." I had no idea what a Blaauw was and peppered them with questions.

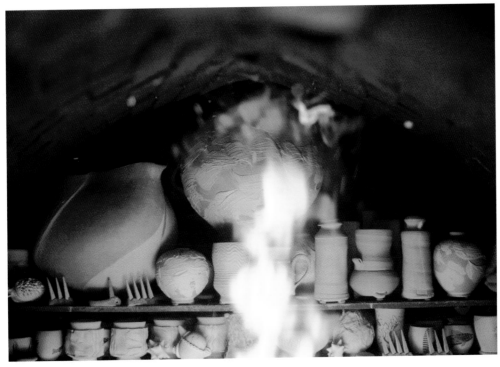

1

2

3

4

1 | The wood firing begins.

2 | One by one the pots are loaded into the kiln.

3 | Throwing wood into the kiln or, as it's sometimes called, "feeding the dragon."

4 | Unloading the kiln is done the same way as loading it. Here Gordon Hutchens looks over each piece before handing it on to the eager hands waiting outside the kiln.

After taking down the wall of the old studio, Stuart Money guides the new Blaauw kiln into position.

My prize from the Fired Up! wood firing. The stem of this slip cast chalice warped in the firing, but as it turns out, I had the perfect rock to mount it in.
Chalice, 2016. Wood fired, mounted in rock, 51 cm T.

Everyone there thought Blaauw kilns were awesome but also pricey. They are the first gas kilns on the market that enable you to program your firings, including the reduction part. Not only that, but because they are fully computerized, you can duplicate your firing. Wowza! I was intrigued big time. I have always wanted a gas kiln. When rebuilding the house, I had installed a gas line to the old studio (now the kiln room) in case I got one in the future or the Legacy Project (see chapter seven) acquired one. Although I had done low-fire saggar work years earlier in a gas kiln, I never had a chance to explore high-fire reduction work before getting ill. It was definitely on my want list. But was it a big enough want to warrant spending an enormous amount of money on a Blaauw?

Although my creative imagination was light years ahead of my budget, the possibility of being able to explore low-fire reduction set my mind racing. I didn't get much sleep that night; all I could think of was what I could do if I had a kiln like that. What would my clay slips look like reduced? How would the lithium work turn out? And wouldn't it be fun to start playing around with cone 10 reduction for my functional pieces? The seed was well and truly planted. I couldn't wait to get home to research these kilns.

The first thing I did was search online for anyone exploring the kind of low-fire reduction I was considering, but I found no one. Then I wrote to the Blaauw company to find out what a 0.4-cubic-metre (14 ft³) kiln would cost. As I sent the email off, I said to myself, "If it costs around $40,000, I think I will see about getting financing and go for it." The quote came in at $50,000 for the kiln and another $10,000 for shipping and the technician to install it. Then there were the costs of taking down the front wall of the old studio to get the kiln in, building the chimney, getting a gas fitter and then all the other costs that one doesn't anticipate that invariably mount up. I was downcast. I felt my dreams of the kiln were just that—dreams.

But I couldn't let it go. I kept thinking about what a great playground this would be for the rest of my creative days, and how amazing it would be to have a Blaauw kiln available for the future artists in residence sponsored by the Legacy Project. As soon as I started thinking of it that way, my feelings about taking on more debt shifted. I asked Jeff Chown, the North American technician for Blaauw kilns, how much of the kiln's longevity I might use up in my lifetime. Maybe 20 per cent, was his reply. Another selling point that he kept bringing up was the Blaauw's exceptional energy efficiency, and he noted that I could also fire my oxidation work in it. Although it would take a lot of firings to even begin to recoup in energy savings what the kiln cost, these facts made a difference for me since stewardship of the environment has become so pressing.

By now I'm sure you've guessed what comes next. The kiln arrived in January 2018, and I have been happily experimenting with it ever since. It has opened up exciting new worlds of glazing and firing methods, and I share some of my discoveries in Part II.

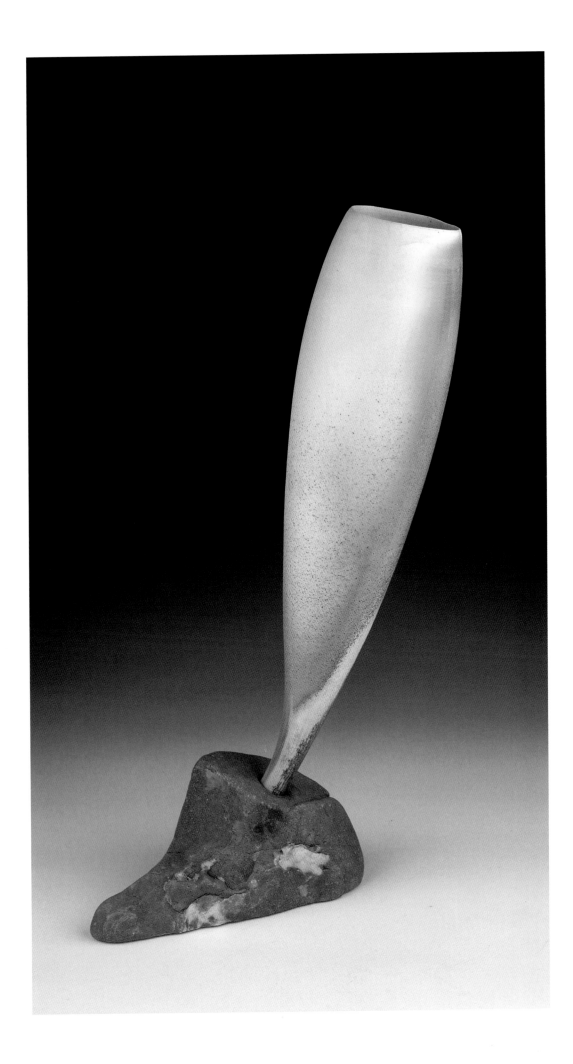

HAND-BUILT
SCULPTURE

"Sculpting was what first entranced me about pottery, long before I turned my full attention to the wheel."

Sculpting was what first entranced me about pottery, long before I turned my full attention to the wheel. I loved how I could take a lump of clay and very quickly turn it into what was in my mind's eye. I didn't have many ideas about what to sculpt, so I often created what I saw. My first sculpture was of an altar boy, and after him came a steady stream of figures in robes or long dresses because the thought of trying to do legs unnerved me. The robed people continued until I finally got bored with them.

Many of my early sculptures were made with clay I dug up at local beaches. On one of our family outings I spotted some clay deposits. Excited about the prospect of an unending supply of free clay, I hounded my dad to take us on "clay hunting" excursions on the weekends. Unfortunately, the sculptures I made from this clay often cracked in the firing—an early lesson for me about the limitations of found clay. I thought any old clay would do, and it took quite a few of my sculptures cracking before I realized the quality of the beach clay was the problem. This was rather a big disappointment as it meant the end of my free supply.

In grade ten I began combining wheel-thrown forms with hand building and made an assortment of very odd creations. Unfortunately, I don't have photos of many of these, but I did photograph one of my favourites. I remember puzzling over how to glaze it. Since the glazes we had at the school didn't seem to suit it, I ended up painting it with acrylics.

My sculpting was put aside when I started down the road to becoming a studio potter. I had so much to learn about wheel-thrown work that I didn't have time to explore sculpture as well. Another reason I set it aside was because it would not pay the bills. I could make a raft of functional pots in the time it took to make one sculpture and I stood a much better chance of selling my pots. Over the years I occasionally did hand-built work but did not devote much time to it until around the time of Heather's

The rhythmic pulse of creativity overwhelms body and soul, vulnerability abandoned as my passion flows into the clay.

Hours pass, and I emerge exhausted and overwhelmed by the beauty that has poured out of me.

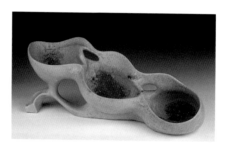

Whale Bearing Gifts, 2011.
23 cm T × 59 cm L.

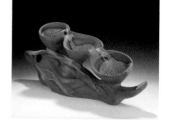

Tidal Pools, 2015.
37 cm T × 87 cm L.

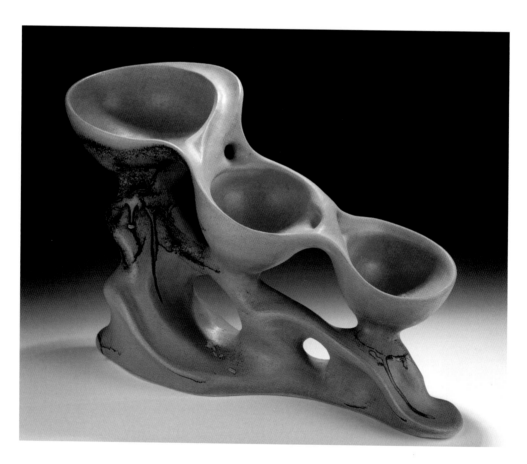

Cascading Tidal Pools, 2012.
41 cm T × 60 cm L.

My first sculpture created in my grade 8 ceramics class, 15 cm T.

Somewhere along the way he lost his head and it was glued back on.

passing. Since then I have explored a few different themes in my sculptures, my favourite being the Cascading Tidal Pool series.

For me sculpting has a whole different vibe from throwing. The beginning stages are physically tiring, as I need to prepare the clay and then create the foundation for the form. This can take up to two days, depending on how large the piece will be. For most of my sculptures I like to work from a solid mass, bringing the sculpture out of the clay. Working this way gives me freedom during the forming stage since I can easily add or take away clay. The problems come when I am hollowing out the finished form: if the walls are too thick or of uneven thickness, the piece will crack during the firings.

CASCADING TIDAL POOL SERIES

For my Cascading Tidal Pool series, I roughly draw out the form I want the piece to take and then set about making the foundation. For the bowls, I throw very thick, rough forms and attach them to the solid foundation. This is the most physical stage of the process. I also find this part to be the hardest emotionally. The piece looks really dreadful for a long time before it finally starts to come together, and I often find myself fighting the urge to throw it off the sculpture stand and walk away. There is a lot of self-talk going on while I work through this stage of creation, as I have to remind myself to be patient. Then comes the exhilarating part, the moment when I step back and see that it is all starting to flow together and the image in my mind is taking shape in front of me. This is when I turn on the club music and truly become one with the piece, my hands and body dancing with the sculpture.

The foundation of "Caddy."

Coils have been added to join the bowls together and start the flowing water lines

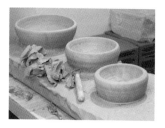 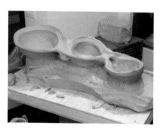

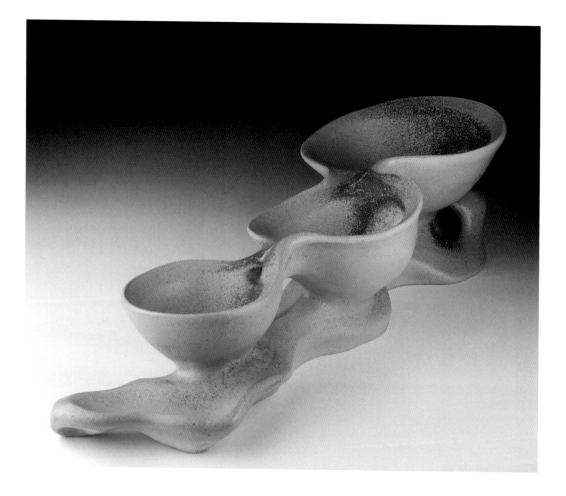

Cadborosaurus Bearing Gifts, 2014.
Lithium compound, 21 cm T × 79 cm L.

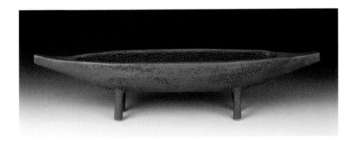

THE CREATION OF *CADBOROSAURUS BEARING GIFTS*

Cadborosaurus Bearing Gifts was a fun and challenging sculpture
to create. Joan Leseur wanted a sculpture to go on the long dining
table at her beach house in Cadboro Bay. It was to be large enough
to be enjoyed by all but not so big that it took up too much space
or blocked people's views of one another across the table.

Usually I make sculptures of this kind quite tall, but since there
were size restrictions for this one, my approach needed to be
quite different. No free-ranging creativity here. I struggled with
the design at first; everything I started on was going to end up
too high. Then one day I envisioned Cadborosaurus—the long,
sleek sea monster fabled to live in the waters near Joan's home.
That was all the inspiration I needed. From then on, the sculpture
flew out of my hands. Near the end of the creation stage I found
myself imagining the many intimate dinner table conversations
Cadborosaurus would be privy to, and I chuckled as I envisioned
all the kids who would play with this sculpture, poking their fin-
gers into the holes and running their little hands over her. These
thoughts made me smile. What a lovely project this sculpture
turned out to be! Now Cadborosaurus takes her place at the
family dinner table, a silent witness to all that goes on around
her through the year.

TRIBUTE TO HAIDA GWAII

Ah, how I loved creating *Tribute to Haida Gwaii!* This is one of the
few sculptures I made while Heather was alive. It was a still winter
evening in 2001. I can still recall being at my wedging table, sur-
rounded by a feeling of *hygge*, as the Danish call it—contentment
and coziness—music swirling around me, Heather in the house
watching TV and me in my studio, so at peace in that moment.

THE MOTHER AND CHILD SERIES

The Mother and Child series began on Earth Day 2008. Nine months had passed since Heather had died, and as I entered the creation room that day I was thinking about the cycle of life. I was overcome by feelings of gratitude for being alive and able to work. I missed Heather dreadfully, while also savouring the release from years of caregiving.

I put on some music and started to prepare the clay. Hours passed. I was completely taken over by my emotions and the work of transferring them to the clay. I worked late into the evening until exhaustion took over and I staggered off to bed. The next day when I walked into the creation room and looked at my work, I was happy inside—the first of the Mother and Child series was born.

Reclining Lady on the Beach #1, 2008. Lithium compound, cone 06 oxidation, 34 cm T × 71 cm L × 35 cm W.

Since then I have done three versions of Mother and Child, the mother representing the earth and new life, the white glaze, the ocean where life began.

This series led into the Reclining Lady on the Beach sculptures.

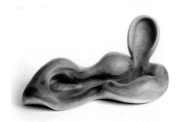

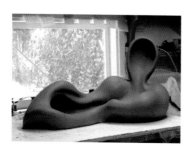

Leather hard stage.

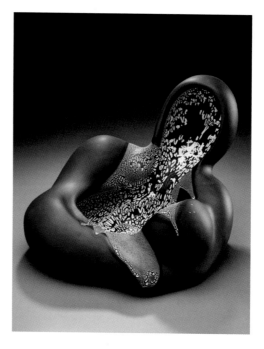

Mother and Child #2, 2008.
Blue terra sigillata, white crawl glaze, cone 06 oxidation.

Finnigan is a sculpture I created around 1998, fired with a layer of orange terra sigillata and then painted with oil paints. When it was finished, Heather asked me if I had ever thought of doing a show based on my fanciful creatures. My first reaction was, *Too much work!* Then I started to chuckle as I thought how fun and hilarious it would be if I booked a show and then, instead of exhibiting my usual vessels, presented a show of creatures like Finnigan. Such a departure for me. What would people think? Heather and I laughed about this idea and then wrote an intro-duction for him:

> In case you haven't met his kind before, Finnigan is a wood gnome. His favourite time of year is autumn because he gets to hide out in the fallen leaves and spy on everyone. It's also when he makes vast quantities of acorn ale to carry him through the winter. Finn likes to get tipsy and entertain the other wood folk with stories well into the wee hours of the morning.

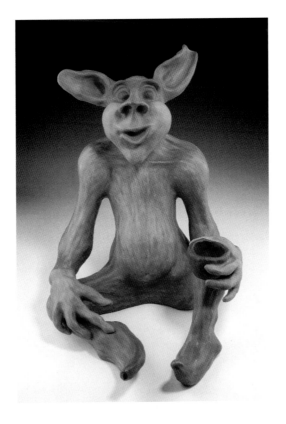

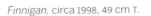

Finnigan, circa 1998, 49 cm T. *Bella*, circa 1998, 40 cm T.

VALENTINE VASES

My Valentine Vases are inspired by the flowing lines of Art Nouveau, the female form and, of course, love.

I start these forms with a large chunk of roughly centred clay that will become the base of the sculpture. I add another big hunk of clay on top of the base and throw a thick-walled form to work from. From there I transfer the work to my sculpture stand, where I add coils to help shape the form and add height.

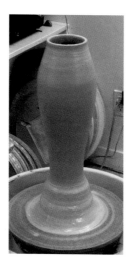

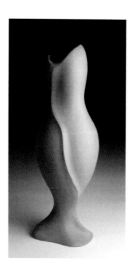

The vase begins.

Valentine Vase #3,
leather hard stage.

Valentine Vase #4, 2015.

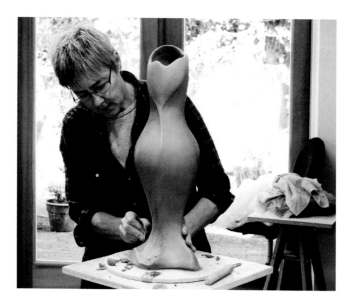

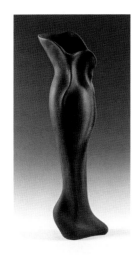

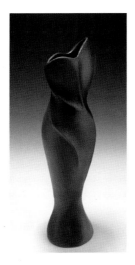

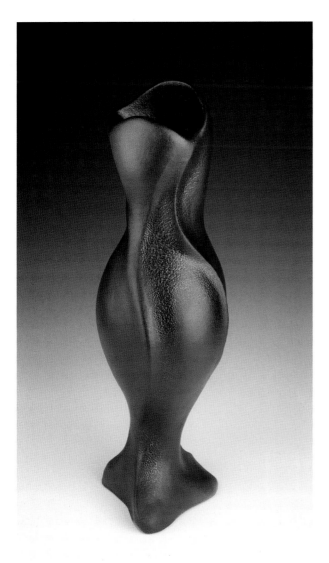

TOP LEFT
Marlene, 2010.
Blue terra sigillata, light over-
dusting of lithium compound,
cone 06 oxidation, 67 cm T.

TOP RIGHT
Valentine Vase #1, 2012.
Orange terra sigillata, brown
crawl glaze, cone 05 oxidation,
60 cm T.

Valentine Vase #3, 2014.
Orange terra sigillata, brown
crawl glaze, cone 05 oxidation,
53 cm T.

LIVING AND WORKING WITH THE SEASONS

CHAPTER 6

"Beauty is everywhere in our lives; we just need to see it."

There are certain threads throughout my life that haven't changed much, the main one being my constant quest for beauty. Beauty, in all its forms, has shaped my life. It has influenced every nook and cranny of my work, personal relationships, gardens, home, food, everything. If you asked me the greatest lesson I have learned over the years, it would be that beauty is everywhere in our lives; we just need to see it. Even in our darkest times it is there holding out a branch to us.

Everyone's life has challenges, and mine has been no exception. How we approach those challenges, how we see them, the choices we make to resolve them—this is what sets people apart. I chose the life of a potter at an early age, and though it was a struggle to learn my craft and earn a living, I always felt that no matter what hardships I faced, this was the right fit for me. I didn't mind if I had to live frugally at first because my day-to-day happiness has always been most important to me. I was driven by my need to create beautiful vessels to enrich and inspire, and in doing so, beauty has permeated my life, spreading through it like a lovely vine, shaping and influencing not just my creations but every-thing about how I live.

My year has a distinct rhythm to it.

WINTER

The quietness of winter soothes me and helps bring me to centre, allowing creativity to flourish. I love this time of year, when it gets dark early and the rain pours down or, better yet, it snows. The dampness outside increases my feeling of coziness as I cocoon in my warm creation room, feeling safe and content. As the music plays, I am transported into the zone. Music has always been a big part of my creative life, and I choose it to match my mood. In the dark months, it is usually classical because

there are no words to distract me. However, if I am working on sculptures, I always seem to go for upbeat tunes, often club music.

January and February are my favourite months to work on decorative pieces. This is an intense time of year for me, when my creativity soars, at times becoming almost too much.

It is sometimes many months before new work takes shape in my mind's eye. It comes to me slowly, as a feeling first before an image gradually emerges. The energy that runs through my body as I start to visualize a piece is powerful, often leaving me awed and breathless, yet with an all-consuming urge to create.

Being in this creative zone is my favourite kind of entry into the year. Creating, relaxing and slowing down, having friends over for dinner and a movie, taking longer baths, just being.

However, I am still plagued by ME, which mainly involves dealing with ongoing muscle pain and occasionally debilitating flare-ups. If I get a bug, it's just plain nasty, with a long recovery time.

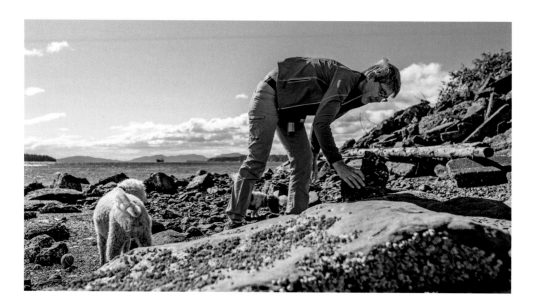

Amy, Sasha and me at the beach. Amy is all about her ball; Sasha could care less about fetching but is always on the lookout for a "wascally wabbit" to chase or something dead and stinky to roll in. Me, I'm all about the rocks.

I came across this bit of writing from a few years back, reminding me of another way the year can start:

Dagnabbit all, I got the flu on December 20 and am still sick. I'm heading into week five of being couched. My strength is slowly coming back but I've lost weight again and with it a lot of hard-won muscle. Now the slow, painful job of building it back up begins. I am having a fair bit of muscle pain after doing pretty much anything; hope that doesn't build. Surprisingly, my mood is quite good. On one hand I'm bummed about not working on all the things I had in mind for the beginning of the month, but then I'm so grateful that I have the luxury of being able to rest for as long as I need. There is nothing on the calendar that can't be postponed.

This brings to mind another of my favourite sayings, this one from *Star Trek: Deep Space Nine*: "Resistance is futile; you will be assimilated." Resistance truly is futile. We have choices in how we respond to life's challenges, and dealing with ME has made me a much more accepting person than I was. I tell myself: *Go with the tide—don't fight it. Eventually you will wash up on a beach.*

Tru, Yvanne and Jacq come for a visit on a snowy day and end up playing with some clay.

My morning ritual: breakfast in the bath.

Dancing with Sasha in the creation room.

How I love spring. It is my favourite time of year; everything is fresh, the green so verdant, the air full of the scent of blossoming trees and the promise of new growth everywhere. It's also when I celebrate my birthday, though I was born on Christmas Day at the darkest time of year.

I never enjoyed sharing my birthday with the Christ child because it's hard to have a party to celebrate *you* when everyone else is focused on the big event. I must have griped about this to Heather at some point around my twenty-fifth birthday, so she suggested that I pick a different date to celebrate. I loved the idea and immediately settled on May 25, since May is my favourite month. We had announcements made up and sent them out, and from that point on I have always set aside May 25 to celebrate me. I don't feel the need to have a party every year, but it is nice when a big birthday rolls around to share it with family and friends without having to compete with Christmas.

Harvesting some fresh spring greens for my salad.

I pick a lot of greens at once, more than one salad's worth, and have found the best way to keep them fresh is to store them in one of my casserole dishes. As an added bonus, it's so much nicer to look at one of my casseroles in the fridge than a bunch of plastic containers. Years ago I started storing my eggs in a spout bowl and loved how they looked, which probably led to keeping the greens in one of my pots.

Heather was a real sweetheart when it came to special occasions and loved to plan surprises for me. For my thirtieth she came up with the idea of having friends write a bit about their experience of me, which she would put together in a binder. She asked everyone to send them to her in big envelopes marked "Do not bend" so there wouldn't be creases in the pages. (She was a detail person!) This was all to be a secret. As soon as the mysterious envelopes started arriving in the mail, I began peppering her with questions, but she revealed nothing. By the time my birthday came around I was beside myself with curiosity.

What a wonderful gift it was, full of funny stories of past adventures with friends and personal insights about me. My dad contributed a piece about choosing my name, my Christmas birthday, and how I love spring. It brings a smile to my face every time I read it:

> We had the name Mary Elizabeth picked out, and it wasn't till after the announcement was published in the local newspaper that I had the idea that Mary Christine sounded like Merry Christmas, and we changed it ... I don't think Mary has ever quite forgiven me!

> So twenty or so years down the line it's either change Christmas or change Mary's birthday, and incidentally put an R into May and what have you got? Mary is not a winter person. When she was very small, she loved to be read *Scuffy the Tugboat*, and one section fairly sums Mary up: "Scuffy was in a hurry as all things are in a hurry in springtime." Mary doesn't sit around waiting for things to happen; she moves things right along!

I don't think I've changed much; I am still in a hurry for spring to come along. It's all about the garden for me. I love the ritual of tidying up the garden after the long winter, deciding which beds will be dug over first and poring over the plant catalogues (always during one of my long Sunday morning baths) to decide which seeds to order. The front courtyard garden comes into its own at this time. The winter pansies, having put on a so-so show during the cold months, are a riot of blooms, popping their beaming heads up toward the sun.

I take off a week or more around my birthday to work in the garden and get ready for the annual Fired Up! show. When I picked the date for my birthday, I didn't know that I would become part of the Fired Up! group and that our annual show would always be on the last full weekend in May, which often falls on my birthday. So the day I celebrate shifts around.

For the most part, I eat out of my garden all year round, but nothing beats the first sprouts of spring. The kale that has fed me throughout the fall and winter now sends out the tenderest of shoots, just as the salad greens are starting to grow. My salads, which have been slowly shrinking in size as I try to eke out the last of the winter garden greens, are now filled out by the abundance of new growth.

One of my favourite ways to
spend a warm summer evening:
sharing good food, wine and
conversation with friends.

SUMMER

The table set and ready
to welcome those coming
for dinner.

Although I take short holidays in the summer, I don't like being
away from home for long. For me the summer is all about
enjoying the simple pleasures in life—the garden, going to the
farmers' market, beach walks with the dogs and visiting with
friends and customers who make their way into the pottery. As I
start my day, I often wonder who might walk into the gallery that
day that I haven't seen in ages. If I'm lucky, an old friend will
show up, and I will invite them to come back later for dinner and
drinks on the balcony. My balcony garden is always one of my
favourites to show people because it is hidden from the street
and you wouldn't know it's there unless you were invited upstairs.
This garden has planters overflowing with annuals, as well as
many of my favourite trees that have been slowly bonsaied over
the years.

All my dinners and dinner parties start with a salad made with
greens from my garden, decorated with edible flowers. I am all
about the simple pleasures in life and love to give to my friends
in this way. To me, cooking for people is an act of love; if I hadn't
become a potter, I might well have become a chef. Not that I
am a fancy cook. I excel at peasant-type food—nothing compli-
cated, just the basics.

Since the gallery is very busy during the summer, my creating
work is squeezed in where possible. This is definitely not the
time to start working on a new show.

THE ALLURE OF LEATHER HARD POTTERY

One of my favourite times in the creation process is when my pots are at the leather hard stage. Like the naked body, the vessels are sumptuous, full of life with a smooth sheen that is profound in its simplicity. It's a fleeting phase; as the work gradually dries, it slowly loses the moisture that gives it this beautiful glow. Usually only the artist gets to see the pots like this, so sometimes I photograph my work to capture the moment.

Once the work is bisque fired, it loses that feeling of vibrancy for me. It becomes like a shell that has been deserted by its occupant, waiting for the next soul to inhabit it and bring forth its latent vitality. That is the final stage in the work's creation and the biggest challenge—how to restore and enhance the energy and beauty of the naked pot through the application of glaze.

Vases, 2014.
Leather hard, 46–50 cm T.

Vessels Huddling, 2011.
Leather hard, created for the show *Unearthing Beauty*,

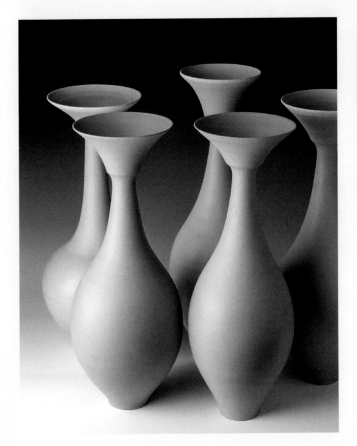

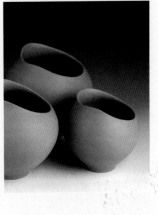

As the summer slowly wanes, I turn my attention to the winter garden. Over the years it has become more important to me, since I have become used to eating fresh greens, and the ones from the store don't compare. I start seeding the winter garden in late July and early August and hope for a mild winter. I plant kale, mustard greens, arugula, parsley and escarole. If I'm lucky, this will keep me going until spring.

In the creation room I start getting ready for my annual studio sale, held every year on the first weekend of November. I walk through the gallery taking note of what's in stock and what tableware needs to be made, and then I get into production mode. I thoroughly enjoy the process of deciding what to create for everyone; as the work comes out of the kiln, I get the fun of creating fresh displays with my new lovelies.

This is my time to move out work that's been around for a while to make room for the new. As the date gets closer, I go through the gallery deciding what will be on clearance; I have also hidden

Amy and Sasha getting up close and personal with Sean Sherstone as he tries to photograph me working at the wheel.

away my seconds all year long for this sale. Over the years people have come to anticipate what I will put out as clearance or seconds. Everyone loves it when I have a year where I've been developing new glazes, since I test them on small cups or bowls. One year I put out over a hundred small cups, all with different glazes, a treasure trove for those who regularly attend my studio sales.

The sale feels like the year-end to me. All my exhibitions and events are usually done. While others are gearing up for the craft fairs and restocking galleries, I get to kick back. Of course, that doesn't mean that I stop creating—oh no! Now I get the pleasure of refilling the shelves, making special pieces for Christmas presents and thinking ahead to a new year when I will be immersed in my decorative work once again.

It's a good life I lead, a very good life. I am now a mature potter with much technical experience and advice to share, which I do in the next section of this book. But before we get there, I would like to share with you my grand plan.

Every time I walk into my gallery, I am thrilled that I have such a beautiful space to display my work. Sometimes, late at night, I come down and just sit looking at it all, a bit blown away that all this work has come from my hands.

Calling the girls in after our morning walk. Amy can't bear not to be right by my side, so I don't really need to leash her; my street dog, Sasha, however …

When my eyes fell upon this sandstone rock, I gasped and carefully picked it up, mindful of its delicacy, its sweet curve, its beauty. As I carried the rock back to my car, I wondered what piece I would create for it that could evoke a similar feeling of grace, strength and fragility. It waited in my creation room for two years until the right chalice came along. This small twenty-five centimetre slip cast chalice is perfect for my precious rock—a marriage that complements, as all marriages should.

Chalice.

Terra sigillata, crawl glaze, oxidation, mounted in rock, 30.5 cm T, rock 27 cm L.

OPPOSITE
Vessel, 2018.
Terra sigillata, crawl glaze, oxidation, 32 cm T × 16 cm W.

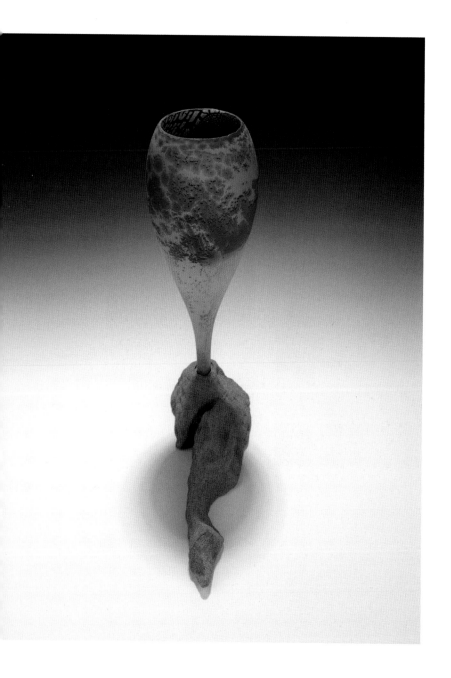

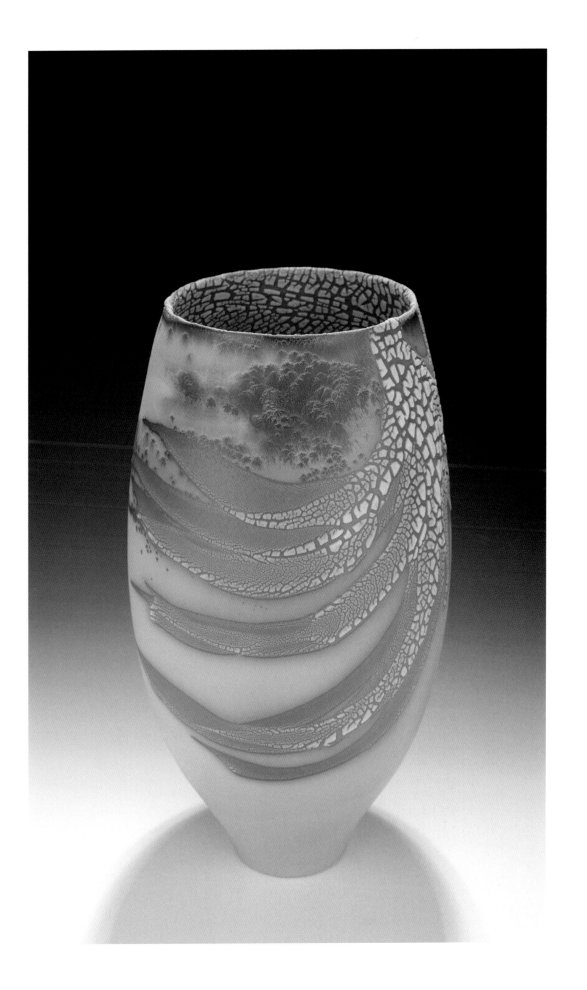

THE ZEN OF UNLOADING
A KILN

With pottery, once you have become good at throwing, the main challenge comes down to the firings. A potter can spend many weeks creating enough work to fill the kiln. Once a load is ready, it requires a bisque firing to semi-vitrify the work so that it doesn't disintegrate when dipped into a glaze. This firing is done to a fairly low temperature, around 1000°C (1830°F).

This is the easy firing: there is no big emotional toll because you know how it's going to turn out. But then comes the glazing. With my tableware, after it is bisqued, I apply the glaze, fire once more and then it's done. However, my decorative pieces often go through many firings as I gradually build up the layers of glaze. This brings much greater opportunity for surprises, both joyful and disappointing.

When I was younger, I approached opening the kiln with a fair amount of trepidation. Had the glaze gods been good to me? Or would I find that most of the work I had spent weeks creating was a disappointment? It was a blend of highs and lows. These days, after years of working obsessively at my craft, my knowledge and skills are at a high enough point that there aren't any bad firings. Almost everything turns out as planned or better.

In most other creative fields, artists spend weeks or months working on a single piece until it is done. They experience the emotional ups and downs that come while creating that piece and then the flood of feelings that comes when they step back and behold the finished work. Potters spend weeks creating several pieces simultaneously, and then they are all finished together in one firing.

When a firing is completed, I take a dozen or more finished pieces out of the kiln at once. Each one packs an emotional wallop. I find it can be almost too much as I become overwhelmed by the beauty of one piece after another. It's a good problem to have, but it can be intense. I am often so overcome unloading the kiln that I have to pause and go for a short walk or sit in the garden until I can bring myself back down to earth. I have never done hard drugs, but I wonder if the high one experiences is similar? The feelings of euphoria racing through my body can be extreme and take their own kind of toll. This is not something I ever imagined having to find ways to deal with. Who needs to find ways to manage their happiness?

A favourite chalice comes to mind in relation to this feeling of being overcome by the beauty of a piece. I glazed it with the Baking Soda Blue glaze, and it was in my early days of learning about the possible effects of this glaze. The bucket of glaze had been sitting in the studio for more than a year. I had done a few test runs with it and then set it aside. When I mixed it up and poured it into the interior of this chalice, I noticed that it had undergone a chemical change and there were jagged slivers of copper visible on its surface. (I wish I had taken a picture of it in this state, as it hasn't happened with any batch of this glaze that I've made since.) I was very curious about how these slivers would look after they were fired, and I was in for a nice surprise. As I lifted the chalice out of the kiln, I saw that all the copper slivers had turned into silvery flecks. It was a knockout. I walked out of the kiln room with my treasure, feeling completely overcome and saying over and over to myself, "Oh my god, oh my god!" I was also looking for a safe spot to put it down because it was a large chalice with a stem trimmed to just under 2.5 centimetres, so that was all it had to balance on. I finally found a spot for it, put it down and then went out to the garden to calm myself.

That experience forever changed how I approach unloading a kiln full of finished pieces. When I have a kiln-load of work that I suspect is going to be "one of those firings," I plan my day around it. I spend more time with each piece as I take it out before going back to unload the next, and I space the unloading out carefully so I don't end up bouncing off the walls with excitement that leaves me exhausted and overwhelmed. After the firing is unloaded, I take my treasures upstairs to be photographed, and my favourites stay there until I am ready to part with them. I jokingly refer to the upstairs as the Platinum Floor because it is chockablock full of pieces that I don't really want to let go.

One by one I look over my latest pieces as I take them out of the kiln. Love how the crawl glaze turned out on this bowl; it's so evocative of the ocean.

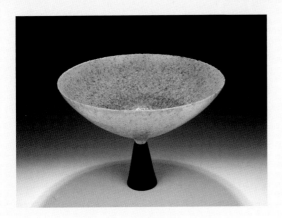

Chalice, 2015.
Baking soda blue glaze, cone 05 oxidation, 27 cm T × 38 cm W.

Close-up of how the jagged slivers of copper turned out.

ENVISIONING THE FUTURE: THE LEGACY PROJECT

"I would like to make it a bit easier for future young potters if I can."

BIRTH OF AN IDEA

I have been a potter all my working life, earning my living from what I create with my hands. Although I have never regretted my career choice and all the challenges that came with it, I would like to make it a bit easier for future young potters if I can. It is so hard to get started in this field without help: there is the costly equipment needed to do the work, and it is increasingly difficult to find a living space that can accommodate a studio, never mind a landlord willing to let you install a kiln.

Before coming to Ladysmith I always managed to find studio spaces, but often they were dark basement rooms that did not inspire creativity. I remember all too well my anxiety whenever talk of moving came up. There was the big job of moving all my equipment and the even bigger stress of finding a place that would be suitable for a studio and then talking the property owner into renting to a potter. Every move was very costly since it invariably required upgrading the electrical circuits to handle the kilns. Then there was building all the workbenches, throwing racks and display shelves that were needed. I was always fortunate to find rentals that worked, but for years I fantasized about owning a house where I could design a studio/gallery that perfectly suited my needs.

Most great ideas start with a dream, and my dream began in 2007 when Heather and I had our conversation about the possibility of lifting our house to make a larger studio space for me. Much as I loved my little studio, I had outgrown it. Over the years it had become increasingly crowded with equipment and all the work I was creating. I had shelves on one wall brimming with pots for sale, drying racks on the opposite wall and cupboards in the house filled with overflow pots. After we had our chat about lifting the house, I couldn't get the thought out of my mind. I was over the moon at the prospect of having more workspace and a proper gallery to display my work. When Heather had asked

me, "What would have made things easier for you?" her question planted another seed, as well, because we had touched on the idea of how to help young potters starting out. As a result, I began to think of a new studio/gallery not just as a space for me, but as a residency for potters when my time on this earth is over. This was the beginning of the Legacy Project.

With this long-term vision in mind, I started making a floor plan of what my ideal studio/gallery would look like, and in August 2008 the house was raised and construction began. I had not originally planned to gut the whole house and do a total rebuild, but as anyone who has embarked on this kind of journey knows, renovations have a way of growing. I soon realized that apart from redesigning the house for the Legacy Project, I also needed to make major changes so that I wouldn't be hit with all the memories from the past whenever I walked in the front door. I needed a fresh start.

It took two and a half years to finish the rebuild, but now I have the house of my dreams. When you step through the front door, you enter a beautiful gallery filled with my work. From there, you are welcome to walk through to the creation room at the back, where you will see works in progress and a view into the secret

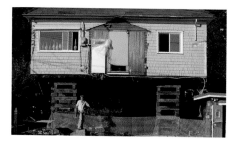

House raised in preparation for rebuild of Mary Fox Pottery, 2008.

Mary Fox Pottery today.

back garden. Off to the side is the entrance to the old studio, which is now the glazing, slip casting and kiln room. These are the parts of the house open to the public.

The upstairs living space was designed as an open-plan kitchen, living and dining room with built-in shelving to display my favourite pieces. There is also a photography room with a desk area and more display shelving. Everything potters need to create and document their work is on site. The loft on the top floor is a beautiful, calm space—my retreat at the end of a long day.

THE LEGACY PROJECT

I envision an artist residency program operating at Mary Fox Pottery after my passing. It will offer the opportunity to young, emerging ceramic artists to develop their skills and live the life of a studio potter with financial support. Selected artists in residence will have full access to the house and studio and the opportunity to sell the work they produce through the gallery. By the end of their residencies, they should know whether they are destined for a career as a studio potter. Hopefully time at Mary Fox Pottery will enable those who choose to pursue the work further to save some money toward starting their own studios.

The program will offer a two-year residency with the option to extend for a third year. The Mary Fox Legacy Project Society will be responsible for maintaining the building, grounds, equipment, taxes and insurance. In addition, the society will appoint a guardian to monitor the pottery and ensure that the resident artists are living up to their obligations. Resident artists will be responsible for their own supplies, utility costs and ensuring that the pottery is open to the public. They will be expected to maintain the gallery, creation room and living space in good condition.

SUPPORTING THE LEGACY PROJECT

Your contribution can support the success of the artist residency program for decades to come. Every dollar contributed helps grow the Legacy Project's capital investment fund and secure the artist residency program well into the future. The Legacy Project is an independent society and has established an endowment fund through the Vancouver Foundation and the Craft Council of BC.

You can support the artist residency program for young potters with a one-time gift, a monthly or annual donation, or by allocating a portion of your estate to the Mary Fox Legacy Project Society. Your contribution will be greatly appreciated and you will receive a tax receipt.

Please join us in this exciting and important project to help young artists establish a strong foundation for a career in pottery. To donate online, please see www.maryfoxpottery.ca/legacy. If you require more information, please contact me through my website, www.maryfoxpottery.ca.

Sasha and I have a moment together in the loft.

OVERLEAF
Happily working on a piece in the creation room while the girls keep watch for incoming visitors to the gallery. This is the ideal studio/gallery/living space that I will offer to emerging potters after my time here.

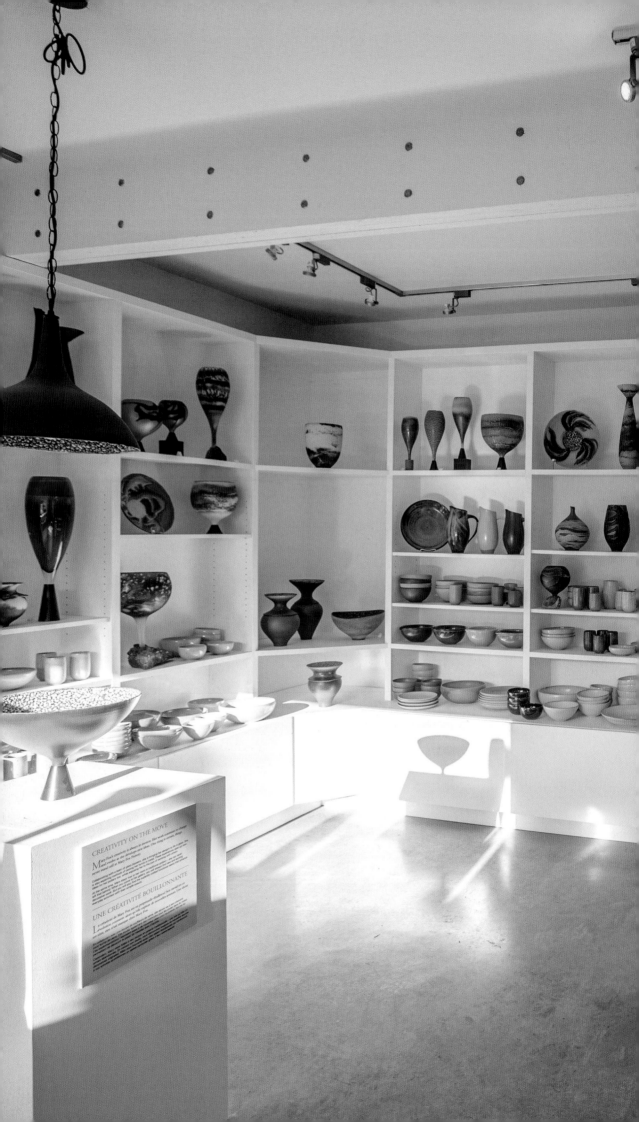

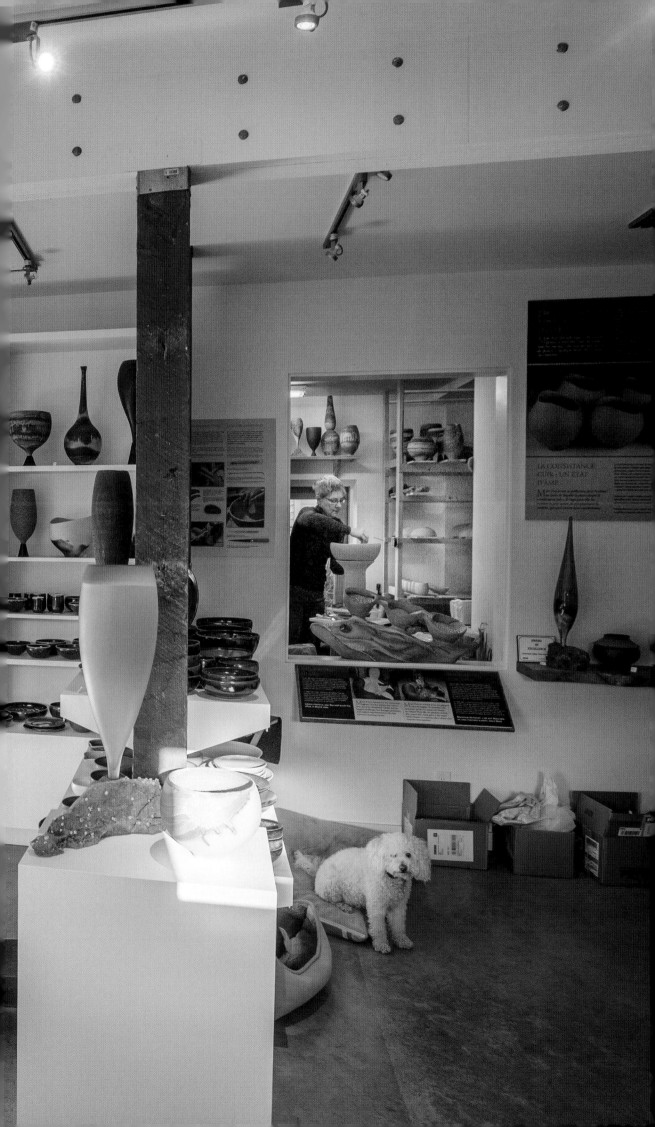

THINGS I WISH I HAD KNOWN

CHAPTER 8

"I cannot stress enough the importance
of good body mechanics."

There are so many things I wish I had known as a baby potter.
At the top of that list would be understanding the toll that repetitive work takes on the body. Over the years I have had problems
with my back, wrists and arms, though overall my body has held
up fairly well considering how many tons of clay my hands have
pulled up.

This is a very physical job, and for the beginning potter I cannot
stress enough the importance of good body mechanics. Having a
good physiotherapist can make a huge difference. I don't think
I would be in nearly as good condition had I not done regular body
work over the years and heeded the advice of my physio on how
to improve my work habits.

WEDGING

Wedging is the single most important step in throwing a good
pot. If your clay does not have a smooth, even consistency, you
will struggle with it as you pull it up. If some areas are stiffer
than others, your piece will likely become wonky. It is much more
pleasant and satisfying to throw with clay that has the perfect
consistency for you. However, purchased clay often has been in
storage for some time, and it can be quite stiff when you first
start wedging. If this is a problem, I recommend having a water
bottle handy so you can spray your canvas-covered wedging table.
Then, as you wedge, you can add a bit of moisture to help even
the clay out. The height of your wedging table is also very important because you want to be able to rock back and forth with the
wedging motion, using as much of your body weight as possible
to help with the job. I am five feet, six inches, and my tabletop is
just right at seventy-six centimetres (30 in) from the floor.

A production potter can go through tons of clay in a year, which
means hours of wedging. I recommend saving up for a good

de-airing pugmill, which will allow you to mix your clay to the exact softness you require, while moisture unevenness and air bubbles become a thing of the past. If I could do my time over again, that's what I would have purchased as early as possible. I now have a Peter Pugger VPM-20. To say I am happy with it would be an understatement. These are sweet machines, very easy to use and clean, though I clean mine only when I switch from my low-fire clay body to my white porcelaneous stoneware. When I'm mixing my clay, I always tear off about the first fifteen centimetres (6 in) that are extruded. I find that first section can be uneven, but after that it's beautifully mixed.

When I bought my Peter Pugger, they weren't available with the option of a stainless steel hopper. If you use only porcelain, it's a good idea to spend the extra money for this feature to avoid the aluminum pitting. To learn more about this issue, go to Peter Pugger's website, where there is a good explanation of this problem and how to avoid it.

Nothing nicer than freshly pugged clay. I'm surprised Amy will sit so close to me when I'm using the pugger, since occasionally I won't be quick enough and a log of clay will break off and drop to the floor. One of Amy's many nicknames is "always in the line of fire," which she earned after being splashed with a glaze containing a lot of red iron oxide. She was stained for quite a while!

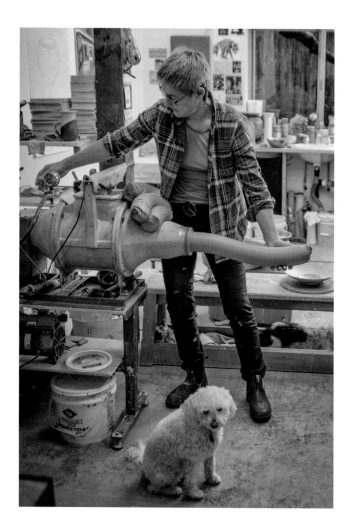

These days there are many good wheels on the market from which to choose. I learned to throw on a kick wheel and a Shimpo. Although I enjoyed throwing on the kick wheel, I felt that over the years it would be harder on my body than an electric wheel. I also found it much easier to centre large pieces of clay with the extra power a Shimpo provides.

I still use a Shimpo with an attached pedal but only because it is what my body is used to. I suspect that a separate pedal might be better for my knees over time. I find my leg is at an odd angle with the attached pedal and as I get older it seems to be stressing my knee a bit. But whether you have an attached pedal or not, be sure that your feet are at the same level; I have some old throwing bats that I use under my left foot to bring it up to the same level as my right foot.

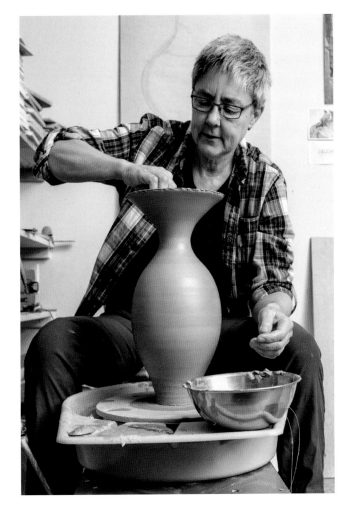

This is a good example of having your chair at just the right height. If the chair were at its normal position, my arm would be pointing upwards instead of nicely on level.

YOUR CHAIR

Years ago I invested in a Creative Industries throwing chair and I love it. Many of the pieces I create are fairly tall, and having a seat that can be raised or lowered gives me much finer control over my throwing, as it encourages better body mechanics. When centring the clay, I like to position my seat so that my hips are just slightly higher than the wheel head. This helps me put more of my body weight into centring. Quite often I adjust the level of my seat ever so slightly while throwing. Consistently being mindful of your body and of which positions are the best will really aid in avoiding injuries.

THROWING

The way I approach throwing now is very different from when I started. Many of the videos and books on throwing still show what, to my mind, are bad hand positions. The worst thing you can do when centring your clay is to hyperextend your wrist.

I was taught this hand position when I first started to throw and still see many potters working this way. Don't! It is only a matter of time before your wrists will start to ache. Once that happens you have the beginnings of an injury that will take time to heal. Now I centre with both my hands on the side of the clay, with my thumbs pressing down to stop the clay from shooting up—unless I am coning, of course, in which case I want the clay to shoot up! When pulling up, I work on the right side so that I am going with the flow of the clay, rather than against it.

OPPOSITE
After coning the clay up, I am now pushing it away from me and down.

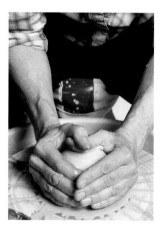

Good hand positioning while centring the clay.

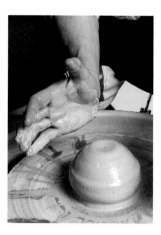

This is the hand position I really don't want you to use. We were taught this way in the past but it is very hard on your wrists.

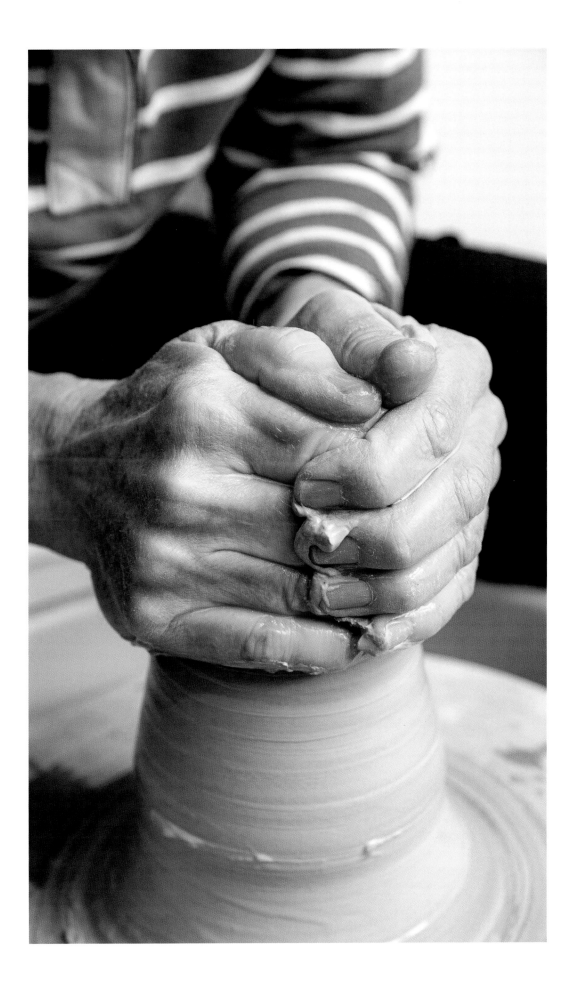

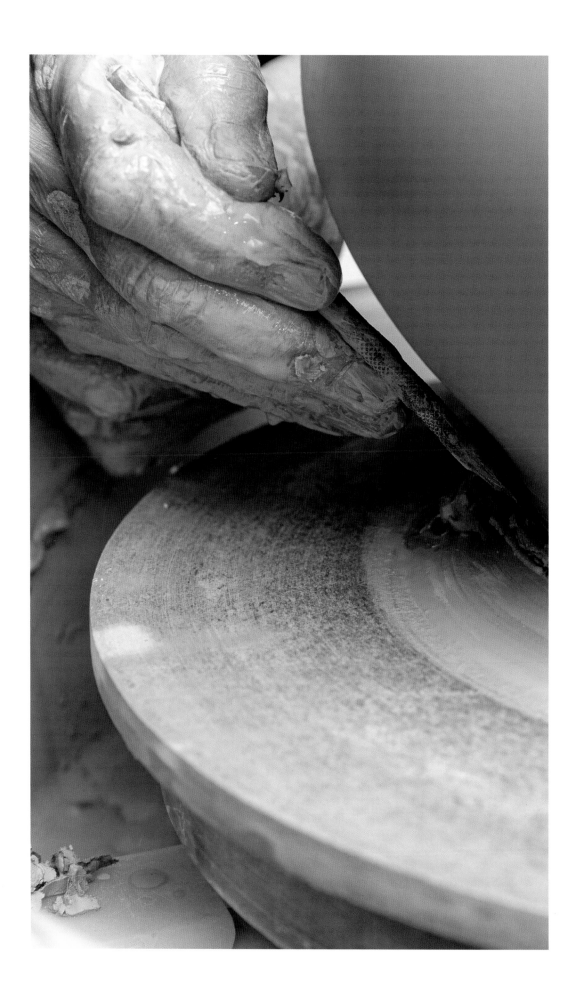

TRIMMING

Never underestimate the power of a well-trimmed foot! There are potters who don't trim as part of their style, but for me trimming is an integral part of the process because it helps to elevate the form and refine it.

Evenness in moisture level is important when you are trimming. When I was younger, I let my work air-dry since I was always in a bit of a hurry. Then I wondered why my tools caught at some points while I trimmed. At last I learned that when you dry in the open air, you don't get uniform moisture content throughout the piece. Now I dry all my work under plastic because the work dries more evenly. Although it may take a bit longer to get to the trimming stage, it goes much better.

I often use a Giffin Grip when trimming. Mine is so old that it is made of particle board. Although it certainly shows its years, it still works quite nicely. There seems to be a fair bit of controversy about the value of these grips in the pottery world, but I have found mine to be a great tool that has made trimming tall forms much easier.

OPPOSITE
Using a needle tool to slowly angle cut through the clay to the wheelhead. Before removing this excess clay, I run my cut wire under the bottom of the piece to release it.

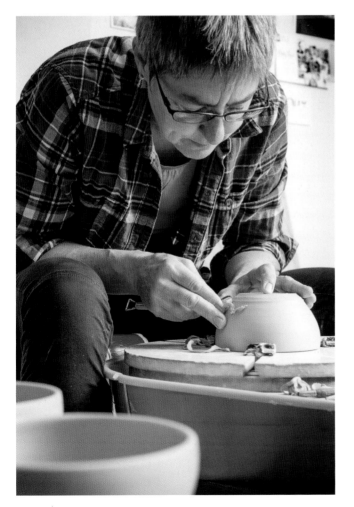

Trimming the base of a bowl secured by the Giffin Grip.

I learned to pull handles individually, lining them up like little hanging tongues before joining them to my pieces. I knew that some potters pulled their handles straight off their pots, but I thought that would be too difficult. I imagined that the pot would need to be quite damp, and I would end up warping the rim. I only came to pulling handles straight off the piece many years later, when I decided that if so many potters were successfully doing it that way, there must be a reason. It was definitely more of a challenge than my old method at first, but it soon became much easier. I loved how the handles looked and felt. They flowed out of the pot and didn't look as if they had been jammed onto the side. Now when I teach about handles, I do one mug with a handle added on and another with it pulled off the mug and ask the group which one they prefer. No one has ever chosen the added-on one. If you are new to pulling handles, I suggest that you practise pulling a handle off a drinking glass until you are ready to try it on a mug. Try not to overwork the clay: pull your handle in three or four pulls at most, or the clay will get tired and your handle won't hold its shape well.

OPPOSITE
Pulling a handle on a leather hard mug.

Demonstrating to workshop participants how to practise pulling a handle off a jar.

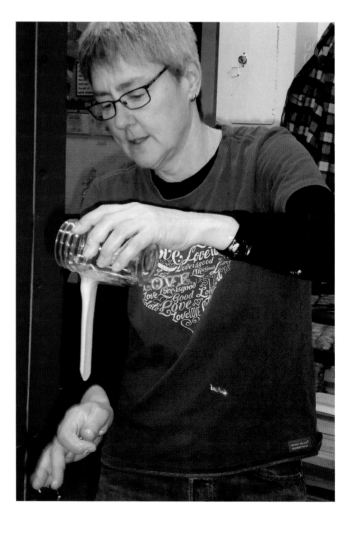

Throwing is addictive. When we are learning and even after we've been potting for many years, it is easy to get so wrapped up in the process that hours can pass before we know it. I was very guilty of this. I used to throw thirty-six mugs at a go, take a break and then throw a different form. When throwing the decorative pieces, if they were large ones (3.5 to 4.5 kilograms), I limited myself to eight in a day. That's still a fair bit of weight. It wouldn't have been too big a deal if my hands got a break the next day, but that wasn't how I worked. The next day I might throw the same number of pieces, and there was trimming to do on top of that.

This is how I came to rely on what I call my Studio Disciplines. Once I have identified a problem area, often one that I have been aware of for some time but have been choosing to ignore, I make myself a rule. These rules help me to avoid the injuries that come with activities like binge throwing and instead to nurture a practice that gives me joy. Once, when giving a lecture, I was asked if I ever break my rules. I thought that was an odd question: what is the point of making a rule for yourself if you are going to break it, especially if it's designed to prevent your own pain and suffering? However, if I think I may forget a rule, I write it on a sticky note and put it near my wheel.

OPPOSITE
Removing my throwing lines from the interior of a bowl using a metal rib. Notice how I have supported my hand so that I am just that extra bit steadier.

Taking a final look at a bottle vase to make sure everything is just so before deciding it is done.

1 | Change Position

My physio has really impressed upon me how important it is to change body position every twenty minutes if possible. It doesn't have to be for long; even a few minutes will help. I now structure this into how I throw. For example, when I throw mugs, I get twelve balls of clay ready instead of the full twenty-four I would do in a normal day. I put a narrow ware board on my throwing bench that will only take six mugs. This means that I have to get up after I've thrown six mugs to move the full ware board and put another one down. When twelve mugs are done, I go back to the pugmill and prepare the other twelve balls. This simple change to my throwing routine makes a big difference in cutting down on my overall body fatigue at the end of the day.

2 | Break Things Up

I used to throw for a few weeks and then turn my attention to glazing and firing. It's a natural way to work, since one gets into the creating zone and it can feel jarring to switch back and forth between activities. However, as this body gets older and I am increasingly mindful of taking the best possible care of it, I now work at the wheel for part of the day and do other jobs for the rest of the day. At times I am still resistant to this but have noticed the benefits.

3 | Keep Studio Notes

I came to this discipline slowly. I've always had sketchbooks in the studio, but since I rarely draw, I used them only sporadically. Some years ago I began the practice of writing notes to keep track of what I was throwing—the number of pieces, what they were and the clay weights. Sometimes I added other notes, such as end measurements or just what was happening in my life that day. The number of times that I went back to my notes to look something up soon taught me that this was a very good practice. I have also started doing this in the kiln room when I am glazing; sure enough, I often find myself going back over my notes to see what I did the last time.

4 | Clean Daily

I didn't always clean my wheel every day. I thought, *Why bother? I'll be throwing again tomorrow.* But my attitude gradually changed after I started to clean my wheel and throwing area each day, and I noticed how good it felt when I came to the wheel the following day. Now I look at my cleaning ritual as a discipline. I wouldn't dream of not cleaning everything up at the end of the day.

There is never much to sweep up in my creation room because I pick up the trimmings that fall to the floor before they dry. Since the floor is polished concrete, it's very easy to sweep without creating dust. I wash down both sides of my ware boards after each use and wash the creation room floor as needed.

5 | Take Your Time. Life Is Not a Race.

In the first few years of life as a studio potter, there is much to learn. Because our skills are still being perfected, everything takes more time. It's natural to push our young bodies because we don't have years of experience behind us. When I was young, I was always in a hurry. I worked long hours creating inventory for stores and craft fairs. My mind was often one step ahead of what I was doing, already thinking about the next tasks that I needed to complete. I ignored my aching body, pushed on by my desire to create more and my fear of being unable to pay the rent.

However, with many years of experience I developed a number of Foxisms that I am happy to share, my favourite being, *Life is not a race!* Take your time to enjoy the process. When I first became mindful of this, I was stunned by how many times in a day my mind jumped ahead to the next job or I pushed to get something done that I believed had to be finished that day. I am convinced that when I was younger, my love for creating tableware was diminished in part by this attitude and approach. When I worked on decorative pieces, I was able to slow down, focus on the forms I was creating and take more time with each piece. I never came to the wheel with the thought, *I'll do x amount of these decorative forms to get them out of the way so I can move on to another form that I prefer.* I was always tuned in to the piece and centred in a calm, happy place. And it showed in the work. As I became more mindful and present in my work, I found it spilled over into other aspects of my life. Now when I feel that urge to hurry, I pause, recognize it for what it is and stop the pattern.

As potters, we craft not only our work but also our lives. Today there is nothing that I create in my studio that I don't take pleasure in. If I find I am putting off creating something, I step back and take a closer look at my resistance. Often it is a case of doing too much of one thing and feeling both body and soul fatigue as a result. Making mugs is a good example of this. I have always taken great pleasure in how much people love using my mugs. Nothing makes my day more than when someone comes into my gallery after breaking their special mug; they don't want to go even a day without replacing it. I certainly have my favourite mugs—for my morning coffee it's a peasant ware mug, for my afternoon cappuccino another mug, for soup yet another. We become very attached to these objects since they bring joy into our days. So why have there been times when I wanted to stop making them? After some thought, I decided the problem lay in how many I was making at a time. Since that realization, I haven't made more than twenty-four at a time and will often just make twelve. This is my way to keep the pleasure alive. Sometimes it just takes a little soul-searching to find what will work for you.

6 | There is Joy in Repetition

We have all heard the question in relation to an artist's output: "Is she doing anything new?" I do understand this question. One wants to see growth in a person's work, but growth can happen through repetition, too. Why do people have the notion that only change represents growth? That constant change is something to aspire to? Why aren't we content with where we are? In Western society we are often looking for the next "great thing" or something new, and yet we seem to have a different standard when viewing the work of potters from other cultures. Then we hold in great esteem the potter who produces the same bowl day after day, marvelling at the beauty that can only come through repetition.

Pottery is a repetitious job. If you find this bothers you, then maybe pottery isn't the job for you. Or maybe you will decide to do repetitive work to build up your skill level and then do original one-offs. I love the incremental growth that so many people have seen in my work over the years, but I am constantly learning through the discipline of creating the same forms over and over again. Through this repetition, I feel I am becoming a better craftsperson.

OPPOSITE
Those big hands of mine fashioning the knob on a teapot lid.

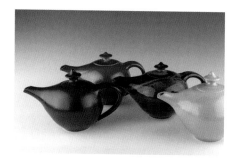

TOP
People often note that my teapots look like Aladdin's lamps. I can't promise they will make your dreams come true, but they will give you a nice cup of tea.

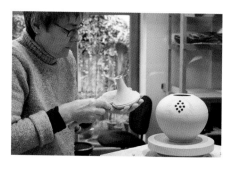

MIDDLE
Cutting the spout at an angle before attaching it to the teapot.

BOTTOM
Joining the spout to the teapot. I like to have a smooth line, so this takes me quite a while.

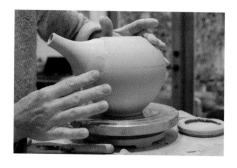

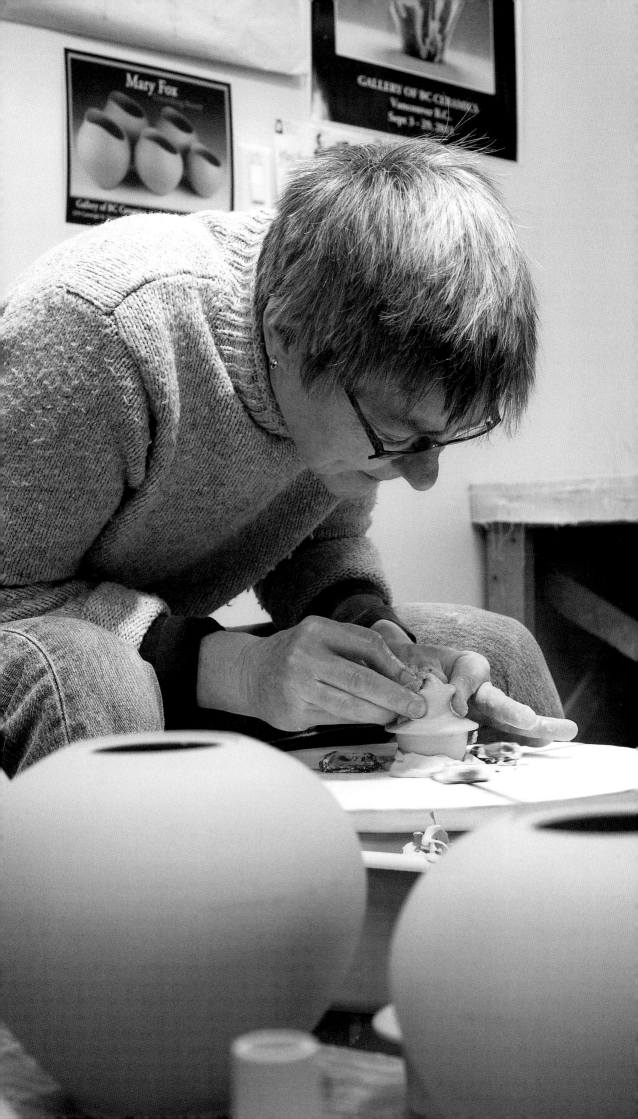

SELL THOSE POTS!

"If you want the world to know about you and your work, it's up to you to get the message out."

Most potters don't exactly light up when the topic of selling arises. Let's face it, most of us are artists first, and selling our work is not a favourite pastime. Who wouldn't prefer to spend time at the wheel rather than pricing, invoicing and shipping? But, after the creation of the work, this is the most important part of our job.

When you are starting out, one of the best routes to market is selling at local craft fairs. I suggest choosing small fairs. You can get invaluable feedback on your work while earning some coin, and you don't usually have to pay too much for a table. There are also many large craft fairs eager to rent you one of their expensive booths, and they court craftspeople with promises of great sales and contacts. But once you take into account the time and costs involved, most people don't do that well at these big fairs unless they are selling food. I have done a couple of them and never made enough to make it worthwhile.

However, imagine if you took all the money you would have spent on one of these big craft fairs and invested it in self-promotion instead? As a young potter, I took note of how other artists marketed themselves and found inspiration in two examples. One was Roy Henry Vickers, who often ran ads featuring his work in Island newspapers. The other was Robin Hopper, who advertised regularly in local news outlets. His ads were small, but they were there week after week, promoting his Metchosin pottery. I watched as the reputations of these artists grew, while those of other artists did not grow at the same pace. Both went on to build successful careers, Roy with his beautiful gallery in Tofino filled with his own work and that of other Indigenous artists, and Robin with a gallery at his pottery where he was able to sell enough work to stop relying on commercial galleries.

Many artists don't pay enough attention to this part of their job since they assume the galleries representing them will also

"I often hear artists begrudging the time spent on their websites or bemoaning how much work it entails. To them I say, imagine if you took all the time you spent sitting at a five-day craft fair and applied it to developing your online presence?"

promote them. Of course, galleries do promote their artists but they promote themselves first, as they should because it's their business. However, if you want the world to know about you and your work, it's up to you to get the message out, and in these days of electronic media, it's relatively easy and inexpensive to do. The internet and social media have been fantastic for artists, making it possible for us to reach large audiences at very little cost.

Some artists are taking full advantage of these tools, but many still aren't. I often hear artists begrudging the time spent on their websites or bemoaning how much work it entails. To them I say, imagine if you took all the time you spent sitting at a five-day craft fair and applied it to developing your online presence? If you want to do this for a living, you need to treat this as part of the job.

WORKING WITH GALLERIES

All ready for the opening of my show *Classic Forms Revisited* at the Gallery of BC Ceramics, 2011.

OPPOSITE
Chalice, 2016.
Layered glazes, oxidation, mounted in rock, 68 cm T.

My customers often ask how commission works with galleries and are surprised to learn that galleries take a 50 per cent cut. Many customers and artists feel this rate is too high. I disagree, though I understand where the critics are coming from, since they see the artistic work as more valuable. But what they often don't take into account is all the costs involved in running a gallery. Once the gallery owner has covered the rent, salaries, utilities, insurance, exhibition costs and promotion, I don't think there is a lot left over. One of my mottos is "Everyone needs to make money." With this in mind, if I get a referral from a gallery that represents me, I send a referral fee back to the gallery. It is a small thing to do but shows that we are in a business relationship together.

I very much see the gallery/artist relationship as a joint endeavour and do what I can to make things as easy as possible for the gallery. For example, I do all my photography in-house so I can document my work before I send it out and provide the gallery with photos. This saves the gallery time while ensuring that the images they use are ones I am happy with. It's more work for me but well worth it. The added bonus is that I have a file with photos of the pieces the gallery has, which can be very handy if I need to reference the work later. Every January I do an inventory for each of the galleries that represent me to make sure that all my work is accounted for. Some galleries do this themselves so that makes it easy, but some don't. If you start a discipline of doing a yearly inventory, it will be easy to keep on top of things.

These days, though I still have galleries representing me, I am happy to say that the majority of my work is sold through my gallery at Mary Fox Pottery.

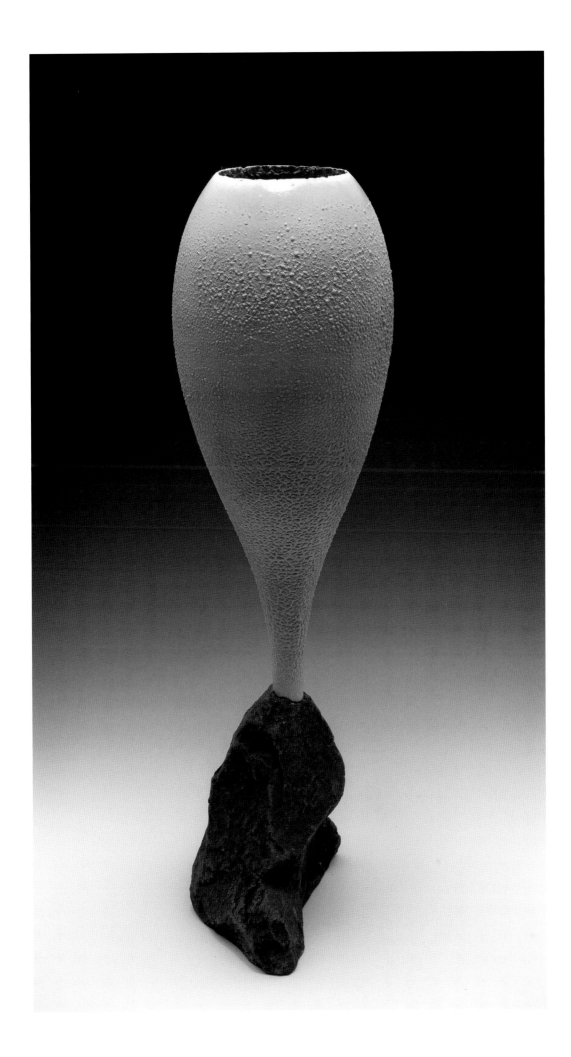

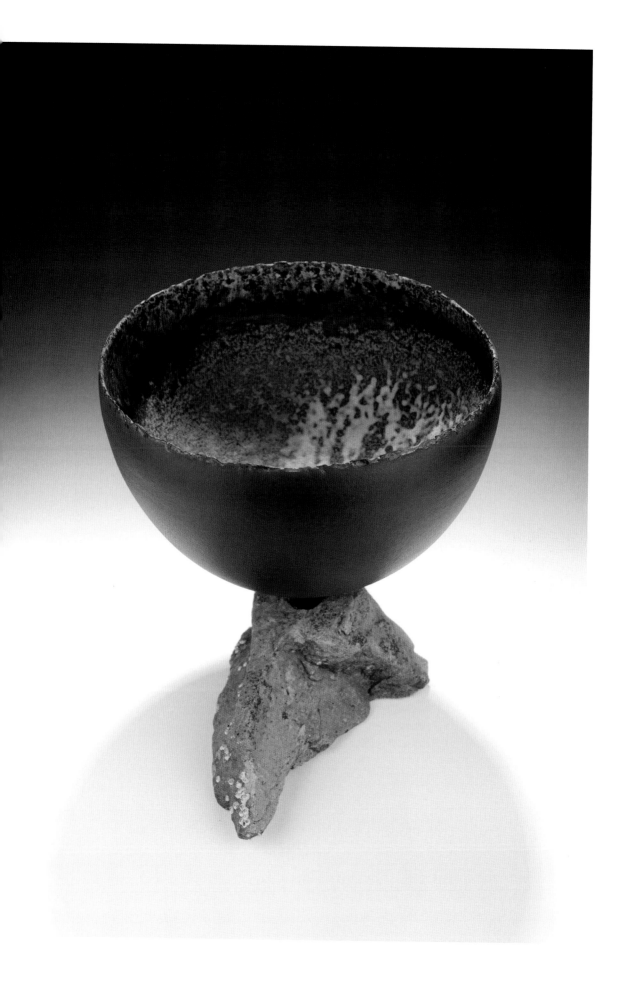

OPPOSITE
Chalice, 2016.
Multiple glazes, oxidation,
mounted in rock,
32 cm T × 31 cm W.

Primordial Beauty at
Winchester Galleries,
2016.

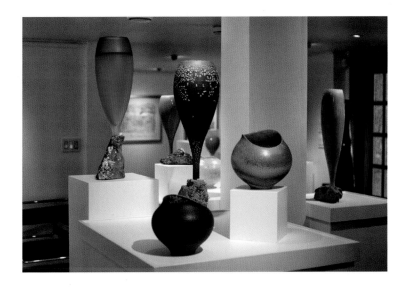

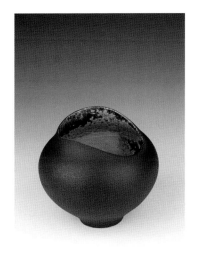

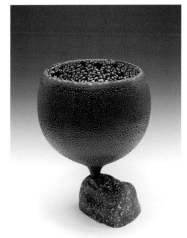

Altered Vessel, 2016.
Multiple glazes, oxidation,
22 cm T × 22 cm W.

Chalice, 2016.
Multiple glazes, oxidation,
37 cm T × 27 cm W.

CHALICE FORMS AND BASES

"My chalices are designed to enhance and inspire everyday life with their beauty and to invite contemplation and reflection."

BASES WITH STEMS

When I started to work again in 1994, one of the first forms I turned my attention to was the chalice. My chalices are designed to enhance and inspire everyday life with their beauty and to invite contemplation and reflection. In these pieces I aim for a feeling of upward flowing energy, which is at the same time firmly anchored to the earth by the base.

The first chalices I created were made with stems to lift them up. Although they evolved into pieces I quite liked, they still weren't projecting exactly the feeling I wanted. Then one day a gentleman visiting my studio reached up, grabbed one of my chalices and said, "This would make a great champagne glass!" This was a comment I did not want to hear! But there is nothing like a complete stranger blurting out what they see in the work to bring you up short. After he left, I felt quite disgruntled and moody, but I knew there was some truth in what he said. If he saw the chalice in that light, so would others. And if I was being honest with myself, I had to admit I saw what he meant.

How could I get the feeling I was after? I mulled this over for a long time. I found myself recalling my conversation at Banff with Victor Margie and reflecting on the lovely feeling of lift Hans Coper often achieved in his pieces. I realized that with my chalices I wanted the attention to go to the form rising up from the base, not to the base itself. How the piece was mounted needed to be a secondary observation.

THE HOCKEY PUCK BASES

I sketched out a few ideas but kept returning to a design for a dark, round base. This felt right to me, so I went ahead and made

a few. I darkened them by heating them up, pulling them out of the kiln, then covering them with sawdust to smoke them black. The first ones looked like hockey pucks, but I felt I was getting somewhere. These bases got away from the look of a goblet or cup stem and came closer to my idea of a mount to hold the chalice form. At last I was getting the upward lift I had been trying for.

CONE-SHAPED BASES

With the hockey puck design, I felt I was finding my style and I was pleased with the work. But as with any body of work, the more thought and energy you put into it, the more it grows and evolves. The round, flat bases I was making started to change to more of a cone shape with an upward angle, and I began to see how the form of the base itself could contribute to the feeling of upward movement I wanted. However, the unevenness of the smoked surface became more noticeable with the more angular bases; I wanted a solid black colour and found that the lighter straw marks on the smoked bases were distracting to the eye. Then one day I was in a hardware store and my eye settled on a can of black spray paint. It was one of my *Aha!* moments. I went home armed

OPPOSITE
Chalice, 1998.
Lithium compound, raku,
34 cm T × 23 cm W.

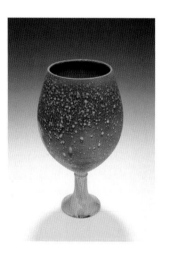 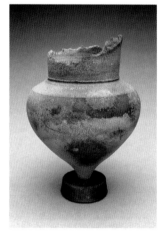

Chalice, 1995.
Lithium compound, raku,
32 cm T × 17 cm W.

A chalice with one of my first smoked black bases. It was exhibited in *Classic Vessels and Adornments* at Circle Craft Gallery, 1996. I still remember making this form and wondering as I was tearing the lip how on earth I was going to trim it, since I clearly couldn't just turn it over and let it rest on that delicate rim. The Giffin Grip came to my rescue but it was still a tricky balancing act.

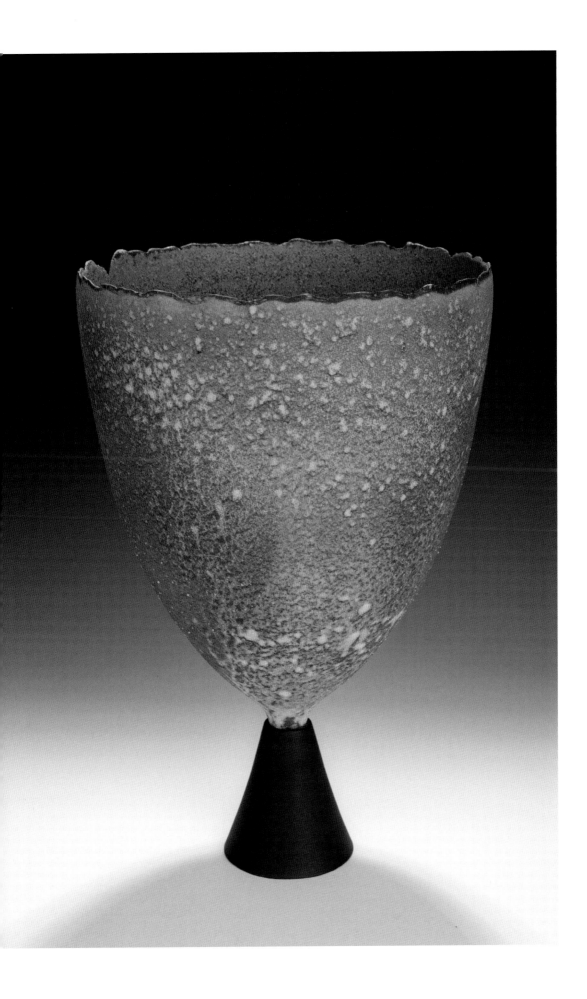

ABOVE LEFT
Trimming chalice bases.

ABOVE RIGHT
Chalices on my throwing racks,
drying upside down alongside
a fresh batch of bases.

with several cans of spray paint and tried it out on the bases. It
worked! The first pieces I mounted with spray-painted bases had
the look I had been searching for. Now instead of my eye going
to the base, it floated up over the contours of the chalice.

───

FROM THROWN TO MANUFACTURED BASES

My next challenge was refining the form of the bases. As each
chalice was different, so too were their bases. To get the flow of
lift just right, the form of the base had to be tailored to the piece.
Over the years I made hundreds of these bases. They were tricky
to throw because any slight unevenness in the surface would
show. When it came to painting them, I would often get drip
marks that showed and I had to fire off the paint and try again.

One of the things I am mindful of in my work practice is enjoying
all aspects of my job. If there is a job I am resisting because I
don't enjoy it, I try to find a way to reframe it. This practice usually
works well for me, as often I can find beauty or pleasure in unap-
pealing jobs if I just look at them differently. With these chalice
bases, though, I was not finding the joy! I started to dread having
to make them. Because they are so finicky to throw and trim, my
body and knee would ache when I was done, likely from tension
and leaning my leg too far out from the wheel pedal.

It occurred to me that maybe I could get someone else to make
the bases, possibly out of metal. But how to go about that? The
chalices I had been making were all different sizes and shapes, and
that meant the bases were variable too. My first thought was to
make all the chalices with the same-sized stem. Until then the
stems had ranged from the size of a dime to a quarter. And then
there was the problem of the variable forms of the bases
themselves.

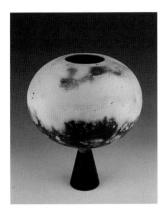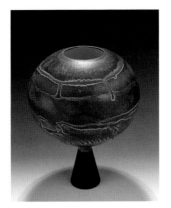

I was having a very hard time figuring this out when, once again, a friend came to my rescue. Greg Nuspel works as a prototype machinist, and he caught on right away to the challenges I was facing. The next time he came to visit he brought some calipers and went around the house examining all the chalices and making notes on the size of their bases. It soon became apparent that I was using some sizes and shapes more than others, so we talked about how I might get bases made to correspond to the most frequently used ones.

I was fortunate that Greg worked for a company that dealt with manufacturers overseas, and we were able to order the black metal bases through his company. Greg did the drawings for the bases, and I ordered seven different sizes to try. I have now used the metal bases on a few pieces and am happy with them on the whole, though I will make an adjustment for the next batch. I was mindful of the cost on the first samples, so I didn't ask them to hollow out the bottom but will request that for the next ones. I think they will sit better with that extra touch. Always fine-tuning! As much as I liked my clay bases, from this point forward I will use the manufactured metal ones.

FORAGED ROCK BASES

Around 2002, after I had been using the black clay bases for a while, I found myself musing that some of the chalices had an earthy feel to them, as if they were mushrooms blooming in the forest. This got me thinking about other ways to mount them. My first idea was to use driftwood, but that didn't seem quite solid enough. Then the idea of rocks came to mind, and I knew they would be perfect. Rocks have the movement I was looking for, they have the necessary weight and they would be unique to each piece.

ABOVE LEFT
Chalice, 2018.
Saggar fired, mounted in metal base, 26 cm T × 22 cm W.

ABOVE RIGHT
Chalice, 2018.
Lithium compound, cone 06 oxidation, mounted in metal base, 26 cm T × 22 cm W.

OVERLEAF LEFT
Chalice, 2018.
Glass Nebula series, mounted in rock, 44 cm T × 28 W.

OVERLEAF RIGHT
Chalice, 2018.
Glass Oceanic series, mounted in rock, 46 cm T × 26 cm W.

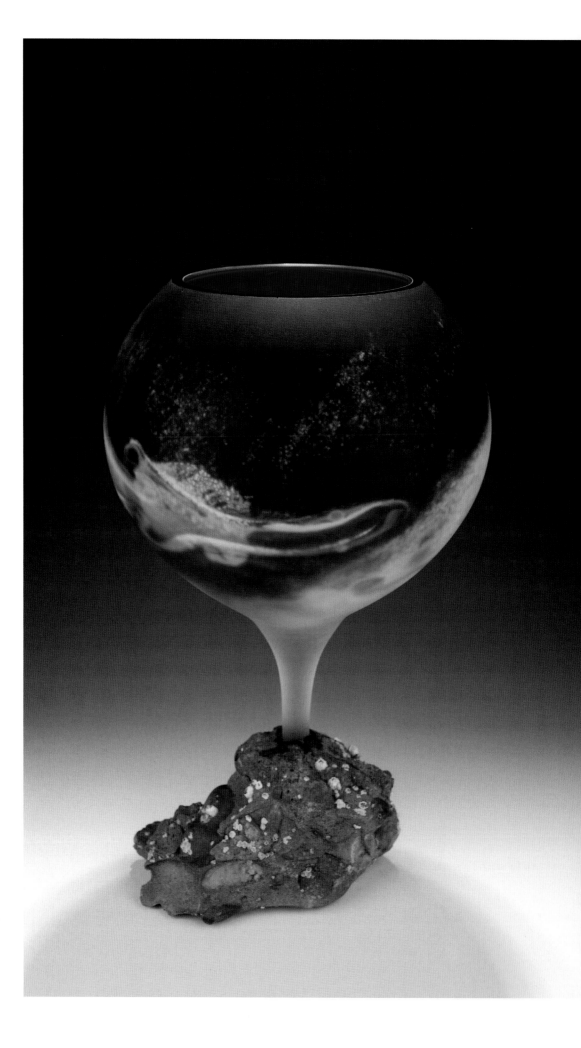

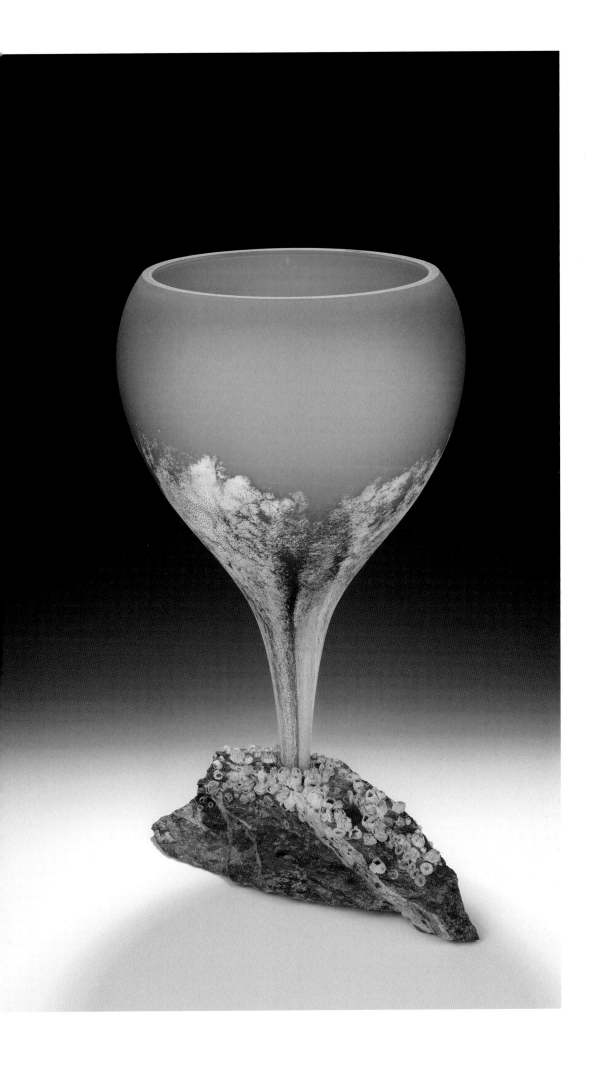

I was very charged up by this new idea but realized that in order to make rocks into bases, I would need to find someone to drill mount holes in them and cut the bottoms flat. I approached Daniel Cline, a rock sculptor who lives in nearby Chemainus. He agreed to do the work for me, and soon I was looking at rocks in a very different way! Now any time I am out in nature, my eye is on the lookout for potential rock bases. Most come from the local beaches, the sandstone ones being my favourites. Daniel is ever so careful with them, as there are often barnacles or oyster shells still attached that I want to keep on the rocks whenever possible.

When people ask me where the rocks come from, I like to say they are all locally foraged. However, some of them have been toted quite a distance! When I go on my rock-hunting excursions, I take a few friends along to help with the hauling. They know my legs will be toast if I lug rocks to the car, so we have developed a system where I hunt and make little piles and they come along and carry them to the car. I admit to sometimes asking them to make more back-and-forth trips than they would like—I am a bit of a taskmaster—but I reward them with a nice dinner out or I cook for them once we get the rocks home.

With the first rock-based chalices I made, I attached the chalice permanently to the rock with epoxy glue, but this proved problematic for shipping. Now I make an epoxy well in the hole that the chalice can slip in and out of, so I can separate the pieces for shipping.

Morning walk with the girls at Transfer Beach in Ladysmith.

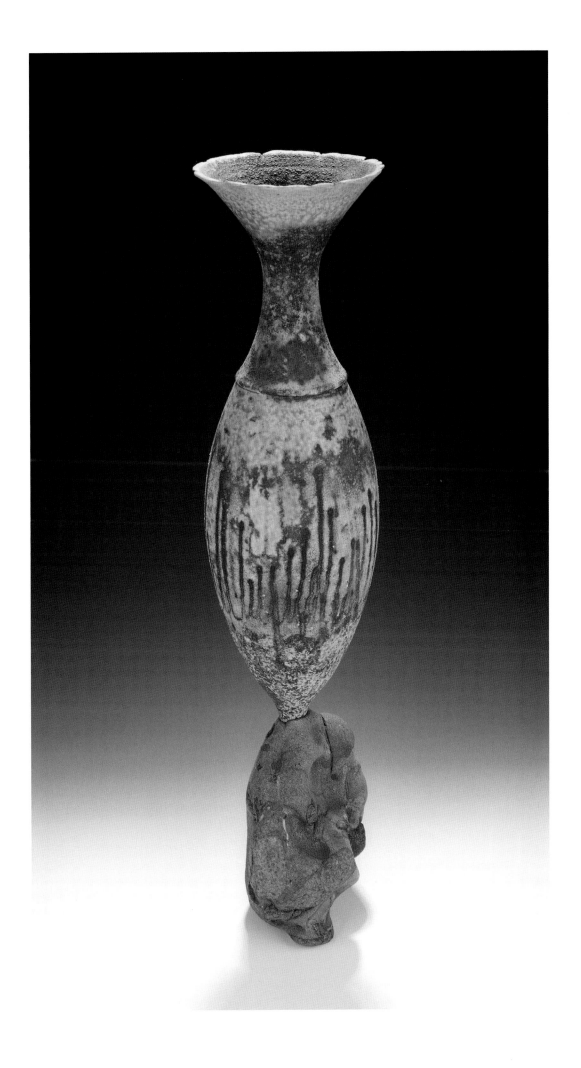

CREATING CHALICES: THROWN AND CAST

"The chalice is one of my favourite forms to throw, and I have created many interpretations of this form over the years."

THROWING

The chalice is one of my favourite forms to throw, and I have created many interpretations of this form over the years, ranging in height from about fifteen to thirty-eight centimetres (6–15 in). My approach is different than for any of my other pieces, as I shape the narrow stem at the bottom during the trimming stage. This means that while throwing I need to keep extra clay at the bottom to trim later. Then, as soon as I open up the clay, I focus on this bottom part, collaring it in as much as I can before pulling up the clay to create height for the stem.

After this, I concentrate on the form. Once the chalice is more defined, I slow the wheel down and tear the rim. I started tearing the rims on most of my forms years ago, as it helps create the feeling of upward movement. I go back to the rim a few times as I work the form, tearing and refining the lip. Once the top portion of the chalice form is finished, I very carefully remove some of the clay at the base to make it easier to trim later. Then I transfer the chalice to the racks to stiffen up overnight.

The next day it will be at the leather hard stage, ready for trimming. To protect the delicate torn top rim during this stage, I place a piece of foam over it, put a bat on top of the foam and then flip it over. Now it's ready to go back onto my wheel, where I trim the foot down to the size of a quarter. This little stem is what the chalice stands on through all the firings. And there you have it … all done!

SLIP CASTING

When I was younger and quite full of myself, I looked down on slip cast work. I understood why someone would slip cast an

1 | Collaring in the base.

2 | Having left about a 2.5 cm thick (1 in) base of clay when opening the form, I now start to pull up.

3 | I collar in the bottom once more and continue to pull the form up.

4 | Tearing the rim.

5 | Shaping the form and removing my throwing lines using a metal rib.

1

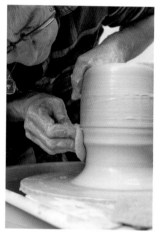

2

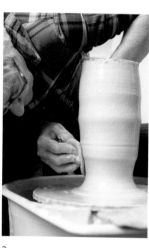

3

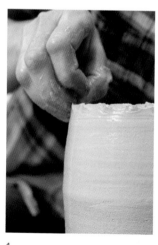

4

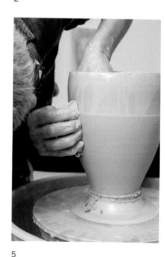

5

6 | Inserting my needle tool at a 45-degree angle to cut through some of the spare clay around the base.

7 | Removing the excess clay before taking the chalice off the wheel.

8 | Beginning the process of trimming the chalice stem.

9 | I place a quarter as a guide to help me make the stem the right width, and smooth out the surface with a plastic rib.

10 | And there you have it, all done.

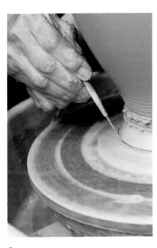

6

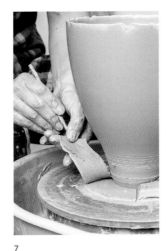

7

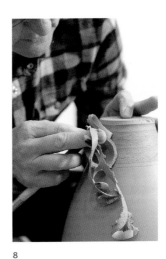

8

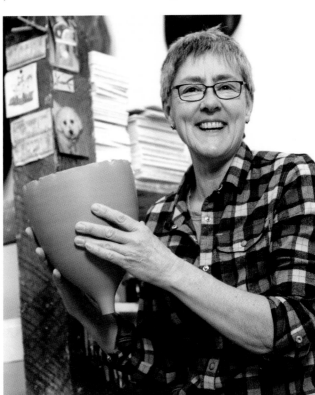

9

10

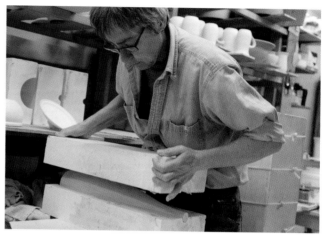

1

intricate form, but I could not fathom why they would cast a simple form that could be easily thrown. What was the advantage, apart from the fact that to slip cast you don't need to know how to throw? I saw it as a production tool that didn't fit with my vision of being a studio potter. I had no idea of the skill involved in casting, other than for making the actual moulds. Then, lured by the possibility of creating taller chalice forms with long, elegant stems, I decided to give it a try and discovered it's not that easy!

The first problem I encountered was the annoying seam lines. Moulds are made in sections; when you pour clay slip into the mould, you inevitably get a seam line in the clay where the sections join. My moulds are made in two halves with a CNC machine, so I only have two seam lines to deal with. However, if you are casting a more intricate form, the mould may be in many sections, and for every section there will be a seam line. I have found them to be more challenging to remove than I expected.

When the chalice first comes out of the mould, I use a fettling knife to remove the lines; then I go over the piece with a soft rib and finally a sponge to smooth everything over. However, sometimes when the piece has dried, the lines still seem to stand out, so recently I tried Kemper Quick Cleaners. These sheets can be used for sanding without leaving scratches. So far, I have only used the 280 grit to sand the seam line on a bone-dry chalice, and it worked very nicely. I also bought the 400 and 600 grit sheets, which can be used for fired surfaces. They will come in handy after the form is bisqued, as sometimes I notice those nasty seam lines have reappeared and are still raised up a little from the surface. Often the layers of glaze will hide this, but I am a detail person: I don't want to take the chance that seam lines will show through when the piece is finished.

2 | Carefully taking the chalice out of the mould.

3 | Ready to carry the chalice to the banding wheel to remove the seam lines.

4 | A chalice balanced in the chuck, ready for me to start the delicate process of finishing the rim.

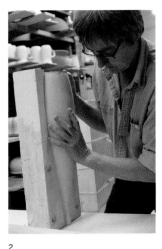

2

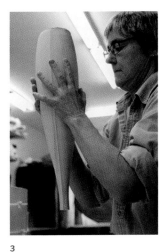

3

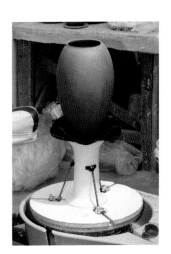

4

The next problem I encountered with slip casting was mixing and pouring the slip. I used a hand-held drill with an ES fifty-three-centimetre (21 in) Jiffy Mixer because everything I read said that slip benefited from long mixing, but I quickly realized I would burn out my drill in no time. Worse than that, I felt an old familiar pain in my elbow and knew that if I kept mixing the slip this way, I would irritate my old throwing injury, tennis elbow. Burning out drills I could live with, but reinjuring myself I could not. I did some research on slip casting equipment and purchased a slip mixer and pump from Lehman Manufacturing, which made the process a lot easier. After the clay slip has been well mixed, I transfer it to the pump machine and, using a nozzle very much like the ones used for pumping gas, pump the slip into the mould. No lifting heavy buckets of slip anymore, and if it's a really big mould, I can use the pump in reverse to suck the extra slip out of the mould instead of draining it through the stem. Problem solved.

After I've poured the slip and drained the excess from the moulds, I leave them to set up. Smaller chalices are left overnight, but I leave the bigger ones two to four days before removing them from their moulds. The bigger the forms, the more weight and mois-ture they contain. I had problems with warping when I tried to take them out of the moulds too early, but now I leave them longer with no ill effects.

Once I have taken care of the seam lines, I turn my attention to finishing the chalice rims. I wanted the rims on my cast chalices to be torn like my thrown ones are, so I came up with the idea of putting the chalice forms in a chuck—basically a bisqued clay form that holds the pot steady while you trim it—so I could work on the rims. Once the chalice is in the chuck and on the wheel, I start forming the rim. This isn't the easiest task since a cast

chalice is never perfectly round, but if I have the wheel going slowly enough, it works. While I am forming the rim, I tear it a little in the same way I tear the rims on the thrown chalices.

The next hurdle was firing. Unlike my thrown pieces, slip cast pieces aren't perfectly true and therefore won't balance on their stems during firing. Fortunately I have found that placing them upside down on a bed of alumina hydrate works well.

Just when I thought I had figured out all my slip casting problems, along came another. This one involved the low-fire casting slip I was using. For the most part it worked well, but it couldn't take the stress of repeated firings or high shrinkage glazes; switching to a raku casting slip from Laguna Clay (CN110) resolved the problem. This clay can take the stress of fast firing or repeated firings, and I've not had any cracking problems. I cast these pieces on the thick side as I find this helps with how the glaze adheres and also makes it easier to deal with those pesky seam lines.

I now have a much greater appreciation for slip cast work and the skill required for the whole process.

OPPOSITE
One of my first slip cast chalices. I was thrilled with how it turned out.

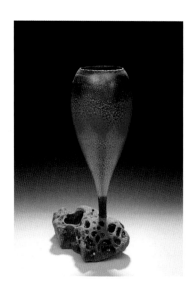 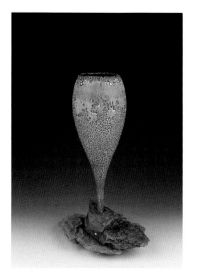

Chalice, 2016.
Cone 05 oxidation,
mounted in rock,
56 cm T × 30 cm W.

Chalice, 2017.
Crawl glazes,
mounted in rock,
41 cm T.

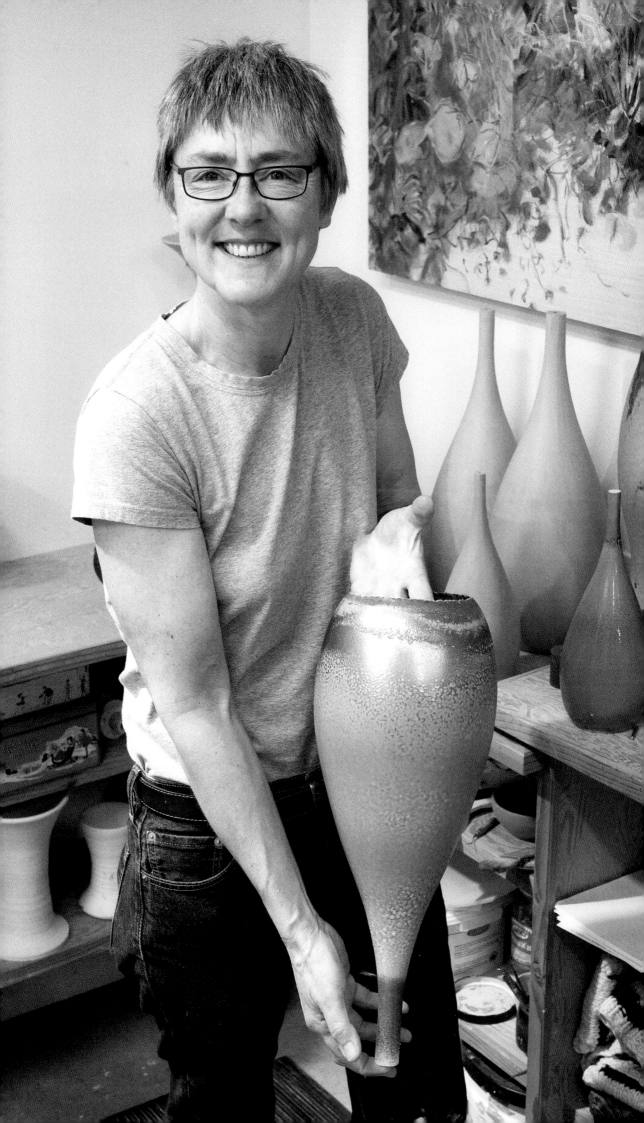

Chalice, 2014.
Crawl glaze, oxidation,
31 cm T × 22 cm W.

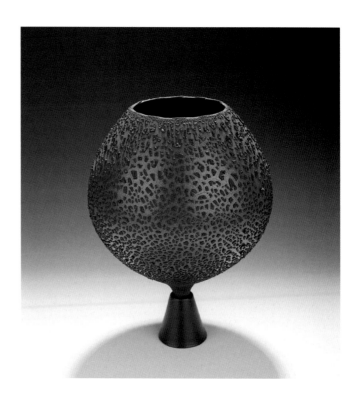

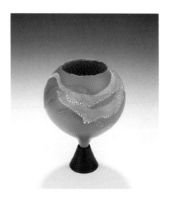

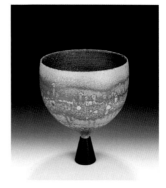

Chalice, 2014.
Layered crawl glazes, oxidation,
25 cm T × 18 cm W.

Chalice, 2018.
Lithium glazes, mounted in
metal base,
30.5 cm T × 24 cm W.

Chalice, 2015.
Lithium compound, oxidation,
23.5 cm T × 18 cm W.

THROWING VASES IN SECTIONS

"Throwing vases in sections on the
wheel was one of the biggest steps
forward for me."

Throwing vases in sections on the wheel was one of the biggest
steps forward for me, and I can't think of any other technique
I have learned that has had more impact on my designs. The first
time I tried this was when I started working again after my five-
year break. Before becoming ill, I had been making pieces in
sections by throwing the parts and then joining them together
at the leather hard stage. I was reasonably successful with this
technique but found it hard to get the scale just right, as I couldn't
see the whole piece until all the parts were put together. I tried
to solve this problem by throwing multiple parts so that I could try
them all out and pick the one that worked the best, but this was
a lot of work, and I didn't enjoy the process.

That's when I recalled seeing an article many years earlier, likely
in *Ceramics Monthly*, that showed someone adding a donut of
clay to an already thrown base to create height in a piece; I had
filed that image away in my memory as something to try one day.
When I first tried this technique, I was nervous about the bottom
part of the vase collapsing under the weight of the added clay,
so I kept the weight of the donut to around half to three-quarters
of a kilogram (1–1.5 lbs) and let the base get a lot drier before
adding the donut.

One of the first things I noticed was that, after the vase dried, you
could see where I had attached the top section to the bottom,
as there was a difference in shrinkage between the two sections.
If I put a collar line where the top part of the vase began, the dif-
ference wasn't very noticeable, but if the vase form was one
smooth line, it was quite visible.

Of course, shrinkage lines are not okay in my world. I am a picky
person who pays attention to details! I wanted those lines to dis-
appear so that the only way someone would know for sure that
the vase was thrown in sections would be to x-ray it. Even today,

it bothers me if I see a slight dip where the sections were joined. I want smooth, flowing lines; anything less just won't do. My solution to removing the join line lay in adjusting the dryness of the bottom section before adding the donut. I played around to see how soft the bottom section could be before it started to cave in when I added the donut and was happy to find that it held up even when quite soft.

These days when I throw sectional pieces, I work with a much softer bottom piece than I did years ago, but the skill in my hands is much greater, too. The bottle vases that I create now often have a donut weighing around a kilogram (2.25 lbs). This extra weight means I can make the necks much longer.

The bottle vase shown on pages 140–41 was made with a base that weighed 3.5 kilograms (8 lbs) and a donut of clay weighing 1 kilogram (2.25 lbs).

Once I have the donut reasonably well joined, I work my finger down under the joint and compress the two sections firmly together before I start to pull the clay up. As soon as I have a bit of height, I start to collar in the neck. By the time I get the piece to this height,

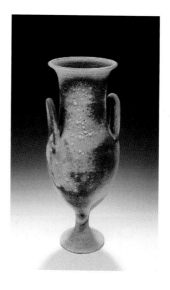 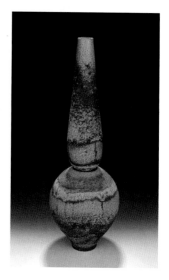

Krater, circa 1996.
Pre-thrown base, lithium compound, raku,
35.5 cm T × 14 cm w.

Tribute, circa 2006.
Created in two sections and joined when leather hard, lithium compound, oxidation, 59 cm T × 20 cm W.

I can't work from the inside very much, so now it's a process of gradually pulling up and collaring in to increase the height. When I have about two-thirds of the height I want, I stop to tear the rim, then shape the jagged rim with a metal rib. It's important to do this now; once the neck is at full height, it is very tricky to make adjustments to the top without throwing the neck off centre.

With the rim roughed out, I begin the final collaring to get more height and make the neck narrower. This part of the process really requires ovaries of steel because the neck can go off at an angle as I am collaring it. It is a matter of staying calm and steadily collaring upward until I am at the very top. Then, very carefully, I release the pressure and take my hands away.

Next I go back to working on the top before starting to smooth out the throwing lines on the neck. I have my throwing chair at its top height now, which helps to steady my arms. Needless to say, the job gets trickier by the moment because I now have a lot of height; one small slip and the neck will get thrown off centre.

At this point I look over the whole form, and if I decide it's a bit thick at the join, I trim a little off. Here I also take a quick look to make sure everything is still true and do a final tidy-up before turning my attention to the bottom.

The final step before removing the piece from the wheel is cutting away the extra clay on the lower part of the piece. I do this by carefully inserting a needle tool at a forty-five-degree angle to cut through the excess clay.

So this is the secret to how I make these impossibly tall forms. They will set up under plastic until they are ready for the next stage: trimming the bottom. Although you can do a fair bit of trimming from the bottom of a vase before you take it off the wheel, in my opinion you can never get as nice a bottom as when you turn it upside down and trim it. To do this, I use a very tall chuck.

Thanks to Zea Wulf for taking the shots of the trimming process. My customers never know what they will be called upon to do!

I am too picky for words. As I look over this beautiful form with my critical eye, I see the tiniest of bulges in the neck. I go back later to trim that fraction off.

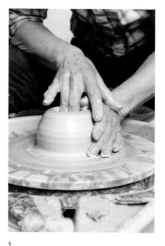

1

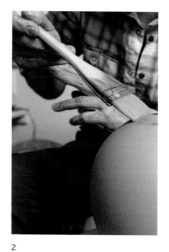

2

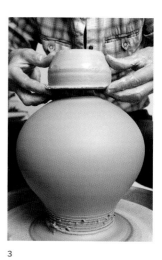

3

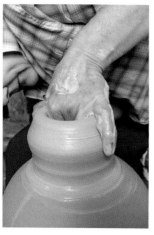

4

5

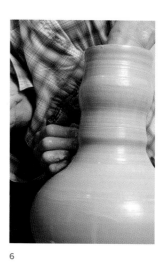

6

1 | Making the donut.

4 | Joining the two sections.

2 | Scoring the top and adding some water before attaching the donut.

5–6 | The donut now firmly attached, I start the process of pulling up.

3 | Putting the donut in place.

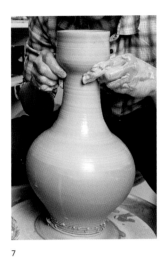

7

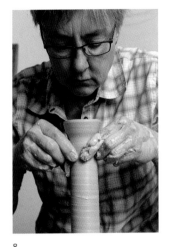

8

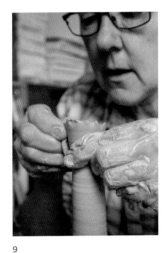

9

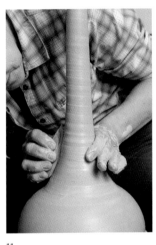

10

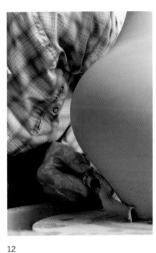

11

12

7 | As soon as I have a bit of height, I start to collar in the neck.

10 | With the rim now torn, I go back to refining the tall neck.

8 | Carefully collaring in the neck for more height.

11 | I have the height and form that I want, so now I take a metal rib to further refine the neck. At this point I need very steady hands, as any slip-up will throw the neck off centre.

9 | Collaring in the top after tearing the rim.

12 | The last step of throwing is taking as much clay away from the bottom as possible before taking the form off the wheel.

1 | To trim the vase, I place it upside down in the chuck. Notice the bits of foam—these are used to cushion the vase and avoid dents in the neck. Sometimes the vase can wobble a bit during trimming, which is a bit unnerving, but I have yet to break a neck on one of these pieces. Just go slow and all should be well.

2 | Carefully lifting the bottle vase out of the chuck …

3 | … and flipping it upright. Voila!

Vase, 2014.
Created in two sections: bottom section was made first, then a donut of clay was added the next day to create the neck. Terra sigillata, white crawl glaze, cone 05 oxidation, 46 cm T × 18 cm w.

1

2

3

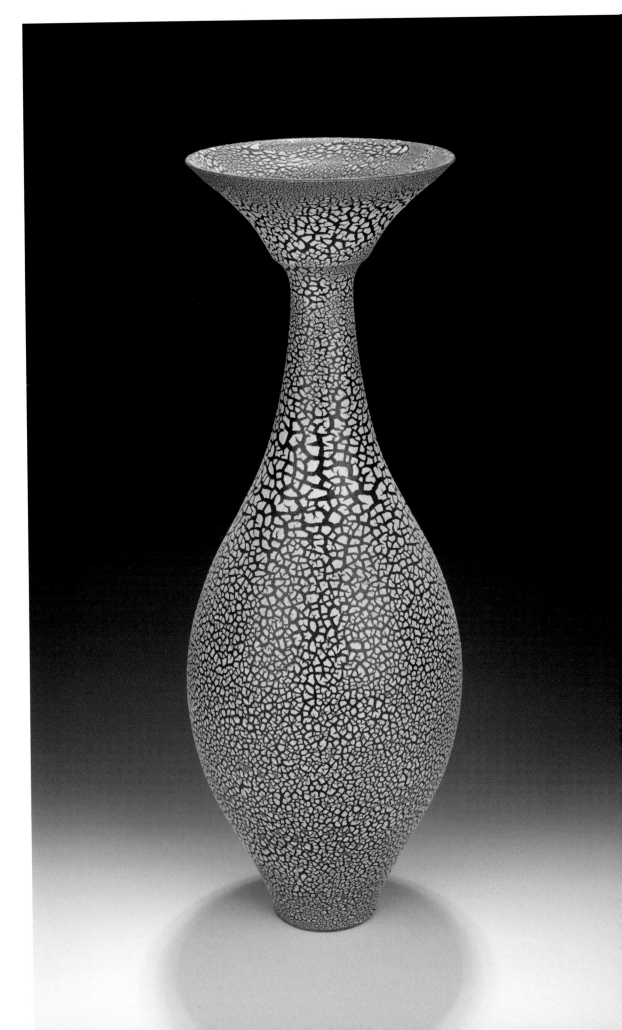

LITHIUM COMPOUND GLAZES

"Lithium compound is a fickle blend,
but it's well worth the time and practice
it takes to become skilled with it."

———

I call this glaze my lithium compound (rather than lithium glaze) because, unlike most glazes, it has only two ingredients—95 per cent lithium and 5 per cent copper carbonate. It is a fickle blend, but it's well worth the time and practice it takes to become skilled with it. The results can be spectacular. However, lithium is notoriously difficult to work with because it is a very strong flux, which can cause the glaze to run and eat into the kiln shelves. It also has a very high shrinkage rate and is prone to shivering, which occurs when a glaze undergoes too much compression in firing. Shivering results in slivers of the glaze flaking off, usually at the edges of a piece. It is a challenging problem to overcome, but I have found that it is less likely to occur if the glaze is applied thinly. When it has been applied thickly, another problem that can occur is blooming. This happens over time and can sometimes be quite a nice effect, though other times not, so I try to avoid it.

I have always applied my lithium compound glaze by spraying it onto the pots. This gives me greater control over the thickness and allows me to create areas where there is almost no lithium, just a fine dusting of glaze that will let the clay colour shine through. After I have sprayed the piece, I use ceramic tripod stilts to lift it so I don't damage the powdery surface. If you touch the glaze surface, your fingerprints will be visible after firing.

Over the years, I have experimented with different temperatures for firing pieces glazed with lithium compound and have settled on a bisque firing of 04 to ensure body strength and a glaze firing between 06 and 08. Most of my early lithium work was bisque fired lower, at 06, but after having problems with lime pops, I raised the bisque to 04. Lime pops are an irksome problem because they don't show themselves until long after the pot has been fired. They occur if clay has been contaminated with lime particles. These particles will gradually absorb water from the air, expand and eventually pop out a section of the fired clay body. I'm sure

Tripod Chalice, 2017.
Lithium compound, oxidation,
26 cm T × 17 cm W.

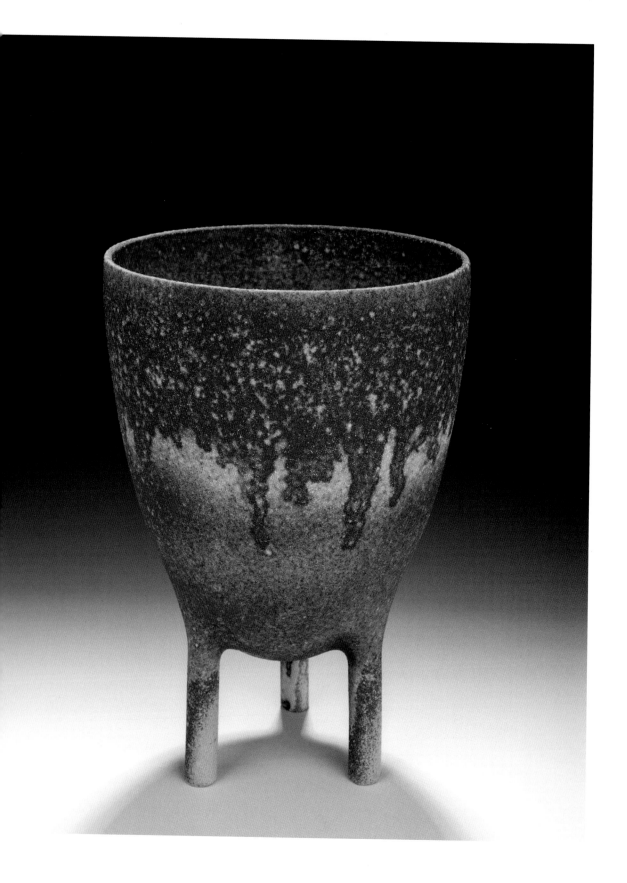

that clay companies are very careful not to let lime get into their clay batches. However, fireclay and lime are often found close together in the ground, so contamination can sometimes occur. One way to deal with this is to bisque fire at 04 to fuse the lime.

I raku fired all my early lithium work. The higher bisque resulted in more cracked pots, so I switched from the clay body I was using to Laguna Clay's Raku Industrial and the cracking issue was solved. I do find the pots a bit harder to glaze when bisqued to this temperature since they aren't as absorbent, but I prefer that problem to having bits of my pots pop off years later.

Around 2002 I started to experiment with firing my lithium compound pieces in oxidation and was thrilled to discover that the results were fantastic and also quite varied. It wasn't long before I was firing all of my lithium compound pieces in oxidation first. If I wasn't happy with the results, I would go on to raku fire them afterwards.

Over the years I have developed another interesting technique with lithium compound, which resulted in my Relic series. It occurred to me that there might be a way that the shivering issue

This early raku fired treasure jar, circa 1988, shows evidence of blooming. In this case I think it adds to the piece.

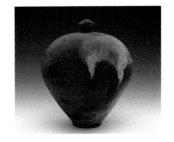

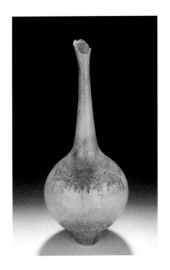

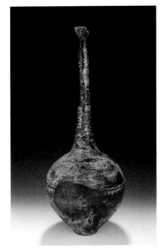

Bottle Vase, circa 2005. Relic series, white terra sigillata, lithium compound, cone 06 oxidation, 59 cm T × 24 cm W.

Bottle Vase, circa 2005. Relic series, white terra sigillata, lithium compound, multifired, oxidation, 61.5 cm T × 23 cm W.

Chalice, circa 1997.
Lithium compound, raku,
22 cm T × 18 cm W.

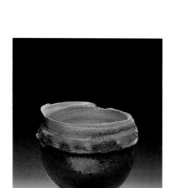

could be turned into a plus, so I took pieces that had shivered, ground off as much of the shivering as I could, applied more lithium and fired them again. Then I noticed that one piece with white terra sigillata on it had crazed a bit, a sign that the sigillata had been applied a bit too thickly. I sprayed lithium over the terra sigillata and it seeped into the craze lines, making a beautiful pattern.

Sometimes only one firing is required, but often I will do multiple firings because the lithium shivers and flakes off more. Between firings I go over the piece with a grinding stone, taking off bits, then applying more lithium and firing again. The more often I do this, the more the surface builds up, creating a beautiful ancient feel to the piece. I only fire these pieces in oxidation between 07 and 05. If I can't get a finish that I like after multiple firings, I try applying a crater glaze over top and firing again.

Currently I am exploring firing my lithium compound pieces in the Blaauw kiln, and I am getting some interesting results. I put them into the kiln with the saggar firings and fire to 06 in reduction. It's early days for me with this technique, but so far the results have been good. These pieces look quite distinct from the lithium pieces I have fired using other techniques.

Both these chalices were glazed with lithium compound and fired a few times, with lithium layers added each time. Unhappy with the results, I then tried adding a crater glaze over top. It took a few attempts, but eventually magic happened.

Chalice, circa 2004.
Layered lithium compound, crater glaze, cone 06 oxidation, 34 cm T × 16 cm W.

Chalice, 2009.
Layered lithium compound, crater glaze, cone 06 oxidation, 28 cm T × 15 cm W.

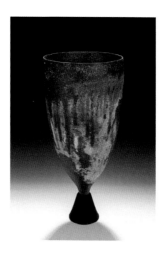

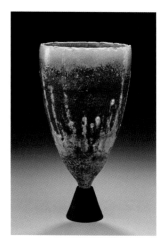

Altered Vessel, 2018.
Lithium compound, cone 06
reduction, 25 cm T × 25 cm W.

Vessel, 2013.
Lithium compound, raku,
27 cm T × 24 cm W.

Collared Bowl, 2019.
Lithium compound, reduction,
19 cm T × 26 cm W.

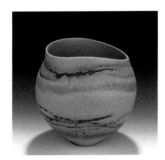

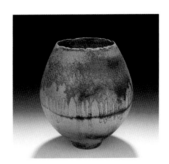

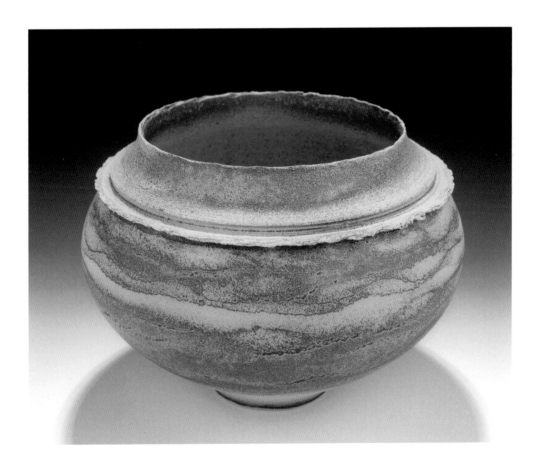

OPPOSITE
This chalice beautifully illustrates how the lithium compound can respond quite differently depending on the clay body it is applied to. This clay is a low-fire casting slip, to which I applied a thin layer of the lithium compound, fired it, then applied another thin layer and fired it again. It is mounted in a piece of rock I brought home from Sedona, Arizona, which made for a rather heavy suitcase. *Chalice,* 2016.
Lithium compound, cone 06 oxidation, 61 cm T × 18 cm W.

Altered Vessel, 2005.
Lithium compound, oxidation, 22 cm T × 23 cm W.

This bottle vase is a lovely example of how the lithium compound can look sprayed over a white terra sigillata and then raku fired. There is a very thin layer of lithium spray in the area that is white.

The dark area at the bottom has no glaze, so has absorbed the carbon from the firing and turned black.

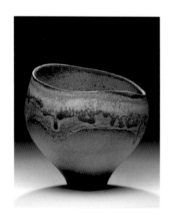

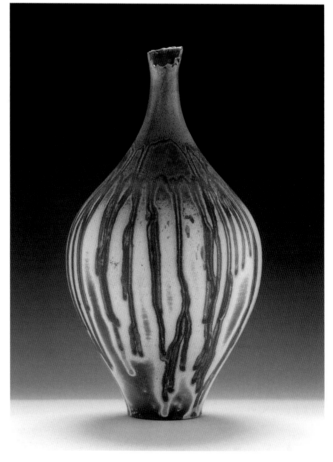

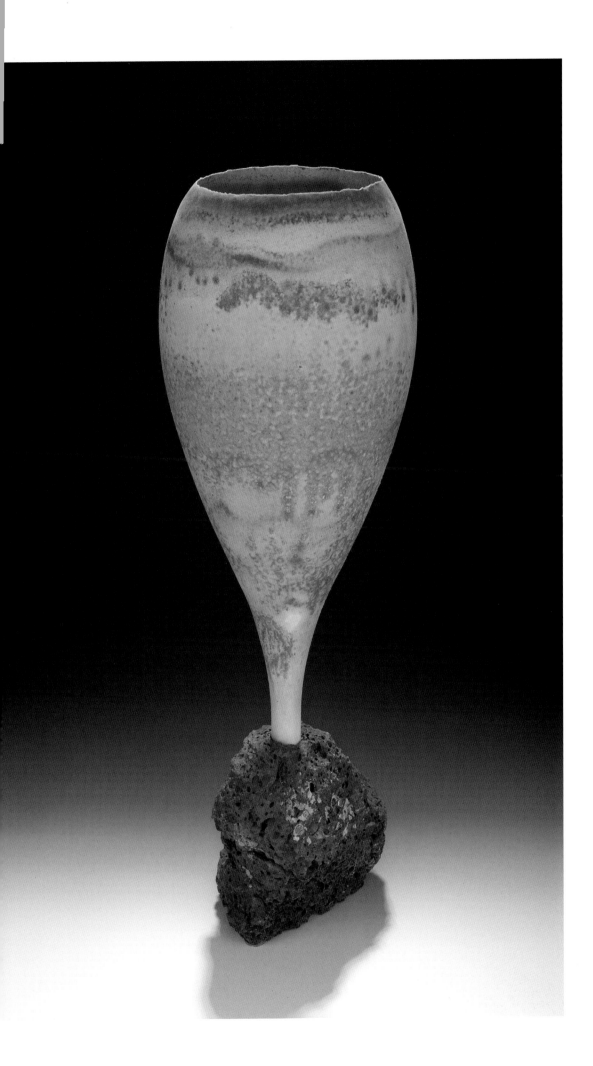

CRAWL GLAZES

> "The crawl glazes awoke in me a desire
> to create work with a modern feel."

In 1995 I began experimenting with crawl glazes, initially in an effort to solve a problem with my lithium work. The lithium compound glaze was giving me fantastic results when it worked, but I was only getting about a 50 per cent success rate and the pile of beautiful vessels with less-than-beautiful finishes was growing. Applying more lithium compound and refiring only made it worse, as that often resulted in shivering.

What to do about this? I reasoned that if I were to put a layer of a different glaze over the lithium to salvage the piece, I would likely have a problem with the glaze running, as lithium is such a strong flux. I pulled out my glaze books to read about shivering and then about glaze crawling, another common problem. Crawling occurs when a glaze shrinks or does not adhere well to the clay body, resulting in beading or peeling. It can be caused by a dusty surface or, more commonly, by having too much clay in the glaze. I realized that this "problem" could actually provide my solution: if I loaded up a glaze with clay or magnesium carbonate, it was unlikely to run. My first tests were made by adding various percentages of magnesium carbonate to my existing glazes, and I was pleased to discover this worked quite well.

Cheered on by my early tests, I began to look for low-fire crawl glaze recipes to play with and settled on one called Mark's Crawl. Since then I have played around with many other crawl glaze recipes in the low temperature ranges, but I haven't found one I prefer.

With this crawl glaze innovation, not only had I found a way to salvage my lithium pieces, but I had discovered a whole new realm of creativity to explore. With my lithium pieces I had tried to achieve an air of mystery around the work, a feeling of unearthed antiquity that would leave the viewer wondering if it was a present-day object or one from an archaeological excavation. The crawl glazes awoke in me a desire to create work with a modern feel

This is one of my earliest multi-fired crawl glaze chalices. Step one was to apply a layer of orange terra sigillata and then bisque fire it. Then I poured a layer of green crawl glaze into the interior of the vessel and sprayed the glaze on the outside.

Once it dried, I picked off areas on the exterior with a dental tool, exposing the terra sigillata underneath. I fired it again and then poured a final layer of a white crawl glaze inside and sprayed the glaze on the exterior. Once again I let it dry and then picked off part of the glaze before putting it back into the kiln for its final firing to cone 05

in oxidation. A lot of my early chalices had smaller stems than the ones I create today. This one was trimmed down to a point about the width of a dime, and that's what it stood on throughout all the firings. *Chalice,* circa 1996. 23 cm T × 28 cm W.

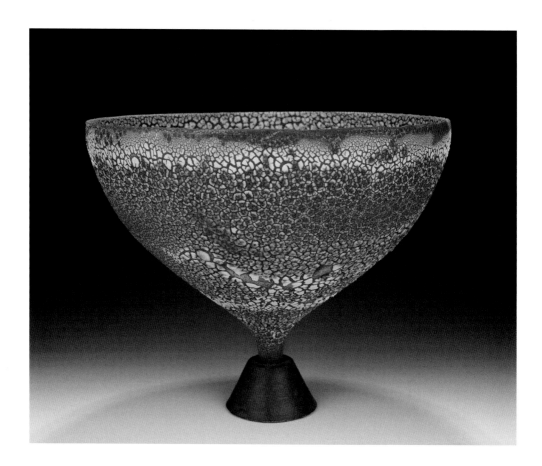

Bottle Vases, 2017.
Blue terra sigillata, white
crawl glaze, cone 05 oxidation,
45 cm T.

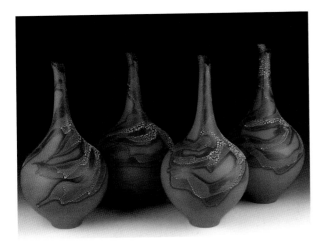

enhanced by colourful finishes, the first departure from my
earliest inspiration of Greek pottery from the classical period.
I recalled that someone at Banff had mentioned that my work
would suit terra sigillata slips, and that memory got my creative
wheels turning again. Terra sigillata is an ultra-refined clay slip
that can give a soft sheen when applied to bone-dry wares and,
if polished or burnished while still damp, may give a high gloss.
The ancient Greeks and Romans used this technique in lieu of
glaze. What if I started using different coloured terra sigillata
slips and underglazes as a foundation layer beneath the crawl
glazes? Down the rabbit hole of experimentation I went again!

Another technique I have used is applying an underglaze instead
of terra sigillata. An underglaze responds very differently to the
crawl glaze; it provides a glossy surface that the crawl glaze can
melt into, unlike terra sigillata, which is more inert. Although it
is more challenging to apply the crawl glaze to an already glazed
surface, I have found that it goes on a little easier if I heat the
pot up a bit before applying the crawl glaze.

Working with crawl glazes can be a lot of fun; with close observa-
tion of results over time, you will gradually be able to predict how
the glaze will shrink in the firing. Pay attention to how the crawl
glaze looks when it dries. If the glaze flakes off before firing, it is
likely because it has been applied too thickly. Adding CMC gum
to the glaze can help hold it onto the pot, but knowing how thickly
to apply the glaze is something you learn from practice and
close observation. The glaze can also flake off during the firing,
so it can be helpful to make a protection wall in the kiln with soft
fire bricks to keep the inevitable glaze spits from damaging the
elements. The protection wall and plenty of kiln wash on the
shelves will be well worth the extra effort. I burnt out many an
element before I came up with this idea!

OPPOSITE
This is a nice example of how crawl glazes can look when layered up through multiple firings. For this vase, I applied a base layer of orange terra sigillata before bisque firing. Then I sprayed on Mark's Crawl with 1 per cent copper carbonate and fired the vase a second time.

Finally, I sprayed Mark's Crawl white over the previous layer and fired the vessel again to 05 in oxidation.
Vase, 2014, 47 cm T.

Vases with terra sigillatas brushed on, ready for bisque firing, 1996.

MARK'S CRAWL GLAZE, 04–06 OXIDATION

Gerstley Borate	46.51%
Magnesium Carbonate	31.01%
EPK	18.60%
Borax	3.88%

FOR COLOURS ADD:

+5.43% Zircopax (White)

+1–5% Copper Carbonate (Green)

+1–3% Cobalt Carbonate (Purple/Dark Blue)

However, my dark brown/black crawl glaze is made a little differently from the above; I make up the black stain below and add it to the base glaze, usually about 5 per cent.

HOMEMADE BLACK STAIN

Red Iron Oxide	20%
Manganese Dioxide	20%
Cobalt Oxide	20%
Chrome Oxide	20%
EPK	8%
Silica	4%
Feldspar	8%

You can also use commercial stains to get the colours you want.

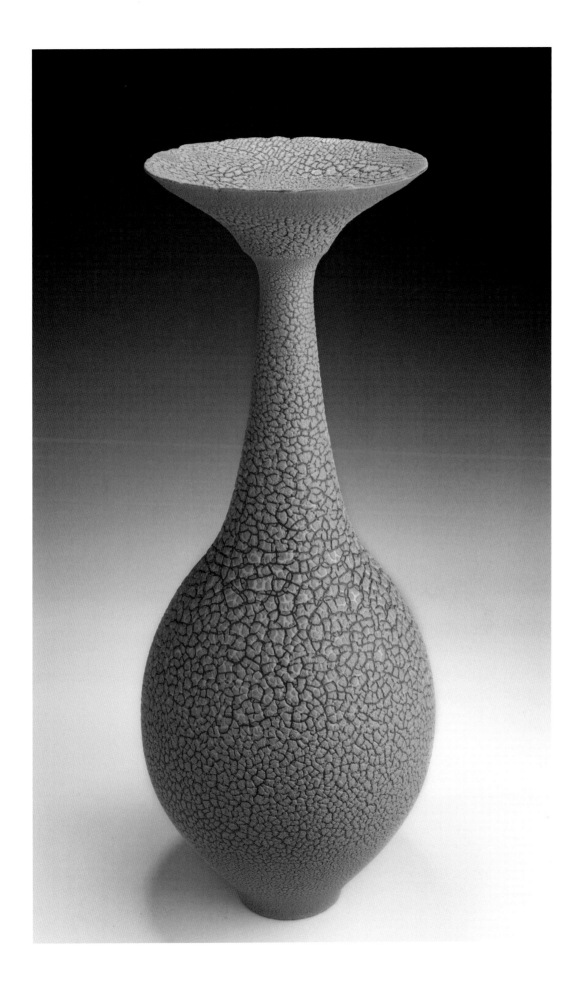

This vase has a shiny blue underglaze applied as the base layer and then a crawl glaze containing 5 per cent copper carbonate sprayed thinly over top. It was exhibited in *The Shape Between Continuity and Innovation* at the Museo Internazionale delle Ceramiche, Faenza, Italy, in 2003, and is in the museum's permanent collection.
Vase, 2002. Layered glazes, cone 05 oxidation, 48 cm T.

Chalice, 2019.
Underglaze, terra sigillata, multi-fired, oxidation, mounted in Ladysmith coal, 35 cm T.

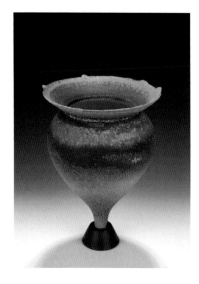

This was my first experimental crawl glaze. I had previously applied a layer of lithium compound on the chalice but wasn't all that pleased with how it turned out on the outside of the form. I liked the interior effect though, so left that alone. I sprayed a glaze to which I had added magnesium carbonate over the exterior lithium surface and fired it again to cone 06 in oxidation.
Chalice, 1996.
25.5 cm T × 18.5 cm W.

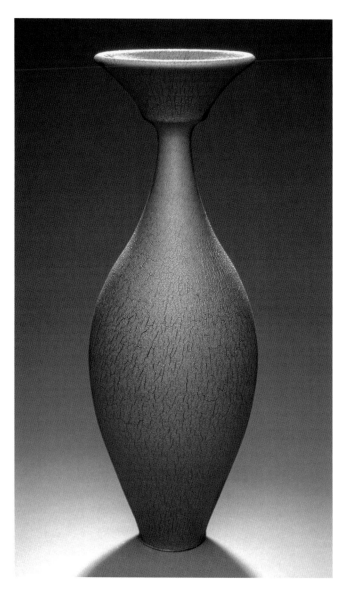

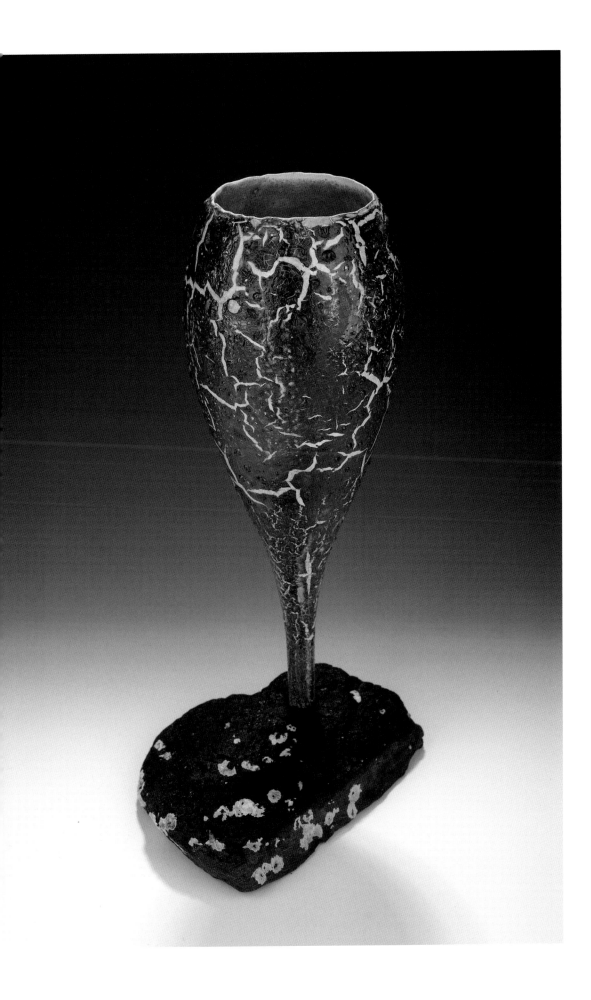

This vessel has undergone a slightly different process. After bisque firing, I applied a blue underglaze layer. After that was fired, I applied a layer of dark green crawl glaze and fired it again. Finally, I dipped the outside of the vessel in a white crawl glaze and fired it once more to cone 05 oxidation. Notice how the final layer of white glaze has crawled in a different pattern from earlier pieces I have shown you. This is because the glaze was applied by dipping rather than pouring or spraying. How you apply the glaze will affect the shape of the shrinking glaze platelets.
Vessel, circa 2002.
25 cm T × 25 cm W.

I applied an initial layer of dark blue terra sigillata before bisque firing this piece. I then poured dark blue/purple crawl glaze on the interior and sprayed it on the exterior. I removed bits from the outside, then fired it again. I poured a final layer of white crawl glaze into the interior and sprayed it on the exterior before putting it back into the kiln for a final firing to cone 05 oxidation.
Vessel, 2019.
22 cm T × 17 cm W.

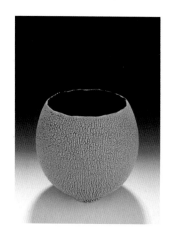

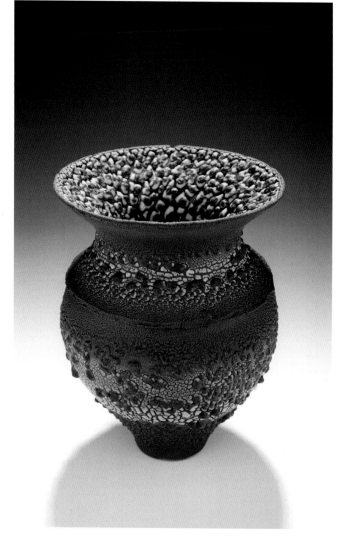

I applied crawl glaze over a bisque layer of orange terra sigillata. On the interior of the vase and the interior lip, I poured the crawl glaze fairly thickly so that glaze formed large beads, allowing the terra sigillata to show through. On the outside, I sprayed the glaze more thinly so that it fit the form like a skin.
Vase, 2014, 45 cm T and *Collared Vessel,* 2014, 22.5 cm T × 19 cm W.

OVERLEAF LEFT
Vase, circa 2000. Green underglaze, white crawl glaze, multifired in oxidation, 40 cm T.

OVERLEAF RIGHT
Chalice, 2015. Terra sigillata, crawl glaze, oxidation, 42 cm T.

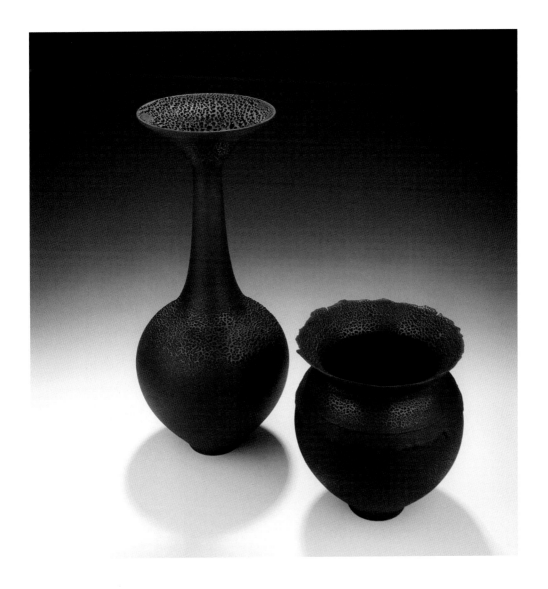

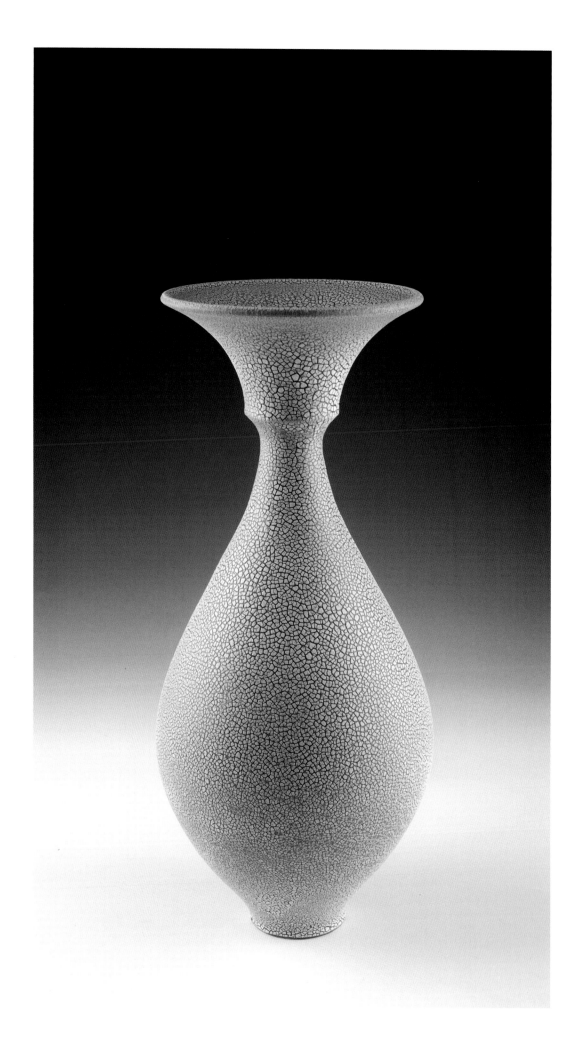

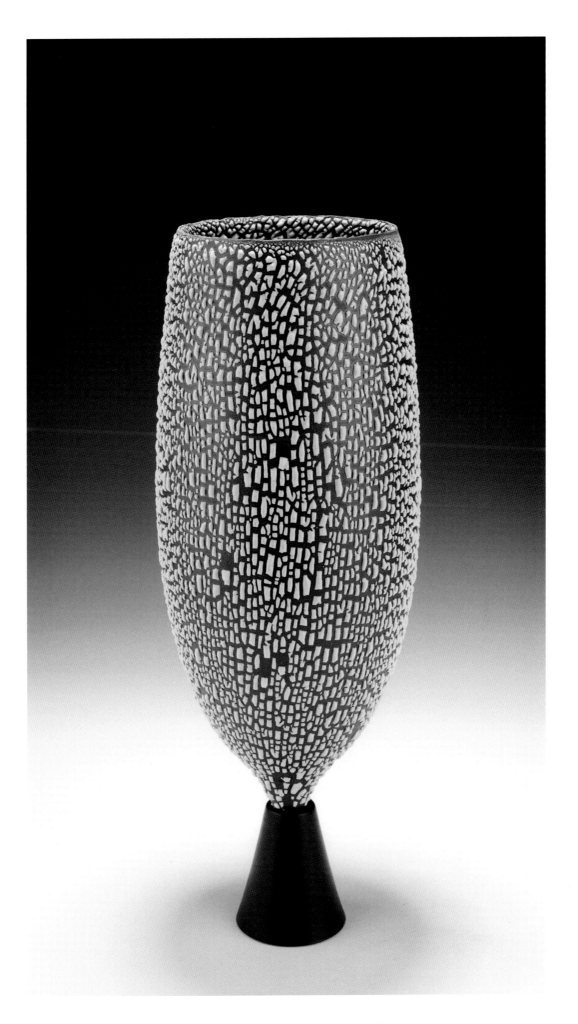

CONE 6 TABLEWARE GLAZES

"When I started working again after my five-year break, I decided it was time to develop some new glazes for my tableware."

When I started working again after my five-year break, I decided it was time to develop some new glazes for my tableware. I began with a glaze base that had been published in *Ceramics Monthly* in the early 1980s. It was a basic 20/20 glaze: 20 per cent silica, 20 per cent ball clay, 20 per cent dolomite, 20 per cent nepheline syenite and 20 per cent Frit 3134, to which I added colouring agents. It wasn't long before I noticed that the oxides or carbonates I added to the base were having an effect on the glaze surface. Some of the glazes were becoming more matte, some had issues with pin-holing or pitting and so on. I wasn't quite sure how to solve some of these problems and sought help from Ron Roy, a potter with more understanding of glaze issues. He had recently published a book with John Hesselberth, *Mastering Cone 6 Glazes*, which I found helpful. We wrote back and forth a few times as he helped me reformulate my glazes. Since then I have gone on to tweak and develop many glazes with much less fear!

Here are the four main glazes that I have used on my cone 6 tableware for the last twenty years, plus my latest, butter yellow. The first, midnight blue, has been my most popular glaze and my moodiest. I have tweaked its recipe and firing program several times over the years. It can be a matte purple or a shiny dark blue with purple flecks depending on how it is applied, where it is in the kiln and, of course, the firing program used. Chrome green is the most forgiving of the four glazes and never gives me grief; it has more of a matte surface. Light green can be on the matte side if fired a bit cool, but if I get the firing just right, it comes out a beautiful, pale green with light flecks. The brown glaze has always been a bit temperamental and prone to pin-holing, but again, if I get it just so, it's very nice.

The clay body I use with these glazes is Laguna Clay's B-Mix 10. I fire up to 1212°C (2214°F) and have not had a problem with vitrification.

━━

GLAZY.ORG

A great glaze resource for potters is www.glazy.org. With its ever-growing database of glaze recipes and images from potters around the world, it is becoming one of the most popular websites for learning about glazes and how to develop them. It was created by Derek Au and is continuously updated.

I have a page on this site where I post the glaze recipes I am using along with photos of the glaze and the firing program or programs used. As I am always playing around with glazes, I update the page often.

MIDNIGHT BLUE

Silica	27%
OM4 Ball Clay	20%
Dolomite	20%
Nepheline Syenite	18%
Frit 3134	15%
+ Cobalt Oxide 4%, Manganese Dioxide 1.6%	

CHROME GREEN

Silica	22%
OM4 Ball Clay	20%
Dolomite	20%
Nepheline Syenite	21%
Frit 3134	17%
+ Cobalt Oxide 2%, Chrome Oxide 2%, Manganese Dioxide 2%	

LIGHT GREEN

Silica	27%
OM4 Ball Clay	20%
Dolomite	20%
Nepheline Syenite	18%
Frit 3134	15%
+ Copper Carbonate 3%, Tin Oxide 5%	

BROWN

Silica	22%
OM4 Ball Clay	20%
Dolomite	20%
Nepheline Syenite	21%
Frit 3134	17%

+ Red Iron Oxide 6%, Rutile 4%

YELLOW

Silica	22%
OM4 Ball Clay	20%
Dolomite	20%
Nepheline Syenite	21%
Frit 3134	17%

+ Rutile 10%

Cone 06 oxidation firing of the midnight blue, chrome green, light green and brown glazes.

You can play around with the amount of rutile in this glaze to get a lighter tone of yellow if you want; 10% gives quite a strong yellow.

BUTTER YELLOW

I also make butter yellow with the following base, which is more on the matte side:

Custer Feldspar	20%
Frit 3134	20%
Silica	19%
EPK	20%
Wollastonite	15%
Talc	6%

+ Rutile 6%, Titanium 5%

FIRING PROGRAM

177°C to 555°C	(350°F to 1032°F)
82°C to 595°C	(180°F to 1103°F)
135°C to 1149°C	(275°F to 2100°F)
43°C to 1212°C	(110°F to 2214°F)

Hold at top temperature for fifty minutes and then cool naturally.

MY FUNCTIONAL
WARE DESIGNS
EVOLVE

"I can't imagine a day when I would stop creating functional wares."

A question that visitors to my studio often ask is, "How many people work here?" It comes up because of the variety of work they see when they come into my gallery. My answer is, "Only one, but she's a bit obsessive!" The work I produce has shifted as my expertise has grown. These days the creativity genie is well and truly out of the bottle, thanks in part to the fabulous kiln I now have to play with.

Though I could make my living solely from my decorative works, I can't imagine a day when I would stop creating functional wares. To me, there is nothing more satisfying than eating and drinking from beautiful, handcrafted vessels. When creating my tableware dishes, I derive great pleasure from knowing that, through the subtle intimacy that grows from their everyday use, these pieces will become treasures in other people's lives.

SIMPLIFYING MY TABLEWARE

My latest challenge is cutting back on some of the tableware forms I've developed, as I simply can't produce them all, but my attempts at culling aren't always successful. Take dinner plates, for example. I decided to discontinue them, but even as I was making the decision, I wondered how I would say no to the people who love them so much.

Some time ago I was visiting my friend and fellow potter Cathi Jefferson. As she cooked a meal for us, she suggested that I pick a plate to dine from, so I started rummaging through her dishware. I pulled out a small dish about eighteen centimetres across and five centimetres deep. There was something about it that I immediately loved. As I exclaimed about its beauty, Cathi said, "Oh, you like that one? You can keep it if you like." I did like, and home with me it came, quickly becoming my eating dish of choice—

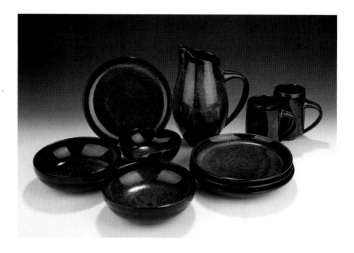

The ever-popular midnight blue glaze.

Rolled-rim soup bowls glazed in brown, chrome green, light green and midnight blue cone 6 glazes.

you know, the one you fish out of the sink and wash because you don't want to use any other. I started to think about this dish. What was it that made it so appealing to me? It was a little on the small side, but the shape of it was lovely. I could use it for most of my meals, it fit nicely in my hand and as for the size, well, I could always go back for seconds. Then one day as I was washing the dishes, that precious plate slipped out of my hands and broke. I was very upset, but it reminded me how attached we become to the objects we use daily. I couldn't stand being without my dish, so I went straight into the creation room and started to throw similar ones, bumping up the size a little. This resulted in a new line of what I call my eating dishes—not a plate and not a bowl but a cross between the two.

Although I did stop making big dinner plates, I was not that successful in cutting back on other tableware forms, so I turned my attention to bowls. I went around the gallery to take stock of how many types of bowls I was creating in the cone 6 line, not including large serving bowls. I counted five different styles of day-to-day eating bowls: rolled-rim soup bowls (originally designed for families with kids because those rolled rims are very chip-resistant), small bowls and their bigger version, the "manly bowls," pasta bowls and finally rice bowls. I produced each of these in my six different tableware glazes, so if I wanted a set of four bowls in each colour, I needed to make at least twenty-four bowls of each style. Something had to change! Change was all around me at this time. My Blaauw kiln had just arrived and I had done my first cone 10 reduction firing in it. My creative mind was buzzing with all the glaze possibilities. I was feeling more than a little overwhelmed by all this, and on top of that I had just begun to write this book, so I flew over to Vancouver to hole up in a friend's condo for several days to write. It was the perfect retreat for me on the tenth floor overlooking Coal Harbour. The only problem

Just a few of the many forms and glazes I work with in the cone 6 tableware.

was that it was cold and I have Raynaud's disease, which causes some areas of my body, such as fingers and toes, to feel numb and cold in response to cold temperatures or stress.

On the fourth day it started to snow. Although this was lovely to look at, I was finding it harder and harder to keep warm. That evening I ventured out for dinner with a friend to a small, cozy noodle house nearby. When we walked in, I felt instant relief. "Ahh, this is perfect!" I said. We grabbed two seats at the bar overlooking a kitchen full of woks and pots of boiling broth, and I felt myself slowly warming up. When my soup arrived, it was in a ramen bowl, which I immediately wrapped my hands around. As we chatted, I kept looking down at my bowl and marvelling at how beautiful the food looked in it—the bright yellow egg yolk poking its head through the noodles, the finely shredded greens all coming together in the loveliest way. I noticed that the form of the bowl was ever so slightly different from the rice bowls I made; it was a tad wider so you could see more of the surface of the food, and that's what made the food presentation so perfect.

A week later I was back at home in my creation room, and that bowl became the inspiration for a new line of tableware with a strong Asian influence. With my new kiln I could now explore all the ancient Asian glazes I had wanted to try as a young potter: temmoku, tea dust, celadon, hare's fur and copper red.

I had been using around half a kilogram (1.5 lbs) of clay for throwing my rice bowls and increased that to just under a kilogram (2 lbs) for my ramen bowls. These go perfectly with my new eating dish design, and I am happy to say that I now make only three styles of everyday bowls. However, I am still experimenting with so many different glazes that many of my tableware firings are limited editions.

PEASANT WARE: EARTHENWARE DISHES FOR PEOPLE WHO LOVE TO COOK

Sometimes late at night, just when I should be falling asleep, an idea for new work will pop into my mind. This was the case with my Peasant Ware. I had watched a Jamie Oliver cooking show in which he was exploring little family restaurants in Italy. A few months later as I was dozing off to sleep, I found myself thinking, *I wonder what kind of dishes Jamie Oliver would like to use for cooking?* And before the night was over, Peasant Ware had been born! I wanted it to be—as Jamie Oliver would say—"easy peasy," so I designed it with no handles sticking out, just a nice thick rim that gloved hands can easily slip under to lift hot baking dishes out of the oven. Now I create spout bowls, mixing bowls, serving bowls, lidded casseroles, open bakers and mugs in this style; they are earthenware with a thick, creamy yellow glaze, which is very durable.

Fashioning a small knob on a lid.

This line of functional ware is made with love for everyone out there who has a passion for cooking. My hope is that they will enjoy using my Peasant Ware to create feasts for their loved ones as much as I love creating it for them.

The clay body I use for Peasant Ware was developed by D'arcy Margesson and is manufactured by Tacoma Clay Art Center. This special order clay, which is called D'arcy's Redart with Mica, is a lovely clay body to work with, but any low-fire red clay should work nicely. I adapted my glaze from the one D'arcy uses on this clay body in order to deal with crazing and to get the rich yellow colour. I apply it fairly thickly to achieve the beautiful deep yellow tone, and I add a bit of CMC gum to help with this. If using a different clay body, you may need to tweak the glaze a bit. I bisque fire low at 06 and then glaze fire to 04 in oxidation.

PEASANT WARE GLAZE

Frit 3124	60 %
Zircopax	12 %
Silica	9 %
Redart Clay	8 %
EPK	4 %
Rutile	5 %
Bentonite	2 %
+ Gum	

"This line of functional ware is made with love for everyone out there who has a passion for cooking. My hope is that they will enjoy using my Peasant Ware to create feasts for their loved ones as much as I love creating it for them."

My Peasant Ware.

Who knew that my heart bowls would become so popular? The original heart bowls I made were quite small, since I designed them as gifts of appreciation for the home support workers and others who helped with Heather's caregiving. I wanted these gifts to be special somethings that weren't available for sale in the gallery. I discovered they were also the perfect gift for someone who was having a hard time. I could fill them with sweets or leave them by someone's bedside with a flower floating inside as a reminder of the beauty in life.

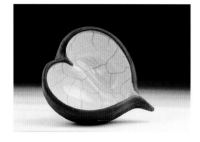

Raku heart bowl.

As the years went by and more and more people had been given these bowls, I got requests for them. I was reluctant to make them to sell because I wanted to keep them as unique and special gifts from me, but one day a customer came in and asked if I had any for sale. When I explained that I did not and the reason why, she replied, "I understand that but, you know, you are denying us the pleasure of giving them." I finally caved! Now I am really glad I listened and started making them for sale because of the pleasure people take in them. I often hear stories about them. I never envisioned them being used to eat from, but it seems they have become the breakfast bowl of choice for many of the children in Ladysmith. One of the sweetest heart bowl stories I heard came from a friend who recounted how, when she remarked on a young girl's heart bowl, the little girl responded, "Oh, you mean my bowl of wonders!" I was very touched by this and often think of it when I am making them.

A few hours after I have thrown a group of heart bowls, I cover them up for the night. When I uncover them the next day, they are still very soft and just barely dry enough to tolerate being turned over for trimming. After trimming them, I do the shaping by hand. If they are a titch on the dry side, I dip the rims in water, trim two or three other bowls, then go back to the dipped ones and shape them. This helps stop them from cracking when I'm altering the form.

I often use heart bowls to test new glazes. For glaze tests, I usually make five hundred- to one thousand-gram (17.5–35 oz) batches of glaze so I can do several tests to see how the glaze will react in a variety of firing programs. Often the first test is just the beginning of getting to know a glaze. The more I work with it, the more I learn. The added bonus is that I end up with many different coloured heart bowls for people to choose from. (You will know if your bowl was one of these tester bowls because it will have a number on the bottom.)

Coming up to Valentine's Day,
I set aside a few days to create
the heart bowls.

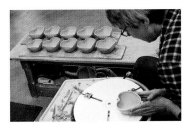 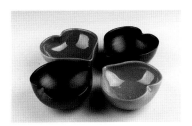

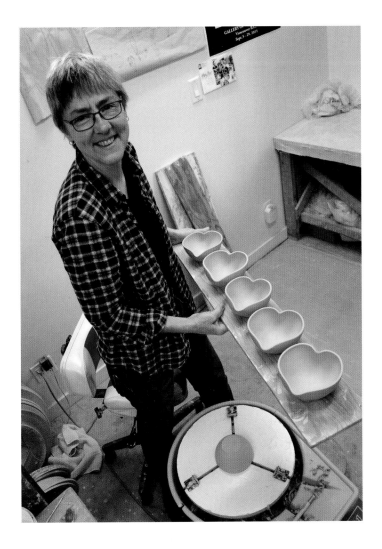

So many possible styles of tableware to make, and this is just a taste of what I was producing. Clearly I wasn't very good at limiting myself!

OPPOSITE
A flock of jugs. They always remind me of birds when they're lined up on the drying racks. Customers have made the same connection—something in the sculpted line at the top, I suppose. Nice example of four cone 6 glazes: chrome green, butter yellow, light green and midnight blue.

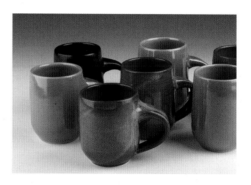

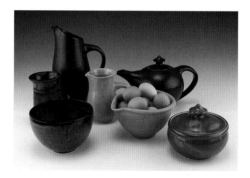

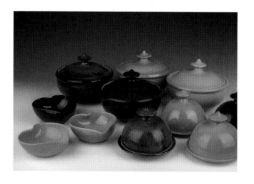

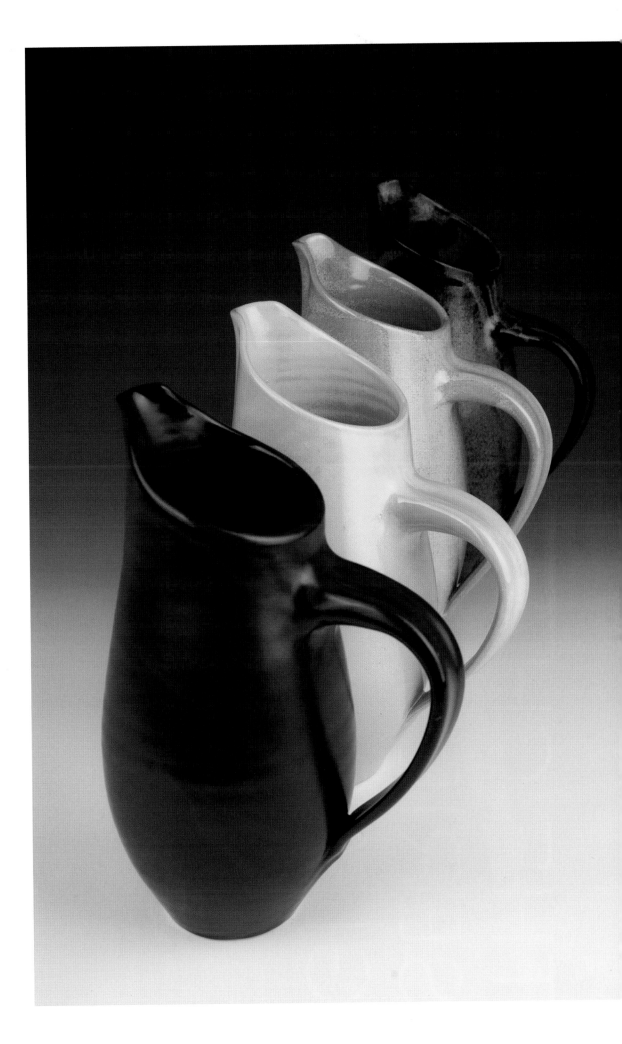

THE CHALLEENGING SERIES OF GLASS CHALICES

My glass work, like my pottery, is always growing and evolving. Although it took some time to resolve the technical challenges I encountered in bringing my forms to life in glass with Lisa Samphire and Jay Macdonell, we are now moving forward creatively.

In creating a blown glass piece, the first stage is blowing the glass into the desired shape. This is done by gathering molten glass from the furnace onto the end of a blowpipe and then blowing air through the pipe to create a hollowed-out bubble shape. Once the bottom two-thirds of the piece (the part farthest from the pipe head) are shaped, the piece is transferred from the blowpipe to a solid steel rod called a "punty" so that the top can be opened and finished. While the piece is on the punty, it needs to be kept at a workable temperature, which is done by reheating it regularly in the glory hole for a few seconds—a process called flashing—and by using a torch on specific areas as needed. The piece must be heated evenly during flashing, though not overheated to the point where it starts to lose its shape.

For my chalices, we made the top part or bowl of the chalice on the blowpipe first, then shaped the narrower stem part at the bottom end away from the pipe head. Once that shaping was done, we transferred the piece to a punty, attaching it by the stem so we could continue to work on the bowl.

For our first attempts, we made the chalices fairly small, and most of them survived being transferred from the blowpipe to the punty. But as soon as we began to bump up the size, we started to lose the pieces while working them on the punty. Sometimes we were almost at the end of the process when—*Bam!*—the form broke off the punty and shattered on the floor.

The thin stems just couldn't take the weight. With such a narrow part attached to the punty, the piece was top heavy, placing too much pressure on the join. The amount of torque made the

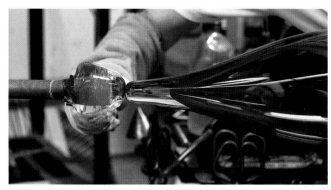

1

whole piece hard to control; added to that was the challenge of keeping the piece at an even temperature overall.

Jay and Lisa discussed the temperature fluctuations in the glass and came up with some ideas to help with the problem, but we still weren't getting there. The count of "on-the-floors" was still rising. The turning point came one day after we lost a technically challenging piece. We had worked on it for an hour and a half when it fell to the floor. Jay was very displeased. "This is not acceptable!" he announced. "We need to fix this!" I tried to be understanding about it all. I never want to cause stress to my team over failures—that is how we learn—but I also realized that if I were in Jay's position I would be just as frustrated by our inability to figure out a way around the problem. Too many of our attempts were ending up in pieces on the floor.

Intense brainstorming ensued, during which Lisa and Jay came up with two ingenious solutions. The first was to create a blown glass punty extension that would reach farther up the outside of the chalice stem, moving the point of axis higher up on the piece. This helped with the weight distribution, reduced the torque and provided heat around the fragile stem. It also meant more cold work would have to be done later, since all that extra glass needed to be ground off, but that's life. As Gilda Radner used to say, "It's always something!"

Our first attempt at this seemed promising. All was going well when suddenly the chalice fell off the punty while it was being reheated in the glory hole. This was a new one for me! I had seen them come off the pipe many times by now, but never when they were in the hole. I was freaking out a bit, but Jay calmly put the pipe back into the hole, managed to get the glass piece stuck onto it again and fished it out. After some discussion about why this had happened, the team decided to try two modifications to the glass punty: we made it bigger and made sure the bead of glass wrapping around the stem to attach the punty was much more robust. It worked!

2 | Once the form is attached, we use the guardrail to stabilize it on the punty before taking it back to the glory hole.

3 | Too much torque—darn! On the floor again.

4 | Our first go at the new blown punty idea. Here we are centring the chalice after its transfer to the punty.

5 | Dang! Lost it again.

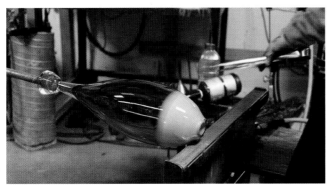

2

3

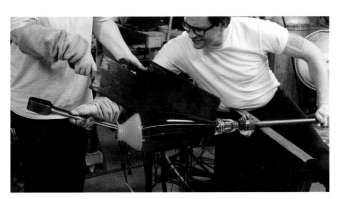

4

5

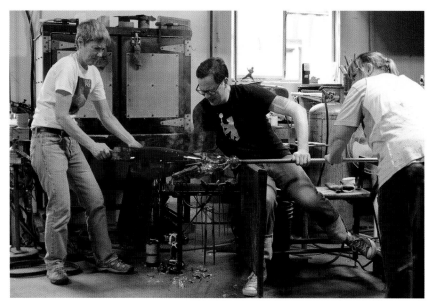

6

Now that this modification had solved our problem, I could ask Jay and Lisa to make the stems longer! And the chalices grew bigger.

This system of using the blown punty and more glass circling the stem where it was attached also worked well for the Torpedo series, which involved pieces that came to a fine point at both ends. Until we arrived at this solution, they dropped off the pipe with regularity.

The second idea that Jay and Lisa hatched was eliminating the transfer of the piece to a punty altogether. They asked, "What if we kept the piece on the blowpipe throughout the shaping and cut the top off the piece after it cooled?" Again, this would mean more work later, but if it reduced our losses off the pipe, it would definitely be worth it.

We did a small trial chalice so that I could understand how this technique worked, and I immediately grasped its potential bene-fits. The piece could be shaped with the top end attached to the blowpipe and the long stem pulled at the free end, avoiding any weight-bearing pressure on the stem.

With our technical challenges resolved, new possibilities opened up and my creative mind took off. I envisioned what I call the Planetary series, which explores environmental elements of life on earth. It began with my Oceanic chalices and has since ex-panded to include pieces that evoke nebulas, volcanic eruptions and desert landscapes. With multiple layers of colour and very long, narrow stems, these pieces are technically very demanding for the team.

7 | Our first pieces with the new punty system, all ready for the next stage: grinding and sandblasting.

8 | Jay attaches the blown punty to the ring of hot glass on the torpedo form.

9 | The top of the form cools a bit while we add heat to the punty before taking it off the pipe.

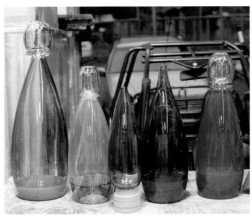

7

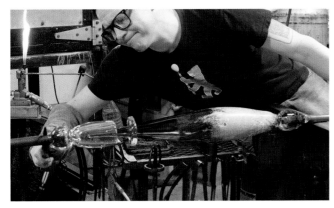

8

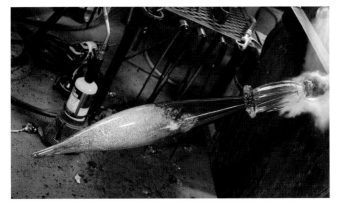

9

As with some of my clay chalices, I wanted the insides of my glass Oceanic chalices to be a different colour from the outsides. However, whenever you want glass of different colours on the interior and exterior of a piece, you must separate them with a layer of white glass; otherwise the colours will not be true. The first step in achieving this effect is to create what blowers call a stuff cup, which will form the exterior of the piece. It has white glass on the inside and coloured glass on the outside. To make it, we heat up a piece of white glass on the end of a blowpipe and centre it over the pipe opening. Then we heat the outside colour and drop it on top so that it can be pulled over the white centre evenly. This is called an overlay.

Next we do a gather, which involves dipping the pipe into the furnace crucible to collect clear glass to go over the two colours that we now have on the pipe. This glass is then blown into a rounded bullet shape, which has the white layer inside and the exterior layer of colour on the outside. Once that is done, it is transferred from the blowpipe to the punty; while on the punty, the top third of the piece is heated and opened to make a simple cup form. When the cup is complete, off the pipe it comes and into the annealer it goes to await its mating with the inside colour.

10

11

10 | Heating white glass that will form the inner layer of the stuff cup.

11 | Centring the white glass on the pipe.

12

12 | Dropping the outside colour over the white glass.

13 | Into the crucible we go to gather clear glass over the exterior colour.

The inside colour is worked on another blowpipe. We blow this into a workable shape, add hot clear glass on the outside and then plunge it into the stuff cup. We now have all three colours joined together in one piece on the blowpipe—the inside colour, the white layer and the outside colour. We then do a couple of gathers of clear glass over the whole piece to get enough mass to make the size of piece we want.

These early stages are all about preparing and combining the basic materials of the piece. During these steps the glass goes back and forth from the glory hole to the workbench repeatedly to keep it heated.

14

15

16

17

14 | Blowing the stuff cup.

15 | Transferring the stuff cup to the punty before opening.

16 | Opening up the stuff cup on the punty.

17 | Knocking the stuff cup off the pipe before placing it in the annealer for later pickup.

18

19

20

21

22

18 | Letting excess glass drip off the gather so we have the correct amount to put into the waiting stuff cup.

19 | Stuffing the cup with the hot gather before pick up.

20 | Stuff cup and gather combined.

21 | With all the layers now joined, we gather more hot glass on the outside to increase the final size of the piece.

22 | Shaping the freshly gathered layer of glass before moving on to the next step.

23

24

Now the fun begins! We start by adding the layers of materials that will create an ocean wave effect on the exterior of the chalice. The first layer is powdered white glass. Then it's back and forth between the glory hole and the bench to work the form before rolling it across the second layer: thin sheets of copper foil, which are then worked into the surface. The copper foil and white powder combine in a chemical reaction to create the lovely teal blue colour that evokes ocean waves.

At this point we are ready to shape the glass into its final form, and this is when the real dance begins! With all the decoration complete, we have a large quantity of glass on the end of the pipe; to keep its temperature just right for blowing and shaping, we move constantly back and forth between the workbench and the glory hole. We also use torches to add extra heat to vulnerable spots or to areas we want to isolate for manipulating.

Early in this stage of production, while the glass is at its hottest, we put in a jack line, which is a crease that we gradually insert around the piece near the join to the blowpipe. When the time comes, the glass at this crease line will be chilled, and droplets of water will be added to break the piece from the pipe.

25 | Lisa "jacking" the crease in the neck for when we need to remove it from the pipe after the final blowing and shaping are done.

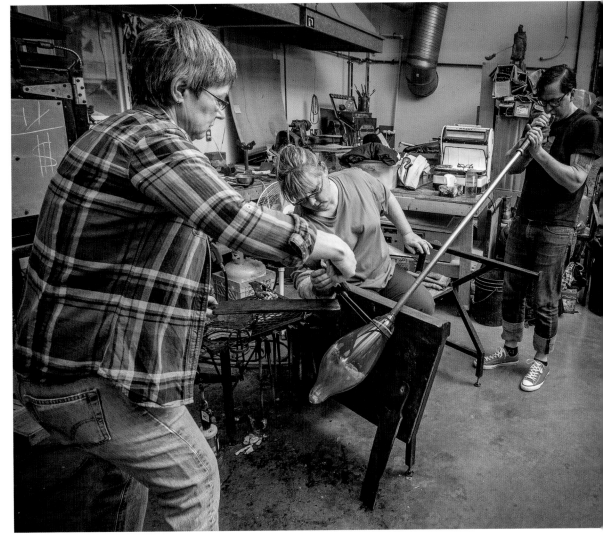

25

We now work incrementally from the pipe end down the piece, blowing the body bubble form, working on the jack line, then moving glass down the piece to form the stem, though keeping it close to the body bubble. We continue to jack and to blow the form at the top until we have a crisp jack line and the bubble form is almost to size. Once that is done, we can heat further down the bubble, away from the pipe head, and start to pull the stem. Throughout all this, we constantly reheat the piece in the glory hole to maintain the right temperature overall.

We are on the home stretch now, fully focused on the form of the piece. The dance back and forth intensifies, and I busy myself shielding my team's arms from the heat with wooden panels, opening and closing the glory hole door and keeping a close eye on the form.

As we pull out the glass at the bottom of the piece to create the long stem, we are focused and in sync as a team, going back and forth from the glory hole to the bench and working the form until we have it just right. This part is exhilarating! As I watch the form take shape, I carefully measure the length and width of the stem, decide if the piece needs more air to fatten it up and make sure everything is just so before we take it off the pipe.

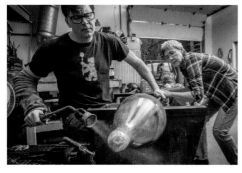

26

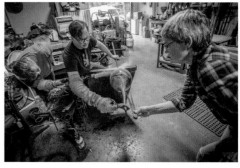

27

26 | The final blowing of the form. We have to make sure that what is now a very heavy piece is centred on the pipe.

27 | Stretching the base to create the long stem and checking to make sure we have the correct length and diameter.

28 | Lisa places a hot piece in the annealer.

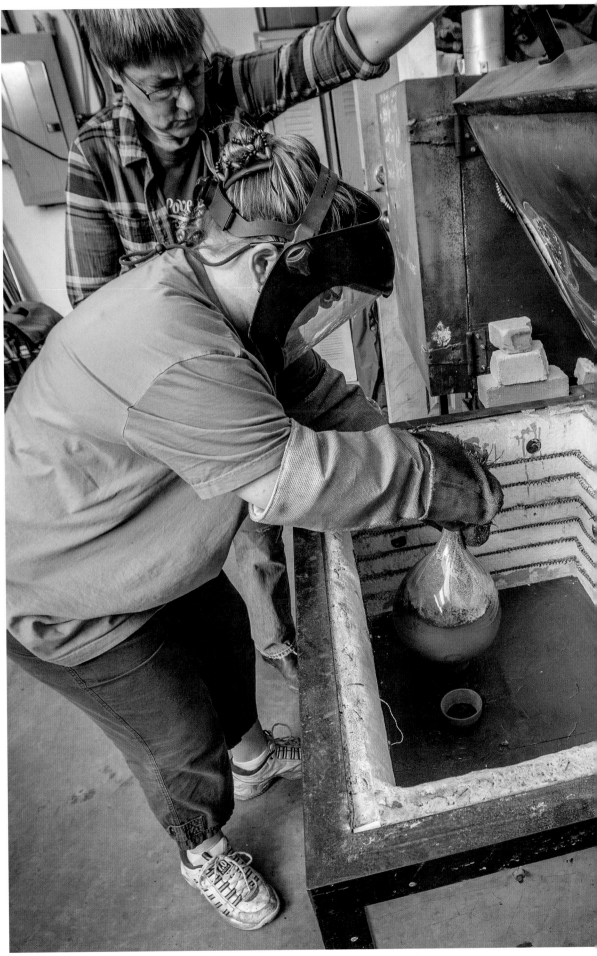

Taking the work off the pipe is always stressful. At this stage the top of the chalice remains an enclosed bubble. Lately we have added a bead of melted glass around the top of the piece before we separate it in order to avoid cracks shooting down the piece. Once it's off, it is placed in the annealer, where it will cool very slowly for seventeen hours before being removed for the next stage.

When the piece is completely cooled, it's time to remove the top of the bubble to expose the interior bowl. To do this, we place the piece upright, with supports, on a banding wheel and score around the top with a glass knife at the level we want to cut. Then we move a small, very hot flame along the score mark until the top pops open. The top is then removed, revealing the inside colour of the chalice.

Finally the piece goes to Lisa's studio for cold work, grinding and polishing the cut at the top and finishing it by sandblasting the whole surface. Then it is ready to come home to me for the last step—finding the perfect rock in which to mount it.

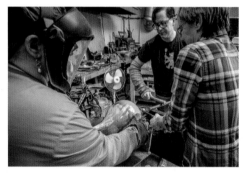

29

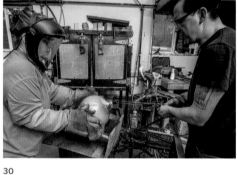

30

29 | After dripping water on the jack line, we take the piece off the pipe.

30 | The final step before putting the piece in the kiln to anneal is "fire polishing." Here Jay adds a bit of heat to the opening to ensure it doesn't crack after being chilled in the water.

OPPOSITE
Glass Chalice, 2017.
Oceanic series, mounted in rock,
49 cm T.

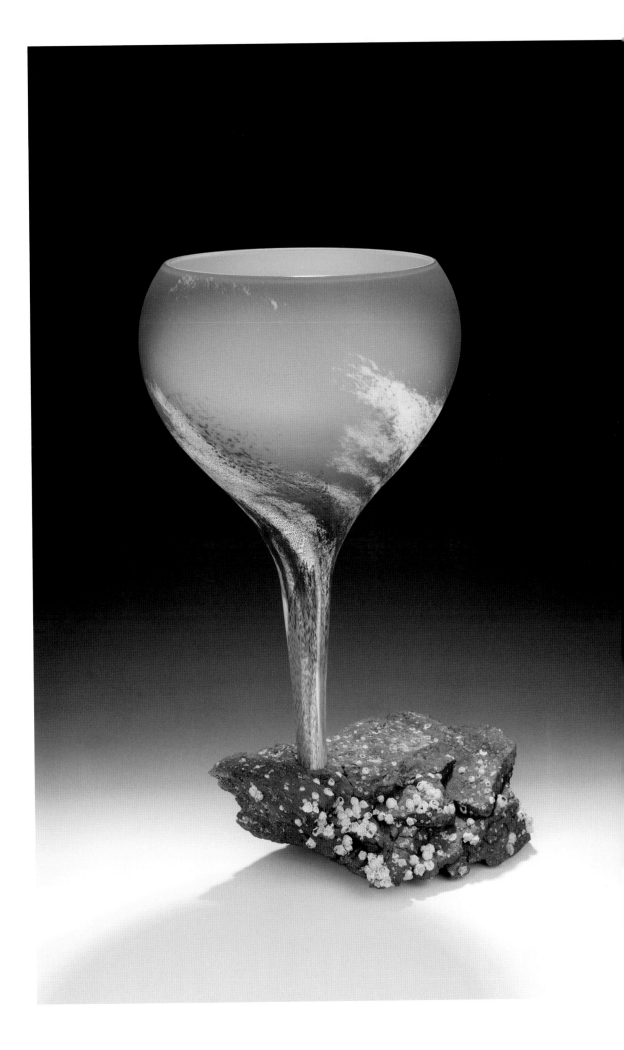

WORKING WITH THE BLAAUW GAS KILN

———

Before I begin to share what I have learned to date about the Blaauw kiln, I must forewarn my readers. If you had told me years ago that I would be writing a technical section for a book, I would have dismissed it as a ridiculous notion! I have only the most basic understanding when it comes to glazes and kilns. It's not that I haven't studied enough. I have read and reread many books on glazes and firing over the years, but for whatever reason I don't seem to retain much of it. I have come to accept my cognitive limitations and keep plugging on, trusting that eventually I will get there. I am a visual and intuitive learner, and I suspect there are many people like me who give up on learning the more technical aspects of pottery because they find it too difficult. I hope that if you are one of these types, I will inspire you to keep at it. Consider adopting my motto: "It's okay to make mistakes while learning, and we are always learning."

When I was researching Blaauw kilns, I found there was very little written about them. To learn more, I contacted schools that had them and asked the teachers about their experiences. Since I had never worked with or studied high-fire reduction, much of what they told me went over my head. Many of these schools had multiple kilns, so I asked which kiln the students preferred working with. Every time the answer was the Blaauw. It wasn't that students couldn't get good results in the other kilns—they could—but the process of firing the Blaauw was so much easier. For a person like me, that was huge. I was always afraid of how many mistakes I could make with more traditional gas kilns; also at the back of my mind was the Legacy Project. A kiln that is easy to work with and to understand would be a big plus for future resident artists in my pottery.

Now that I have worked with the Blaauw, I totally get it. With this kiln I have learned more about glazes and how firing schedules affect them than in all my years of working with electric kilns. Besides being an extremely efficient and inexpensive kiln to fire,

"Now that I have worked with the Blaauw, I totally get it. With this kiln I have learned more about glazes and how firing schedules affect them than in all my years of working with electric kilns. Besides being an extremely efficient and inexpensive kiln to fire, everything on the Blaauw is controlled by computer."

everything on the Blaauw is controlled by computer. After writing the firing programs on your computer, you enter them manually into the kiln's computer, which creates a graph that shows what the firing will look like. Although the Blaauw is a sealed environment with no peepholes, during the firing a coloured graph follows the original one so the operator can "see" what is going on inside the kiln at all times. I have found this visual aid very helpful; looking at numbers alone can be confusing at times, but with this visual representation I know I have made far fewer mistakes than I would have otherwise.

Below are some general tips and notes about firing with the Blaauw.

———

DRYING/BISQUE

The Blaauw has a drying mode that enables the operator to keep tight control at temperatures below 200°C (392°F). There is no need to candle overnight or fire with a kiln door partially open as you would with a traditional kiln. Using this drying mode at the beginning of the bisque program is very handy when firing damp work. Many of us have blown up our pots by firing slightly damp or even bone-dry ware too fast! With the Blaauw, I am happy to say, that is a thing of the past. I go very slowly through the beginning of the firing where shrinkage cracks can occur, up to 140°C (265°F). I also go slowly through the water smoking stage of firing, 140–232°C (285–450°F), when greenware is most at risk of a steam rupture. I then speed up the firing until reaching quartz inversion, 550–650°C (1025–1200°F), and then I slow it down until moving on to the final leg of the firing. My total firing and cooling time is sixteen hours, and no blown-up pots! You can shorten the drying time in the program if everything is bone dry, but given how inexpensive the Blaauw is to fire, why not bisque this way just to be on the safe side?

Mugs, charcoal glaze, R3 firing on left, R1 on right.

Tableware, yellow salt glaze on porcelaneous and iron-rich clay bodies, 02 and R1 firings.

REDUCTION

Reduction is the fun stuff. With a Blaauw you can program the amount of reduction you want, when you want it. The mode used during reduction is "main on," which restricts the kiln to keeping the main gas line feeding the burner at all times, thus ensuring the atmosphere in the kiln remains consistent. Heavy reduction is 85, medium is 90, light 95. Each kiln is a little different, but these are good values to start with. If you are already familiar with reduction firing, you will be able to read the reduction flame shooting out of the top of the kiln into the chimney to see if you have the amount of reduction you want and adjust accordingly. There's no need to be checking oxygen meters or playing with a damper, as the computer does all this for you. You write the program and the kiln does what's asked of it, taking a lot of the fear and guesswork out of the process.

My first programs fired very nicely, and my learning about reduction began. I had never been around high-fire reduction firing, and I soon realized that my visual knowledge was sorely lacking. What did proper reduction look like? What was an under-reduced glaze? I read through my library of glaze books and found John Britt's book on high-fire glazes to be the most helpful. It is well written and easy to follow, though I admit to having to read sections of it repeatedly in order to "get it." Slowly things are becoming clearer to me. Britt's book includes firing program suggestions to go with the glaze recipes, which helps to explain the amount of reduction needed and how it differs from glaze to glaze. I took the high-fire programs he designed for traditional kilns and adapted them for the Blaauw. The main difference is that I took out the hold in the R1 and T3 firings where the body reduction begins. Reduction holds between 843°C and 1048°C (1550°F and 1920°F) are traditionally used for reducing the clay body. The kiln is put into reduction because the clay body is

sensitive to the reduced flame, and the red iron in the clay transforms to black. This is programmed as a hold in traditional kilns because it takes time for the entire chamber to change over from an oxidized atmosphere to a reduction atmosphere (typically between thirty to forty-five minutes). Since air is constantly seeping into a traditional kiln, some time is required to beat back the influx of oxygen and fully pressurize the chamber with a reduction flame. This is not the case with a Blaauw; it takes only about thirty seconds for the entire chamber to reduce, so the hold serves no purpose.

Some glazes have very distinct needs and will only perform well in one or two firing programs, whereas others seem quite forgiving. An oil spot glaze will look fantastic in the O2 firing, but put it in the R2 and not so much. One of my favourite programs is the R3; its slow cooling has a dramatic effect on many glazes.

All loaded up and ready for a cone 06 reduction firing.

Then there are the easy going glazes. These are not too fussy about the firing, so you can use them for filler pots. I have found that most of the blue glazes are good in all the programs; yellow salt is also a favourite of mine, as it turns out quite lovely no matter what firing program or clay body is used.

For the potter who wants to learn and experiment with glazes, the Blaauw is an ideal kiln. With more finicky glazes, you can keep fine-tuning your programs until you get exactly what you want. This is what I did for my copper red, shino and celadon glazes, all of which require longer and heavier reduction. For them I use the R4 program.

First peek at the firing.

If the kiln is loaded similarly, the firings will be the same. When I write a new program, I print out a copy for my files and make brief notes on how the firing went as I unload it. Later I enter more detailed comments in my firing logbook. The printout comes in handy later when I look back on the firings because I have the visual graph right in front of me. Another reminder I use when I am first learning about a glaze is to keep an example from each firing and write the firing number on the bottom of the pot in pencil. This way, if some time has gone by between the firings, I have a visual sample as well as my notes for reference.

OXIDATION

Oxidation firing can also be done in the Blaauw by firing the same programs that are used in an electric kiln, leaving out the reduction and being sure to remember to set the "Ox-protect" to "yes."

COOL DOWN

To be honest, when Blaauw technician Jeff Chown first told me about the cooling feature of the kiln, I wasn't that interested. Firing speed has never been an issue for me, and if the kiln takes a couple of days to cool, so be it. That's what I was used to. But

now that I have worked with the kiln, I love this capability. For the first time in my pottery life, I can fire the kiln during the day and open it up the next morning with no need for kiln gloves!

LOW-FIRE REDUCTION

Low-fire reduction is what really excites me and keeps me up at night! I am at the very beginning of these explorations and wish I had been able to delve further into this field before writing this book. However, I will share what I have learned so far, and a little about the avenues I hope to explore in the future.

I decided the best way to start my learning was to fire a mixed load of saggar work and pots with low-fire finishes on them. This meant that instead of filling the kiln with experiments, I could load it up with the bulky saggars and put the low-fire pots where there was room, between or on top of the saggars.

When I did raku in the past, I used my electric kiln, which took three hours to get to temperature. I wrote a program to mimic that for the Blaauw and added a fast cool. I also remembered

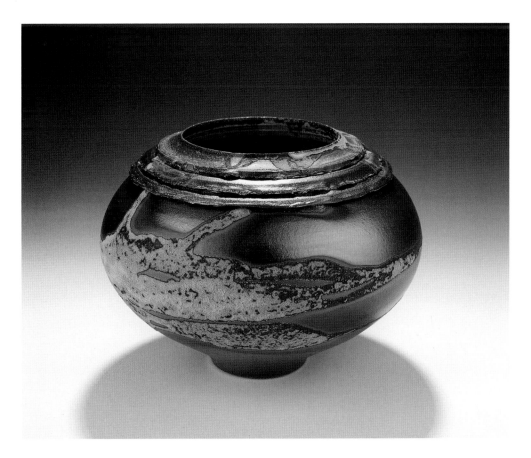

Vessel, 2018.
Orange terra sigillata, Lana Wilson Chartreuse glaze, low fire reduction, 25 cm T × 18 cm W.

that when I had done saggar firing in a gas kiln years earlier, I had started reduction fairly early on and, when it got up to around 08, watched the colour of the flames licking out of the top of the saggars to decide when to shut it all down. Since the Blaauw has no peepholes, that option wasn't available, so I had to guess what to do. My first firing wasn't great as far as the saggar pieces went, but I was pleased with how the firing had warmed up the pieces glazed with my lithium compound. The lithium work wasn't anything like my raku fired lithium work, however, and that was a bit disappointing, but I told myself it was early days.

I tweaked my program for the next firing and was very happy with the results. The saggar work was great, but what really shone in this firing was a bowl with an orange terra sigillata and Lana Wilson Chartreuse glaze applied over sections of it. The sigillata reduced beautifully and there was haloing around the edge of the glaze. Lana Wilson Chartreuse can be quite unstable, and it takes a while to learn how to apply and fire it, but I have found it to be a fun glaze to work with. I can get a variety of effects depending on how it's applied, the temperature it's fired to and the atmosphere it's fired in.

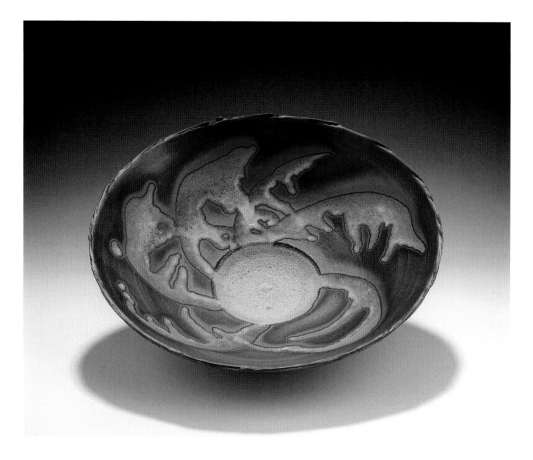

Bowl, 2018.
Orange terra sigillata, Lana
Wilson Chartreuse glaze, cone 05
reduction, 9 cm T × 30 cm W.

Hammered bowl fired in oxidation.

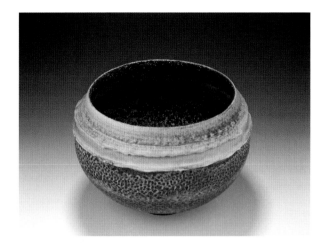

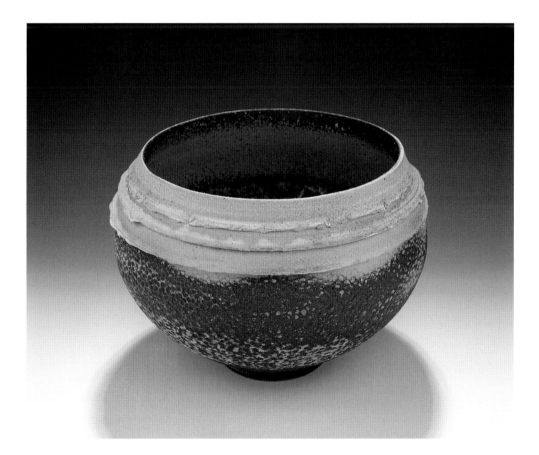

The same bowl refired in one of my first low-fire reduction loads. It was a surprise to me how much it brightened up.

Collared Bowl, 2018. Lithium compound, 17 cm T × 24 cm W.

Saggar with coal gathered from the beach, ready for the fired lithium piece to go in. The broken posts are there to keep the pot just above the reduction material.

My lithium pieces were nice but still not changing in the ways I was hoping for. I asked myself how my Blaauw raku firings were different from my previous raku firings. I was using the same rate of climb and reducing the glaze, but I wasn't introducing any carbon from burning straw. Also, though I cooled the kiln quickly, it wasn't as fast as in a raku firing. Maybe, I told myself, I couldn't get the same effect, but possibly I could get something close if I changed my way of thinking. Ladysmith used to be a coal town, and the beach where I walk my dogs still has a lot of coal slag on it. I had gathered seaweed with bits of coal attached to it to use in the saggars, so I thought, what if I put a bit of coal and sawdust at the bottom of a saggar and sat the lithium-glazed pot on top of that? This would introduce the carbon that was in the raku firings, though in a different way. I quickly got another firing together, and sure enough, this made a huge difference. The lithium reduced quite heavily and the bottom of the pot was black, just like a raku fired pot. I thought the piece was a tad heavy on the reduction, but those are the kinds of results you can play around with till you get what you want. The main lesson for me was that there was merit in my idea, and I look forward to further exploration.

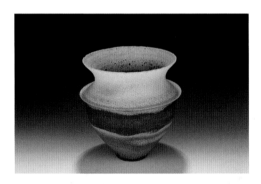

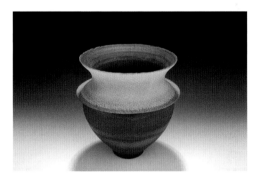

TOP
How the vessel looked after a 07 oxidation firing, before going into the saggar.

BOTTOM
The same vessel after going through the saggar firing. It is a little heavy on the reduction but still I think it's quite nice.

This vessel had a very light spray of the copper carbonate on the outside and a quick pour of it on the inside. Then it was fired in oxidation to around 06.

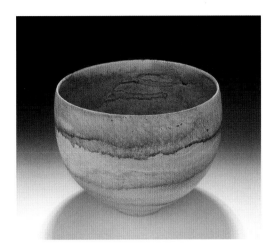

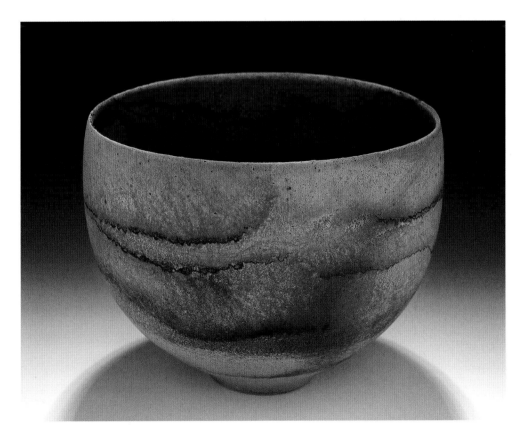

Here is the same piece after going through a saggar firing.
Vessel, 2018, 17 cm T × 21 cm W.

I fire some of my crawl glaze pieces in bisque firings in the Blaauw, since they are also fired at cone 05. It's nice to be able to tuck a few pieces in with a bisque, as often I don't have enough of the crawl glaze work for a full load and I don't want to have to wait too long to see how they are going to turn out. Here I am glazing one of my newer forms, from the Altered Vessel Chalice series, and then including it in a bisque firing.

1 | Pouring the first layer of crawl glaze into the form.

2 | I swirl the glaze around over and over again until I think I have the right thickness, then pour it out. After drying overnight, the form is ready to go into the kiln.

3 | Taking a look to see how the first layer of glaze fired.

1

2

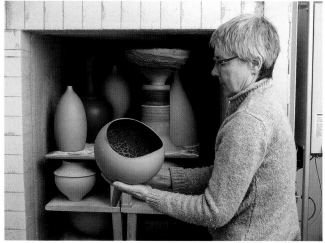

3

4–7 | With the first layer of crawl glaze fired into place, I coat the interior with a different crawl glaze. Once it has dried, I turn my attention to the outside of the form. In this case, I sprayed a very thin layer of baking soda blue glaze on the outside before putting it into the kiln for the final firing.

OVERLEAF LEFT
Torpedo Form, 2019.
Saggar fired, mounted in rock,
74 cm T.

OVERLEAF RIGHT
Chalice, 2018.
Saggar fired, mounted in rock,
76 cm T.

4

5

6

7

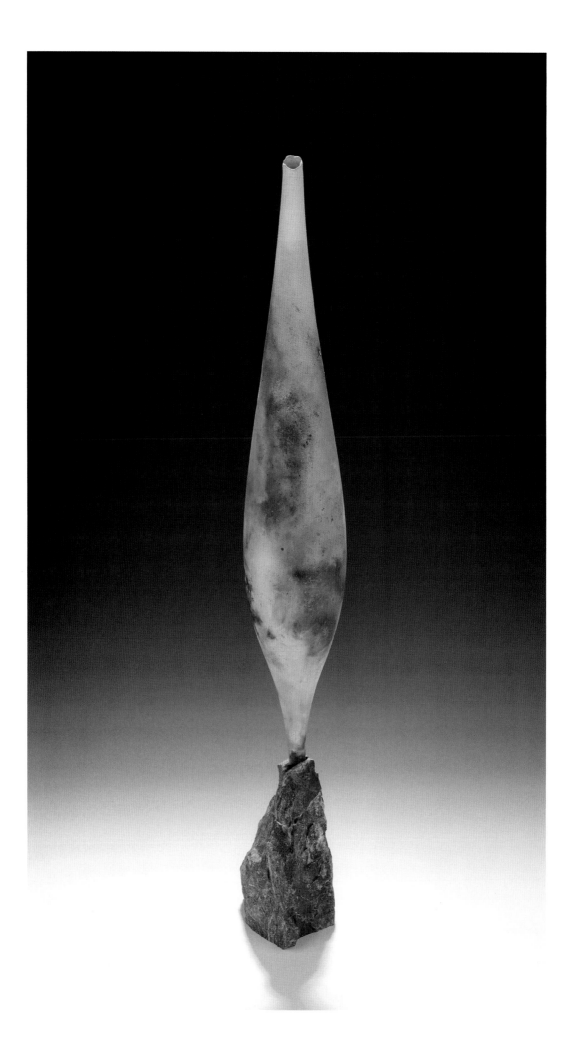

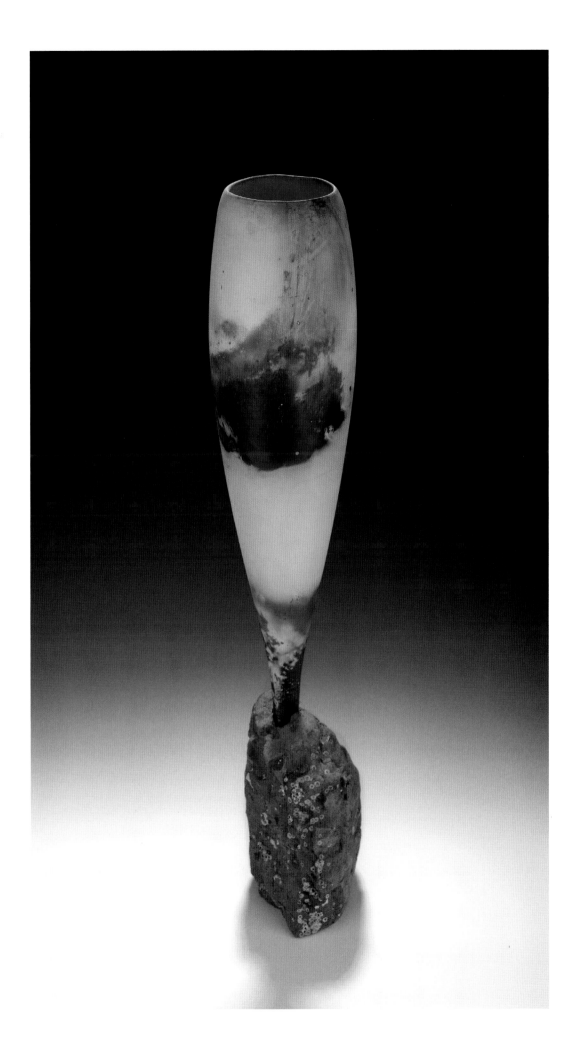

ACKNOWLEDGEMENTS

Writing a book is a large and rather daunting project—where does one begin? Back in the '80s when I first began to make decorative works, I thought it would be a good idea to have some pieces photographed just in case I decided to write a book someday. Over the years I had as much of my work photographed as I could possibly afford and held on to many of my favourite pieces. Now these decisions are paying off.

As with all my projects, it really is about the team that I put together, and this book was no exception. Roberto Dosil, designer, and Pat Feindel, editor, are good friends whom I have known since my twenties. I had worked with both of them on projects in the past but none as big as producing a book.

When I look back on our first planning meeting, I am doubly grateful for my team. I had no idea how to go about things; I had been thinking about a book for years—I had an outline, notes and loads of photographs—but had not begun to write. When I was asked about the manuscript, I replied, "Oh, it's in my head," having no idea that in creating a book, the manuscript comes first. I suppose I wanted to be sure I would have the help of my two friends before starting to write. As we talked and I gradually got a sense of all that needed to be done, I began to feel a bit unsure of my writing capabilities. That's when Pat said, "Oh, I have *no doubt* that you can write this book." She couldn't have known how much those words meant to me or how many times I would replay them when doubts started to creep in. Pat's skill as an editor, coupled with her support, guidance and encouragement, helped especially to get me through the more personal sections that were challenging to write and share with the world.

Roberto's design skills are exemplary; to have someone so gifted in his craft designing my book was a huge gift. His perceptiveness and his innate understanding of my work led to a truly beautiful, original and inspiring layout. Always a generous admirer of my art, Roberto kindly donated his time on the book to support the Mary Fox Legacy Project.

The photographs in this book have also benefited from the much sought-after expertise of Ernst Vegt, whose pre-press work with photographs and images has enhanced many of Canada's finest illustrated books. I am thrilled that he volunteered to work on optimizing the images for this book, making it that much better for you, the reader. Ernst Vegt also generously donated his time in support of the Mary Fox Legacy Project, for which I am very grateful.

A number of photographers are represented here, but the majority of the shots of me working creatively were taken by Sean Sherstone. Sean was also my go-to guy whenever I couldn't figure out a photography problem; whether it was how to get an image just right or how to tackle an issue with the computer, Sean calmly helped me find my way to a solution.

I am forever grateful to my glass team, Lisa Samphire and Jay Macdonell, whose enthusiasm, skill and vision helped bring my forms to life in glass. These artists have been inspiring to work with and have profoundly changed my creative world. In addition, Lisa provided valuable assistance with the challenging technical chapter on creating a glass chalice in my Oceanic series.

Jeff Chown from Blaauw Kilns was very helpful both in teaching me about the kiln as well as contributing to the technical information I included in the Blaauw chapter. *Pottery Making Illustrated* published an earlier version of the crawl glaze chapter.

The following individuals kindly allowed works from their collections to be included in this book: David Bird (p. 69), Amy Brown (p. 73), Margaret Jones Callahan (p. 21), Anastasia & Wilf Cameron (pp. 46 & 47), Caroline Dabrus and Randy Romanin (p. 85), Jamie Evrard (p. 21), David Harris Flaherty (p. 3), Michelle Frazer (p. 73), Helga Grove (p. 11), Gunter Heinrich (pp. 113, 115, 132 & 162), Joan Leseur (p. 68), Mim & Rob O'Dowda (p. 70), Patricia Reed (p. viii), Mike Samuels (pp. 72 & 150), Sandra Scott (p. 159), Melinda Seyler (p. 66) and Michael Shuster (p. 44).

Guiding me through the process of actually getting the book into print was Harbour Publishing. Everyone I worked with there was clearly dedicated to their craft and has been patient in leading me through the publication process—another excellent team!

Lastly I must thank all the people here in Ladysmith who assist with the myriad jobs that need doing here at the pottery to keep everything ticking along, and who bolster my spirits with their encouragement and the occasional delightful drawing. This "Fox that Pots" very much appreciates her village of helpers. I am eternally grateful to you all.

MYALGIC
ENCEPHALOMYELITIS

The illness that changed our lives is called myalgic encephalo-myelitis (ME). It is sometimes equated with chronic fatigue syndrome (CFS), but many medical researchers consider it a separate illness with specific diagnostic identifiers. It is often referred to as ME/CFS, or as part of a group of chronic illnesses that includes ME, CFS and fibromyalgia.

Although ME/CFS affects over half a million Canadians, until recently, comparatively little medical research has been devoted to understanding it. A major challenge for people with this illness is finding a well-informed medical practitioner who will take their symptoms seriously, provide a diagnosis (which can take years) and provide the best care available to alleviate symptoms.

ME is an acquired chronic illness that affects all body systems, but mainly the neurological, endocrine and immune systems. Many people become ill with ME after a bout of the flu or other acute illness, but the precise cause is not known. It is now classified as a neurological disease by the World Health Organization.

The primary symptoms of ME are extreme fatigue, muscle weakness, pain (muscle and joint pain, headaches, neck pain) and difficulties with concentration, memory and cognition. Basically, the body can't produce enough energy or strength to meet even simple daily demands. Symptoms flare up and get worse with physical and mental exertion. Other common symptoms include visual impairment (such as blurred vision), extreme sensitivity to light and noise, tingling, burning or numbness in the extremities (paresthesia), problems with bladder and bowel function, and sleep disturbances.

People with ME can have very different experiences of the illness, depending on its severity and duration. Affected individuals do not completely recover but may gradually see improvement of symptoms over time and regain most of their abilities. For others, however, it remains a long-term disabling illness that can worsen over time.

People with severe ME are usually unable to leave the house; if they do, they will likely suffer severe and prolonged worsening of symptoms afterwards. Most never leave their beds and need to minimize light, noise and scents in their environment due to their hypersensitivity. Unable to walk more than a few feet, they require a wheelchair for mobility and assistance with basic daily tasks such as washing, dressing and eating. These limitations are often accompanied by psychological issues brought on by social isolation, lack of treatment options and the inevitable financial stress that results from the inability to sustain employment.

"We need supportive people in our lives. We need a basic level of economic security and healthcare. We need to find meaning, even in our suffering."

– JENNIE SPOTILA, author of *Occupy M.E.*, a blog for people with ME

Although Heather and I both experienced most of these symptoms intensely in the first few years of illness, my symptoms gradually became less severe, while Heather's became worse over time. I continue to have symptoms (physical and mental fatigue, pain and weakness in my legs) but manage them with rest and self-care.

As Heather's health declined, she struggled to find activities that would give meaning to her life and keep her spirits up. Having access to the internet and online support groups for ME was a great help, though social media was only just beginning when she was nearing the end of her journey. She and a few others formed a small writing group, which provided her with creative support and a way to reach out and connect with others in similar circumstances. When she was able, she took photographs, which she called her *Series from Below,* since they were taken looking up from her bed, reclining chair or foamy on the ground outside. On a good day, Heather would pick out her favourite photos to make into cards; these would then wait on her desk for me to glue onto cards. She was too weak most of the time to have visitors or even talk on the phone with friends, so mail became her lifeline. She looked forward to it every day as it eased her isolation.

The two things a person with severe ME needs most are well-informed, compassionate medical care and assistance with daily living. Fortunately, on the medical side, new research is beginning to shed more light on the illness. As for caregiving assistance, we learned from experience that additional outside support is essential for anyone with severe ME even if they have a family member providing care, not just to meet the needs of the ill person but to prevent the burnout of the family caregiver. However, an adequate level of home care is still not readily available for people with ME since the illness is not well recognized as a serious chronic and disabling condition, and most of those with the illness do not have the energy to advocate for themselves.

A third requirement of those who have ME is hope. In recent decades some people with ME have managed to become advocates and offer support to others. If you or a loved one are facing this illness, you are not alone. Today there are organizations, support groups and resources that can help you sort through your needs and issues. You may want to join an online support group, or if you can't find one, start one.

SELECTED REFERENCES

MYALGIC
ENCEPHALOMYELITIS
RESOURCES

Action for ME (UK)
 https://www.actionforme.org.uk/what-is-me/introduction

Disability Alliance BC – Disability advocacy and resources for BC
 residents. Offers help applying for CPP disability and provincial
 disability benefits, and locating accessible affordable housing.
 disabilityallianceBC.org

ME Research (UK)
 http://www.meresearch.org.uk/what-is-me

National ME/FM Action Network (Canada)
 https://www.mefmaction.com

OCCUPY M.E. blog – by Jennie Spotila, who has had ME since
 October 1994. ttp://occupyme.net

POTTERY

Britt, John. *The Complete Guide to High-Fire Glazes: Glazing and
 Firing at Cone 10.* New York, NY: Sterling Publishing, 2007.

www.glazy.org
 Extensive and evolving online database of glaze recipes,
 firing schedules and more.

Hesselberth, John, and Ron Roy. *Mastering Cone 6 Glazes:
 Improving Durability, Fit and Aesthetics.* Brattleboro,VT:
 Echo Point Books and Media, 2020. First published 2002 by
 Glaze Master Press.

Hopper, Robin. *The Ceramic Spectrum: A Simplified Approach
 to Glaze and Color Development,* 2nd ed. Westerville, OH:
 American Ceramic Society, 2009. First published 1984 by
 Chilton Book Company.

Ron Roy
 Ron Roy offers help to studio potters with glaze questions
 through his website, www.ronroy.net.

PHOTOGRAPHY CREDITS

All photographs courtesy of Mary Fox unless otherwise credited.

FRONT COVER
Sean Sherstone

OPENING SPREADS
Ashley Marston: xxi; Sean Sherstone: i, xii, xvi

CHAPTER 1
Doug Berg: 5; Bob Matheson, courtesy of the Art Gallery of Greater Victoria: 11; Sean Sherstone: xxii

CHAPTER 2
Ingeborg Suzanne Hardman: 21, 23, 24; Ladysmith Archives: 31 (bottom); Sean Sherstone: 16

CHAPTER 3
Geoff Cram: 46; Janet Dwyer: 38, 47; Pat Feindel: 39 (right); Gail Johnson: 42, 43; Edward McCrea: 37; Sean Sherstone: 32

CHAPTER 4
Jacqueline Neligan: 57, 58 (right), 61 (bottom centre); Sean Sherstone: 50, 56

CHAPTER 5
Janet Dwyer: 70 (right); Jacqueline Neligan: 72 (bottom); Jackie Noble: 70 (top left); Sean Sherstone: 64

CHAPTER 6
Ashley Marston: 76, 77 (bottom left), 78, 80 (top), 83, 87 (top and centre); Edward McCrea: 77 (bottom right); Sean Sherstone: 74, 82

CHAPTER 7
Brian Hogg: 90 (bottom); Ashley Marston: 91; Sean Sherstone: 88, 90 (top), 92–93

CHAPTER 8
Jacqueline Neligan: 108 (centre and bottom), 109; Sean Sherstone: 94, 96, 97, 98, 99, 100, 101, 103, 104, 105

CHAPTER 9
Lois Clayton: 112; Sean Sherstone: 110

CHAPTER 10
Ingeborg Suzanne Hardman: 118 (right); Ashley Marston: 124; Jacqueline Neligan: 120 (left); Sean Sherstone: 116

CHAPTER 11
Jacqueline Neligan: 128, 129, 130, 131 (left and centre), 133; Sean Sherstone: 126

CHAPTER 12
Sean Sherstone: 136, 140, 141, 142; Zea Wulf: 143

CHAPTER 13
Janet Dwyer: 148 (bottom right), 150 (left); Edward McCrea: 150 (right); Sean Sherstone: 144

CHAPTER 14
Vince Klassen: 158 (right); Sean Sherstone: 152

CHAPTER 15
Sean Sherstone: 164

CHAPTER 16
Edward McCrea: 170 (left), 174; Jacqueline Neligan: 172, 175 (top left and bottom); Sean Sherstone: 168

CHAPTER 17
Jacqueline Neligan: 180, 181, 182, 183; Sean Sherstone: 178, 184, 185, 186, 187, 188, 189, 190, 191, 192

CHAPTER 18
Sean Sherstone: 194, 204, 205

ABOUT MARY FOX

A professional potter for over forty years, Mary Fox knew she had found her life's work after her first exposure to ceramic arts at the age of thirteen. Her innovative layered glazes and exquisitely balanced vessels have garnered national and international acclaim. Her work has been featured in numerous exhibitions, books, journals and design magazines, and is held in institutional, corporate and private collections in Canada, Italy and the United States. Fox also delivers artist talks and workshops on ceramic techniques and the creative process.

Largely self-taught, Fox has supplemented her learning by participating in a six-week workshop at the Banff School of Fine Arts (1988) and conducting self-directed explorations of cone 10 glazes with the support of a Circle Craft Co-operative scholarship (1998). She is a core member of Fired Up!, the longest running ceramic exhibition group in Canada, and has exhibited with them regularly since 1997.

Fox lives and works in her studio located in Ladysmith on Vancouver Island, BC, where she creates both functional and purely decorative work.

SELECTED EXHIBITIONS	SOLO
2016	*Primordial Beauty: New Explorations in Glass and Slip Casting,* Winchester Galleries, Victoria, BC.
2015	*Unearthing Beauty,* Gallery of BC Ceramics, Vancouver, BC.
2014	*Beautiful Vessels to Enrich and Inspire,* Circle Craft Gallery, Vancouver, BC.
2014	*Mary Fox: Forms and Vessels,* Winchester Galleries, Victoria, BC.
2011	*Classic Forms Revisited,* Gallery of BC Ceramics, Vancouver, BC.
2005	*Beauty of Form Enhanced,* Gallery of BC Ceramics, Vancouver, BC.
2000	*Treasured Vessels,* Portfolio Gallery, Vancouver, BC.
1997	*Fine Form,* Gallery of BC Ceramics, Vancouver, BC.

SELECTED EXHIBITIONS	INTERNATIONAL AND TOURING
2018	*Living with Clay: California Ceramics Collections,* Nicholas & Lee Begovich Gallery, Fullerton, CA.
2016	*Crawling: The Amusing Skin,* Ceramic & Colours Award Exhibition, Special Mention, Museo Internazionale delle Ceramiche, Faenza, Italy.
2011	*Vasefinder International 2011,* online, vasefinder.com.
2007–2009	*Elemental Connections: An Exhibition of Sustainable Craft,* Ontario Crafts Council, Toronto, ON; Feature Gallery, Alberta Craft Council, Edmonton, AB; Saskatchewan Craft Council, Saskatoon, SK.
2006	*New Growth: Synthesizing Clay,* Fired Up! Group Show, Fortieth Annual NCECA Conference, Portland, OR.

2005–2006	*In the Palm of a Hand:* BC *to Jajimi,* Jajimi Creative Plaza, Jajimi, Japan, and Gallery of BC Ceramics, Vancouver, BC.
2003	*The Shape Between Continuity and Innovation,* Museo Internazionale delle Ceramiche, Faenza, Italy. Entry selected for permanent collection.
2002	*Sidney Myer Fund International Ceramics Award Exhibition,* Shepparton Art Gallery, Shepparton, Australia.
1989	*9th Annual Northwest International Art Competition Exhibit,* Bellingham, WA.

SELECTED EXHIBITIONS GROUP

2019	*Unstoppable: The Women's Exhibition,* Winchester Galleries, Victoria, BC.
2018	*Anatomy of a Collector,* Tom Thomson Gallery, Owen Sound, ON.
2016	*Saltspring Island Ceramic Awards Exhibition,* Saltspring Island, BC.
2014	*20/20,* Winchester Galleries, Victoria, BC.
2014	*Fired Up! Celebrating 30 Years,* Gallery of BC Ceramics, Vancouver, BC.
2013	*New Works,* Winchester Galleries, Victoria, BC.
2013	*Turning 40: The Art of Ceramics at Circle Craft,* Circle Craft Gallery, Vancouver, BC.
2012	*Back to the Land: Ceramics from Vancouver Island and the Gulf Islands 1970–1985,* Art Gallery of Greater Victoria, Victoria, BC.
2011	*Matter of Clay III,* Jonathon Bancroft-Snell Gallery, London, ON.
2009	*What the Rain Brings: Fired Up! Contemporary Works in Clay,* Canadian Clay and Glass Gallery, Waterloo, ON.
2008	*Contemporary Craft in* BC*: Excellence within Diversity,* Crafts Association of BC and Vancouver Museum, Vancouver, BC.
2008	*Fox & Norgate,* Wallace Galleries, Calgary, AB.
2007	*Surfaces,* Jonathon Bancroft-Snell Gallery, London, ON.
2006	*A Matter of Clay II: Repeats and Occasional Pots,* Jonathon Bancroft-Snell Gallery, London, ON.
2007	*OBJECTToronto: An Art Exposition of Contemporary Craft and Design,* Harbinger Gallery, Gladstone Hotel, Toronto, ON.
2005	*Circle Craft Scholarship Recipients,* Pendulum Gallery, Vancouver, BC.
2005	*TransFormations: Ceramics 2005,* Celebrating the Potters Guild of BC at 50, Burnaby Art Gallery, Burnaby, BC.
2003	*Genius Loci,* Canadian Clay & Glass Gallery, Waterloo, ON.
2003	*We Are Circle Craft!* Celebrating Our First 30 Years, Pendulum Gallery, Vancouver, BC.
2000	*ARTS 2000,* Gallery Stratford, Royal Canadian Academy of Arts, Stratford, ON.
1998	*Made by Hand,* Silver Edition 1998, Canadian Craft Museum, concurrent exhibitions in Vancouver and Victoria, Crafts Association of BC.
1997	*APEC Ikebana Exhibit,* Vancouver Trade and Convention Centre, Vancouver, BC.

1996	*Classic Vessels and Adornments* (with Marianne Brown), Circle Craft Gallery, Vancouver, BC.
1989	*Exhibit* (with Maggie Tchir and the Orceas Basket Weavers), The Gallery Shop, Art Gallery of Greater Victoria, Victoria, BC.
1988	*Exhibit* (with Jan MacLeod), Circle Craft Gallery, Vancouver, BC.
1988	*Exhibit*, Crafthouse Gallery, Vancouver, BC.
1988	*Exhibit*, Market House Gallery, Annapolis, NS.
1988	*Raku* (with Gordon Reisig and Robin Righton), Gallery of BC Ceramics, Vancouver, BC.
1986	*Vault of Dreams* (with Miles Lowry), Out of Hand Gallery, Victoria, BC.

PUBLICATIONS
FEATURING WORK

Carr, Dianne, and Nancy Janovicek. *Back to the Land: Ceramics from Vancouver Island and the Gulf Islands, 1970–1985.* Victoria, BC: Art Gallery of Greater Victoria, 2012. Exhibition catalogue.

Crafts Association of British Columbia. *Made by Hand, Silver Edition 1998.* Vancouver, BC: Crafts Association of British Columbia, 1998. Exhibition catalogue.

Crawford, Gail. *Studio Ceramics in Canada.* Fredericton, NB: Goose Lane Editions, 2005.

Doherty, Linda, ed. *Made of Clay: Ceramics of British Columbia.* With text by Carol E. Mayer. Vancouver, BC: Potters Guild of BC, 1998.

Gustafson, Paula, ed. *Craft Perception and Practice: A Canadian Discourse, Volume 2.* Vancouver, BC: Ronsdale Press, 2005. Cover photograph.

Hopper, Robin. *The Ceramic Spectrum: A Simplified Approach to Glaze and Color Development,* second edition. By Robin Hopper. Iola, WI: Krause Publications, 2001.

——. *Making Marks: Discovering the Ceramic Surface.* Iola, WI: Krause Publications, 2004.

Jacobs, Richard. *Searching for Beauty: Letters from a Collector to a Studio Potter.* Tythegston, Wales, UK: Kestrel Books Ltd, 2007.

Jefferson, Cathi, and Meira Mathison. *"Fired Up!" Contemporary Works in Clay.* Vancouver, BC: Fired Up! Publications, 2009. Twenty-fifth anniversary catalogue.

Mayer, Carol E. *TransFormations: Ceramics 2005.* Burnaby, BC: Burnaby Art Gallery, 2005. Potters Guild of BC exhibition catalogue.

This is the first finished piece
of a new-to-me series, altered
vessels with added stems. Tricky
to make, but I love how elevat-
ing the form changes the feeling
emanating from the piece.

Altered Vessel, 2020.
Chalice series, mounted in rock,
42 cm T × 26 cm W.

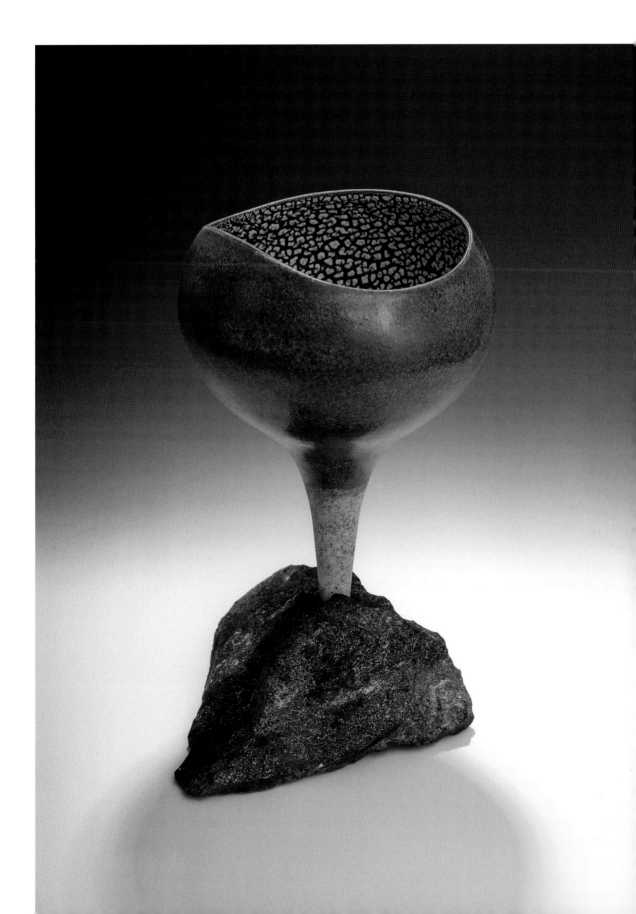

Harbour Publishing Co. Ltd.
P.O. Box 219, Madeira Park, BC, V0N 2H0
www.harbourpublishing.com

Edited by Pat Feindel
Substantive edit by Betty Keller
Cover and text design by Roberto Dosil
Printed and bound in South Korea

Harbour Publishing acknowledges the support of the Canada Council
for the Arts, the Government of Canada, and the Province of British
Columbia through the BC Arts Council.

LIBRARY AND ARCHIVES CANADA CATALOGUING IN PUBLICATION

Title: My life as a potter : stories and techniques / Mary Fox.
Names: Fox, Mary, 1959- author.

Description: Includes bibliographical references.

Identifiers: Canadiana 20200221175 | ISBN 9781550179385 (hardcover)

Subjects: LCSH: Fox, Mary, 1959- | LCSH: Women potters—Canada—
 Biography. | LCSH: Potters—Canada—Biography. | LCSH: Pottery.
 | LCSH: Autobiographies.

Classification: LCC NK4210.F69 A2 2020 | DDC 738.092—DC23

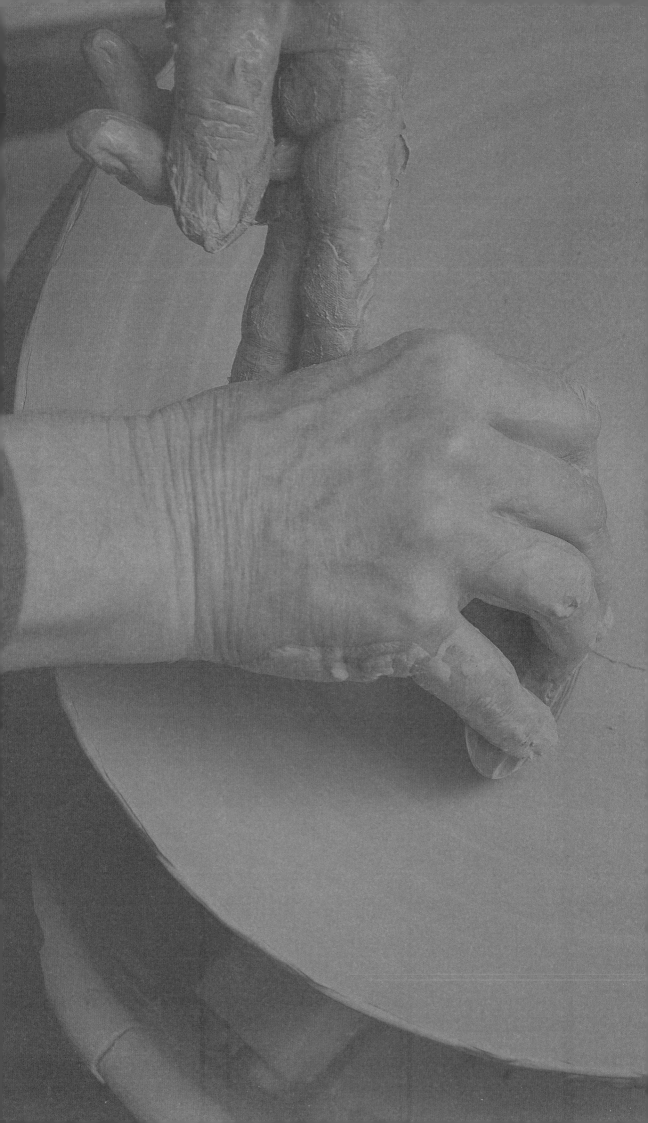